DRAWING
CUTTING EDGE
ANATOMY

DRAWING CUTTING EDGE ANATOMY

THE ULTIMATE REFERENCE GUIDE FOR COMIC BOOK ARTISTS

CHRISTOPHER HART

WATSON-GUPTILL PUBLICATIONS/NEW YORK

Thanks to:
Alisa Palazzo, Bob Ferro, Candace Raney,
Ellen Greene, and Bob Fillie.

CONTRIBUTING ARTISTS:
Ron Adrian: 40, 41, 103–108, 111, 112,
 118–121, 123, 124
Darryl Banks: 1, 2, 36–39, 42, 43, 52, 53, 57,
 70–73, 75–80, 83–96, 100–102, 114–115
Will Conrad: 16–17, 27, 30, 51, 55,
 58–63, 74, 81, 82, 122, 125–129
Kerone Grant: 10–13, 15, 18–21, 31–35
Christopher Hart: 110, 130–135
Adriano Melo: 44–47, 54, 56, 64–69
Pop Mhan: 6, 8, 9, 14, 22–26, 28, 29
Nicola Scott: 48–50, 97–99, 109,
 113, 116, 117

Cover color: MADA Design, Inc.
Cover art: Darryl Banks
Interior color: Brimstone

Senior Editor: Candace Raney
Project Editor: Alisa Palazzo
Designer: Bob Fillie, Graphiti Design, Inc.
Production Manager: Ellen Greene

Published in 2004
by Watson-Guptill Publications
a division of VNU Business Media, Inc.
770 Broadway, New York, NY 10003
www.wgpub.com

Library of Congress Cataloging-in-Publication Data
Hart, Christopher.
 Drawing cutting edge anatomy : the ultimate reference guide for
comic book artists / Christopher Hart.
 p. cm.
Includes index.
 ISBN 0-8230-2398-2 (pbk.)
 1. Human beings—Caricatures and cartoons. 2. Figure drawing—Technique.
3. Cartooning—Technique. 4. Cartooning—Vocational guidance. I. Title.
NC1764.8.H84H37 2004
741.5—dc22
 2004012864

Printed in the United States of America

1 2 3 4 5 6 7 8 / 11 10 09 08 07 06 05 04

VISIT US AT
www.artstudiollc.com

CONTENTS

INTRODUCTION 6

THE FOUNDATION 8
THE SKELETON 9
THE MUSCLES 10
THE MUSCLES IN PROFILE 13
SIMPLIFYING THE BODY (WHEN
ROUGHING OUT A POSE) 14
AGE CHART 15
HEIGHT CHART 16
BODY SHAPES: MEN . . . AND WOMEN 18
BODY LANGUAGE 20

MUSCULAR DETAILS 22
THE PRIMARY MUSCLES
IN ACTION 23
EXTREME BULK 27
EXTREME VEINS 28
DRAWING VEINS THAT POP 29
PRIME LOCATIONS FOR
SUPERVASCULARITY 30
SURFACE MAPPING 31
THE EFFECTS OF LIGHT ON THE BODY 34

THE HEAD AND NECK 36
THE SKULL 37
THE MUSCLES OF THE FACE 38
DRAWING THE EYES 39
MALE EYES VS. FEMALE EYES 40
THE TYPICAL MALE HEAD 42
THE TYPICAL FEMALE HEAD 44
DROP-DEAD GORGEOUS HEAD TILTS 46
DRAWING THE EARS 48
THE MAIN NECK MUSCLE 49
THE MAIN NECK MUSCLE IN MOTION 50
THE HEAD, NECK, AND
SHOULDER AREA 51

THE CHEST AND ABS 52
THE RIB CAGE 53
BASIC CHEST STRUCTURE 54
THE MALE TORSO 55
WASHBOARD ABS 56
THE MUSCLES ON TOP OF MUSCLES 57
ARMS DOWN 58
ARMS UP 60
THE MALE TORSO IN MOTION 62
THE FEMALE TORSO 63
OPPOSING FORCES 64
THE FEMALE TORSO IN MOTION 66

THE BACK AND SHOULDERS 70
UPPER BACK, RELAXED
(ARMS DOWN) 71
UPPER BACK, FLEXED (ARMS UP) 72
LOWER BACK 73
SURFACE RENDERING 74
CONTRACTING THE BACK MUSCLES 75
COOL COMIC BOOK POSES
FOR THE BACK 76
THE MAJOR MUSCLE GROUPS
OF THE SHOULDER 79
THE SHOULDERS IN MOTION 82
COOL COMIC BOOK POSE
FOR THE SHOULDERS 83

THE ARMS AND HANDS 84
ARM BONES 85
GENERAL MUSCLE INFO 86
THE MUSCLES BETWEEN THE
BICEPS AND TRICEPS 87
THE TRICEPS IN ACTION 88
THE FOREARM 90
PUNCHING: THE FOREARM
TWIST IN ACTION 93
COOL COMIC BOOK POSES
FOR THE ARMS 94
THE HANDS 96
DRAWING EXPRESSIVE HANDS 97
VARIOUS HAND POSES 98

THE PELVIS, LEGS, AND FEET 100
THE PELVIS 101
THE LEG BONES: AN OVERVIEW 102
LEG BASICS 103
SIDE VIEW 104
THE LEG MUSCLES IN BULK 105
THE FEMALE LEG 106
SIDE VIEW OF THE FEMALE LEG 108
THE TROUBLE SPOT: THE KNEE 109
BACK VIEW 110
CALF MUSCLES 111
FEMALE CALF MUSCLES 112
DRAWING FEET 113
THE BONES OF THE FOOT 114
SHOES AND BOOTS 116
THE COMPLETE LEG 118
THE COMPLETE FEMALE LEG 120

ELEMENTS TO PRACTICE 122
HOW TO BEGIN 123
RENDERING THE MUSCLES 124
WOMEN AND THE SARTORIUS 125
LATS AND A GOOD BACK VIEW 126
RIB CAGE POSES 127
KEEPING IT SIMPLE 128

THE BIZ 130
STARTING OUT: THE ASHCAN
AND OTHER STRATEGIES 131
SWITCHING SIDES 135

THE INTERVIEWS 136
MIKE MARTS, MARVEL COMICS 137
CHRIS WARNER,
DARK HORSE COMICS 140
SCOTT ALLIE, DARK HORSE COMICS 142

INDEX 144

INTRODUCTION

The trend in comics today is toward more extreme figures whose muscles are bigger and more defined than ever. While this creates powerful, exciting comic book characters, it can present a problem for the artist, who needs to become more familiar with stylized, cutting-edge anatomy.

If there's one thing above everything else that comic book artists must know, it's how to draw the human figure. Therefore, many comic book artists stock up on anatomy books but are often disappointed with their purchases. Why? Because anatomy books typically illustrate the muscle groups on mannequinlike figures, standing at attention; the moment you draw a figure in an action pose, the positions of the muscles change—and the example in the anatomy book is of no use to you.

You need a book that gives detailed examples of anatomy as it appears in all the *typical comic book poses* you might draw. And, you need enough examples so that you'll start recognizing the correct placement of the muscle groups. That's the point at which understanding takes the place of memorization.

In addition, most anatomy books show the muscles on figures on which the skin has been removed. That's great if all you want to do is draw cadavers. But in the real world—and the comic book world—people walk around with their skin *on*. And the skin and fat layers have the effect of masking the deeper and less-defined muscles. Why should you have to guess which muscles show through to the surface? This book lays it out for you in black and white so that you can compare the *muscles without the skin* to the *muscles with the skin* (referred to as *surface anatomy*). You'll even learn how to draw the muscles as they appear through clothes and costumes.

This book is highly readable—maybe the first highly readable anatomy book. Most only use the Latin names of the muscles, making things hard to remember and even harder to understand. In this book, you'll not only get the Latin names of the muscle groups, but also the regular, everyday terms for them, as well. For example, if a muscle is labeled *scapula*, I'll also tell you that this is the *shoulder blade*.

You'll also learn how to draw a variety of body types and how to adjust the posture as the body ages. And so that you'll have plenty of examples on which to practice, this book has many step-by-step illustrations of original, exciting comic book characters that incorporate the muscles and anatomy you'll be learning.

The book closes with two invaluable sections: The first describes the steps to take to get published in comics so that you don't have to invent the path to success—it's all explained to you, in detail; you'll learn exactly how to capitalize on each success in order to reach the top strata in the business. The second features three amazing interviews with editors from two giants of the comics industry: Marvel Comics and Dark Horse Comics. You'll get insider viewpoints on how the comic book business works, how to approach editors, and what the most important qualities are in a comic book artist.

7

THE FOUNDATION

The skeleton is the foundation of the body. Observing it will show you why the body's contours are where they are. To be sure, not all artists sketch out the skeleton before roughing out a pose (although some do). But all accomplished illustrators have enough basic knowledge of the skeleton to have an intuitive sense of the body's framework. Take a look at the underlying structure of the body, and just keep this stuff in the back of your mind as you progress toward mastering anatomy.

When you take a look at Mr. and Ms. Bones here, do the following: Notice how the rib cage actually widens toward the bottom before tapering back in a little. Observe how much space there is between the lowest rib and the pelvis. Note how thick the joints are at the elbows and knees. All good things to be aware of.

The male skeleton is slightly larger than the female skeleton, with thicker bones. The main difference is in the pelvis (hips). Men's hips are taller from top to bottom, but narrower from side to side than women's hips. Women's hips are widest where the femur (thighbone) meets the pelvis. That's where a big

ball-and-socket joint (the outermost point of which is the great trochanter) is located. Okay, so the bones have complicated names. Relax. This isn't biology class. You don't have to memorize a thing. No one's going to quiz you. What you want to notice is the *angle* of the bones and their basic shapes: Notice how the collarbone dips at the center where it meets the sternum (breastbone). Note how the femur (thighbone) angles inward as it approaches the knee area but the tibia (shinbone) travels straight down. Also note how large the shinbone is at the bottom. That's what gives the ankle its mass.

MALE

FEMALE

The same structure applies, except the overall frame is lighter.

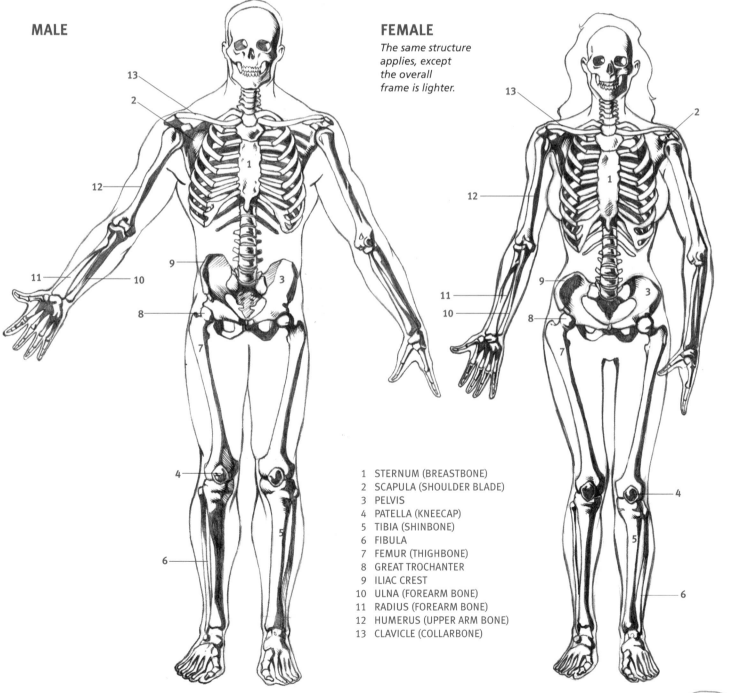

1 STERNUM (BREASTBONE)
2 SCAPULA (SHOULDER BLADE)
3 PELVIS
4 PATELLA (KNEECAP)
5 TIBIA (SHINBONE)
6 FIBULA
7 FEMUR (THIGHBONE)
8 GREAT TROCHANTER
9 ILIAC CREST
10 ULNA (FOREARM BONE)
11 RADIUS (FOREARM BONE)
12 HUMERUS (UPPER ARM BONE)
13 CLAVICLE (COLLARBONE)

THE MUSCLES

You can't fight bad guys unless you have big biceps—and a few other oversized muscle groups. Again, there's no need to memorize these. Just familiarize yourself. Each group of muscles interlaces with the next group, and so on. I'll go through each individual muscle group step by step in a clear, easy-to-follow method so that you'll get it. "Go slow" is the key to our approach.

And note a new point to remember here. The secret to drawing strong characters is threefold: make 'em wide on top, narrow at the waist, and big in the legs. Look to "bunch" the shorter, more compact muscles of the upper torso (the abs, pecs, and delts). Look to create striations (long lines of definition) on the longer, thinner muscles of the legs (the thigh and calf muscles).

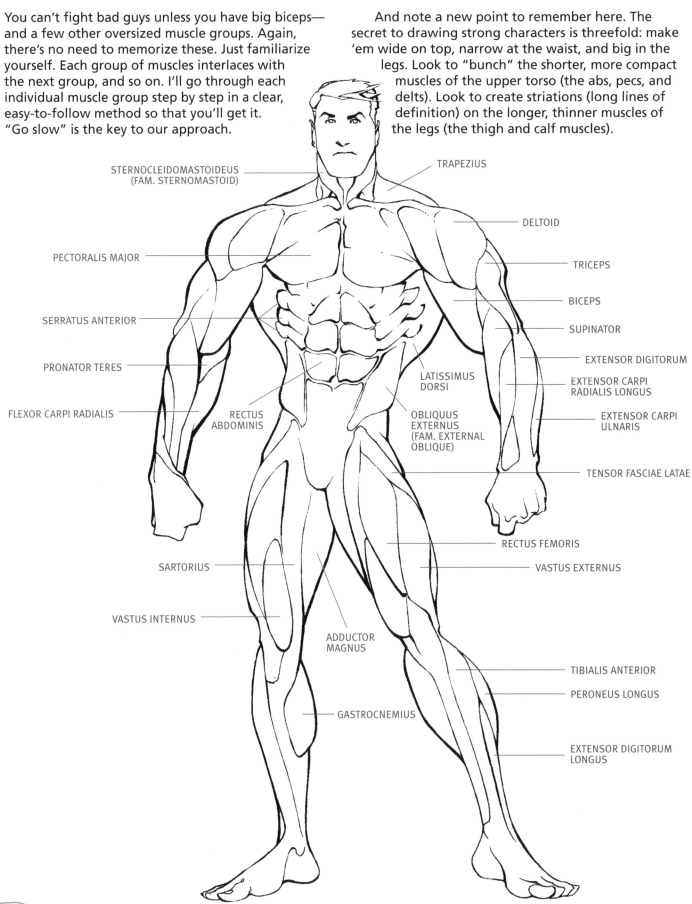

STERNOCLEIDOMASTOIDEUS
(FAM. STERNOMASTOID)

TRAPEZIUS

DELTOID

PECTORALIS MAJOR

TRICEPS

BICEPS

SUPINATOR

SERRATUS ANTERIOR

EXTENSOR DIGITORUM

LATISSIMUS
DORSI

EXTENSOR CARPI
RADIALIS LONGUS

PRONATOR TERES

OBLIQUUS
EXTERNUS
(FAM. EXTERNAL
OBLIQUE)

EXTENSOR CARPI
ULNARIS

FLEXOR CARPI RADIALIS

RECTUS
ABDOMINIS

TENSOR FASCIAE LATAE

RECTUS FEMORIS

SARTORIUS

VASTUS EXTERNUS

VASTUS INTERNUS

ADDUCTOR
MAGNUS

TIBIALIS ANTERIOR

PERONEUS LONGUS

GASTROCNEMIUS

EXTENSOR DIGITORUM
LONGUS

BACK

The "lats" (you bodybuilders know that *lats* stands for *latissimus dorsi*) dominate the back. The shoulders top the lats off with even more width. The "traps" (more bodybuilding lingo for the *trapezius*) gives the neck a hunched look, which is excellent for highlighting brute strength. The gastrocnemius (calf) is the biceps of the lower leg and bulges accordingly. The external obliques (what your girlfriend derisively calls your love handles) are actually muscles that you would see if you ever lost those last ten pounds.

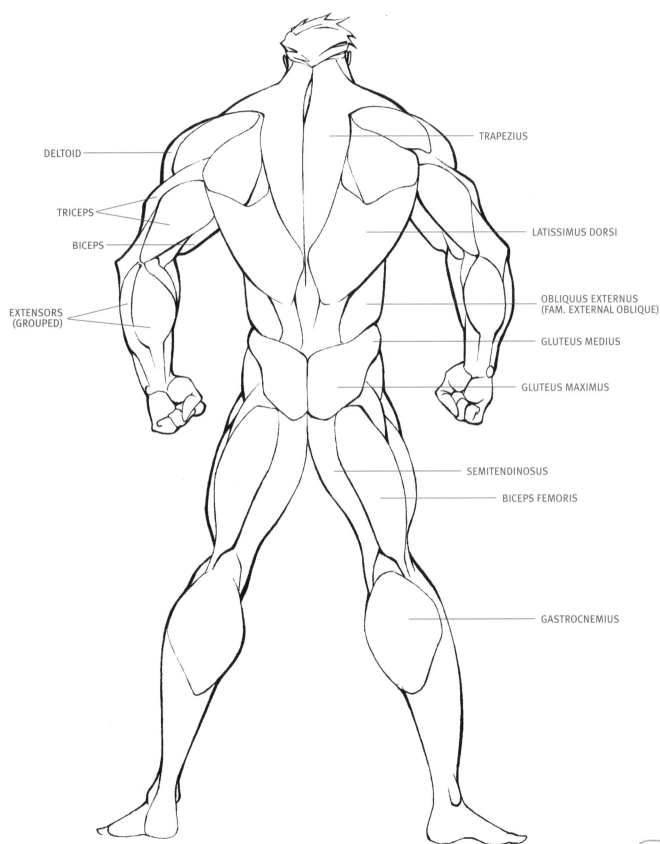

DELTOID

TRICEPS

BICEPS

EXTENSORS
(GROUPED)

TRAPEZIUS

LATISSIMUS DORSI

OBLIQUUS EXTERNUS
(FAM. EXTERNAL OBLIQUE)

GLUTEUS MEDIUS

GLUTEUS MAXIMUS

SEMITENDINOSUS

BICEPS FEMORIS

GASTROCNEMIUS

FRONT

Women have a higher percentage of body fat than men (just don't tell them that). On comic book figures, you indicate this body fat by creating fuller curves without high definition. That's not to say that the comic book woman is soft, but her muscles are long and lean—and don't "bunch" like the muscles on a comic book man. You don't want her looking like a female professional bodybuilder. Think more in terms of her being a toned athlete with looks that could kill.

BACK

When comparing female anatomy to male anatomy, the first thing you'll notice is that her lats don't give her that wide-back look. Also, her traps aren't an accentuated muscle group because she needs a long, supple neck to retain her femininity. *Never* draw her external obliques as separate muscles, as they appear on a man; there's no "bump out" of the obliques. And, she has wide hips and full, muscular thighs. Also, square—not drooping—shoulders are a feminine look.

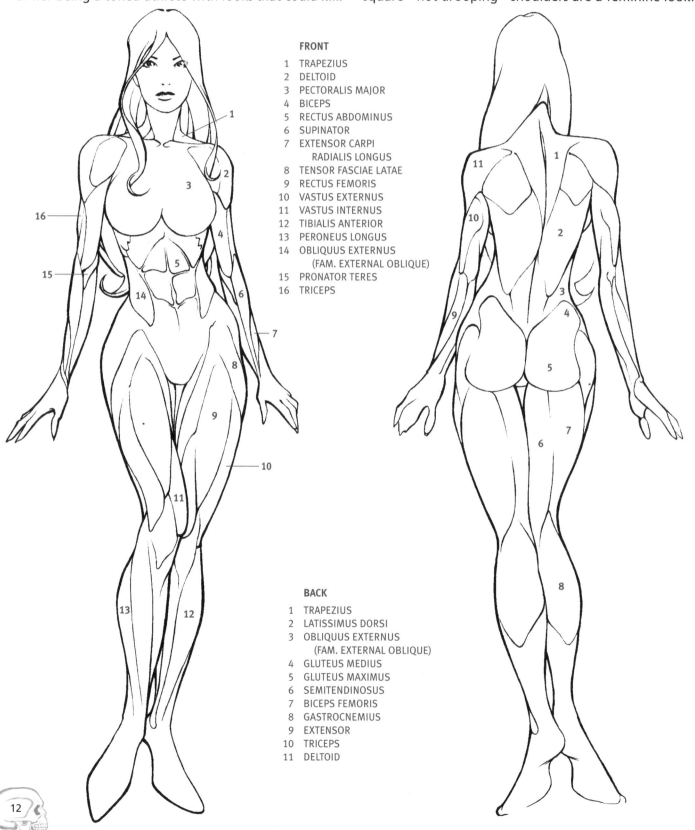

FRONT

1 TRAPEZIUS
2 DELTOID
3 PECTORALIS MAJOR
4 BICEPS
5 RECTUS ABDOMINUS
6 SUPINATOR
7 EXTENSOR CARPI
 RADIALIS LONGUS
8 TENSOR FASCIAE LATAE
9 RECTUS FEMORIS
10 VASTUS EXTERNUS
11 VASTUS INTERNUS
12 TIBIALIS ANTERIOR
13 PERONEUS LONGUS
14 OBLIQUUS EXTERNUS
 (FAM. EXTERNAL OBLIQUE)
15 PRONATOR TERES
16 TRICEPS

BACK

1 TRAPEZIUS
2 LATISSIMUS DORSI
3 OBLIQUUS EXTERNUS
 (FAM. EXTERNAL OBLIQUE)
4 GLUTEUS MEDIUS
5 GLUTEUS MAXIMUS
6 SEMITENDINOSUS
7 BICEPS FEMORIS
8 GASTROCNEMIUS
9 EXTENSOR
10 TRICEPS
11 DELTOID

Muscles that looked slender from the front, such as the vastus externus (outer thigh muscle), are often revealed to actually be quite massive when viewed from the side. The external obliques are prominent at this angle. And the entire deltoid (shoulder)

muscle group—which is really comprised of three heads (front, middle, and back)—is overpowering on the male figure in this view. Note, too, how the collarbone juts out slightly at the bottom of the neck on both the male and female figure.

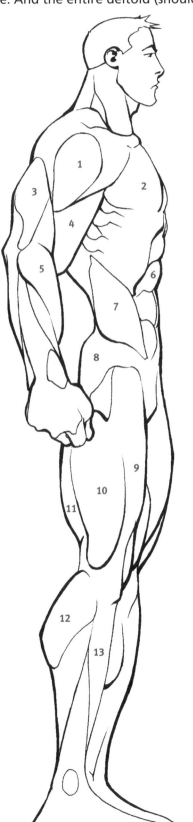

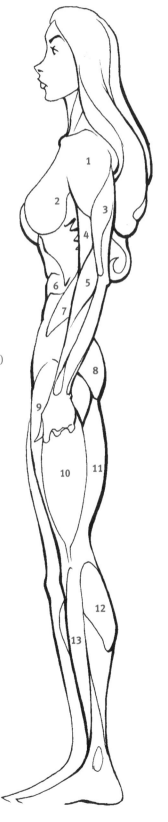

1 DELTOID
2 PECTORALIS MAJOR
3 TRICEPS
4 BICEPS
5 SUPINATOR
6 RECTUS ABDOMINIS
7 OBLIQUUS EXTERNUS
 (FAM. EXTERNAL OBLIQUE)
8 GLUTEUS MAXIMUS
9 RECTUS FEMORIS
10 VASTUS EXTERNUS
11 BICEPS FEMORIS
12 GASTROCNEMIUS
13 TIBIALIS ANTERIOR

SIMPLIFYING THE BODY (WHEN ROUGHING OUT A POSE)

When roughing out an initial pose, there's no need to focus on getting the muscle groups just right. At this stage, you're only looking for a good pose. Why work to get all the individual muscles right when you might not even like the position of the character? It's wiser to draw two or three simplified poses, choose the one you like best, and then refine it before sculpting the muscles. Simplified figures are made up of only the major body parts, hinged together by ball-and-socket joints.

Note: When professional artists use simplified figures, they don't generally draw as cleanly as the examples on these two pages. Their lines are sketchier and looser, which comes with years of experience. Some artists will use a lot of detail in sketching out a particular area of the body, as it helps them to visualize the pose better. Others will simplify it further, for example, drawing the rib cage as an oval. Others use stick figure lines to indicate the arms and legs. Everyone has his or her own method. The only requirement is that the simplified sketch conveys the feeling of the pose.

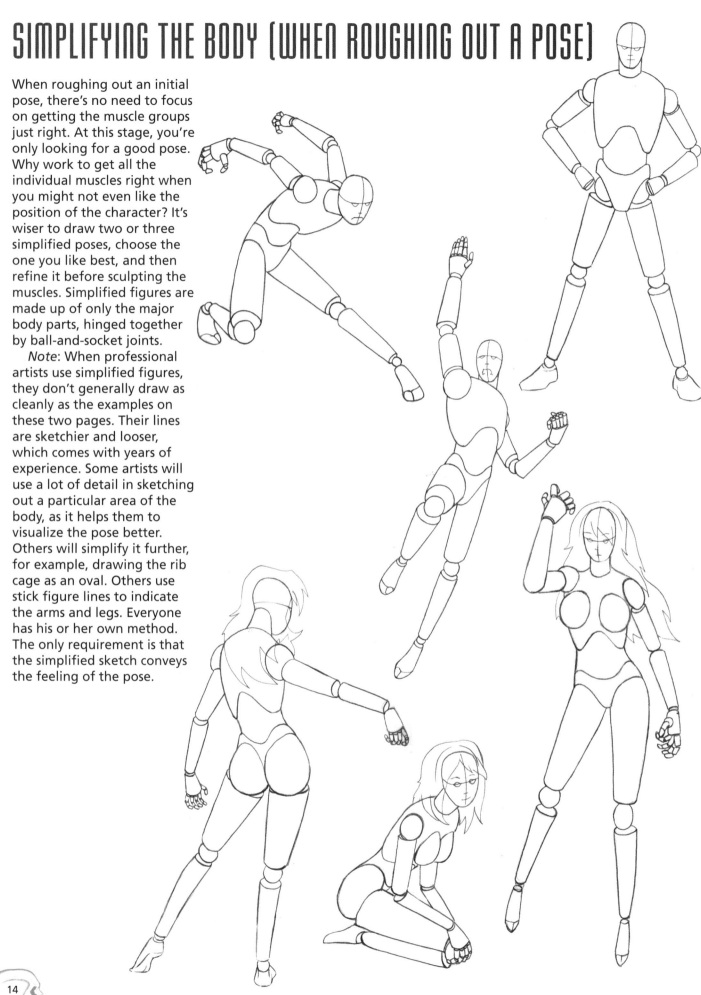

14

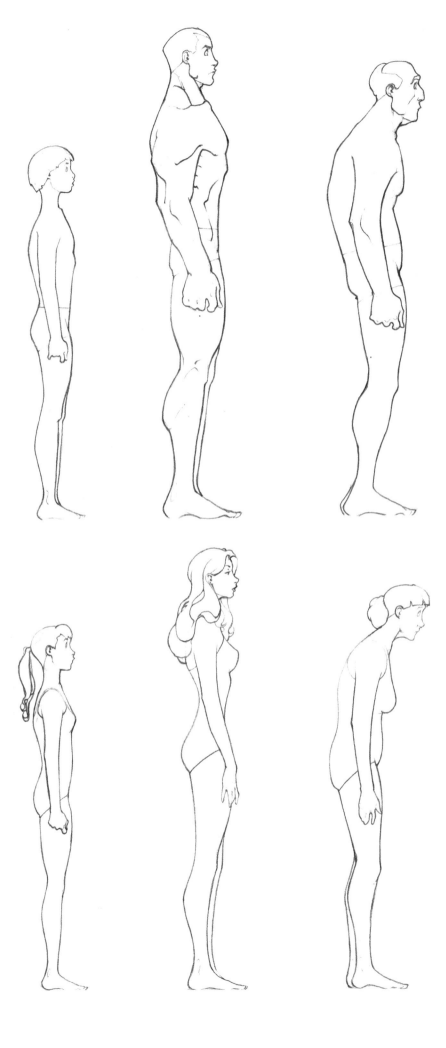

AGE CHART

Age creates several noticeable changes in the body, including in height and posture. In adulthood, the body doesn't just grow taller, it fills out. The frame get larger and denser. The chest sticks out, and the curve of the lower back becomes accentuated. The posture of middle aged people and senior citizens, however, is the reverse of all this: the chest curves in and the lower back sways outward. The stomach muscles lose their tone, resulting in a paunch, even if the character is not fat. Gravity also affects the body. As we age, parts start to sag. That's when lots of people purchase antigravity devices, also known as facelifts.

HEIGHT CHART

Different types of comic book characters are depicted at different heights. You've got to match the character type with the correct height. You're not going to see a five-foot-tall hero in comics. Not gonna happen.

Over the years, some stereotypes (based on height) have fallen into place. It's in the public consciousness. Therefore, it becomes an unwritten law. So here it is, in writing: An Average Guy in comic books is 7 head lengths tall. (The average real-life person is about 6½ to 7 heads tall, but everything is exaggerated in comics.) The Hero (the leading-man type or a costumed hero) is taller, at 8 heads. Remember: the taller a character is, the bigger the body will be by comparison. A bigger-looking body translates into more power. So, the next figure is the Antihero (a good guy, but just barely), and he comes in at an

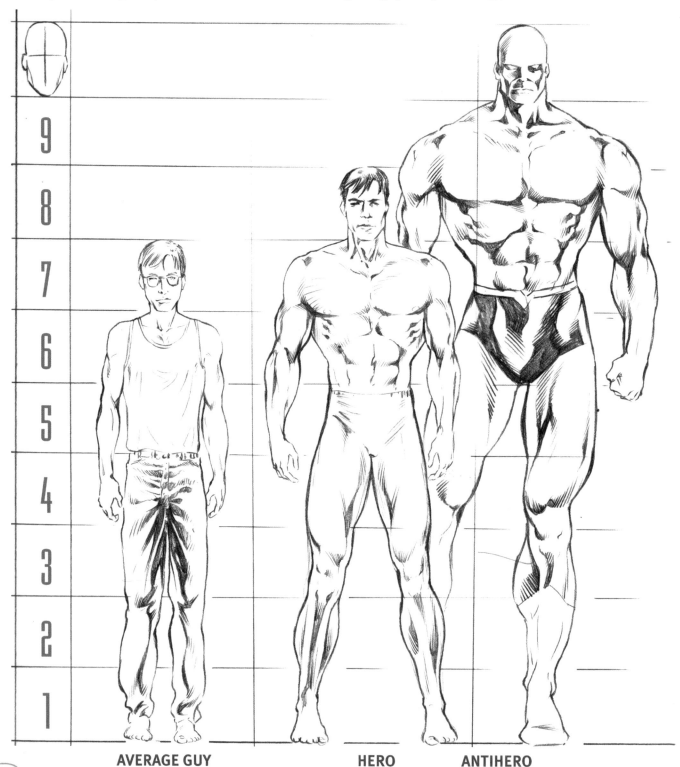

AVERAGE GUY **HERO** **ANTIHERO**

impressive 10 heads tall. Following him is a very popular character type, the Brute, at a cool 12 heads tall. Then the Giant, at a whopping 15 heads tall. These last two are not to be messed around with. They're always in a bad mood.

Female characters start at 6½ to 7 heads tall. They can be exaggerated to up to 12 heads tall, but this is not to add a sense of raw power so much as to promote a sense of long-legged sex appeal, grace, and a commanding presence.

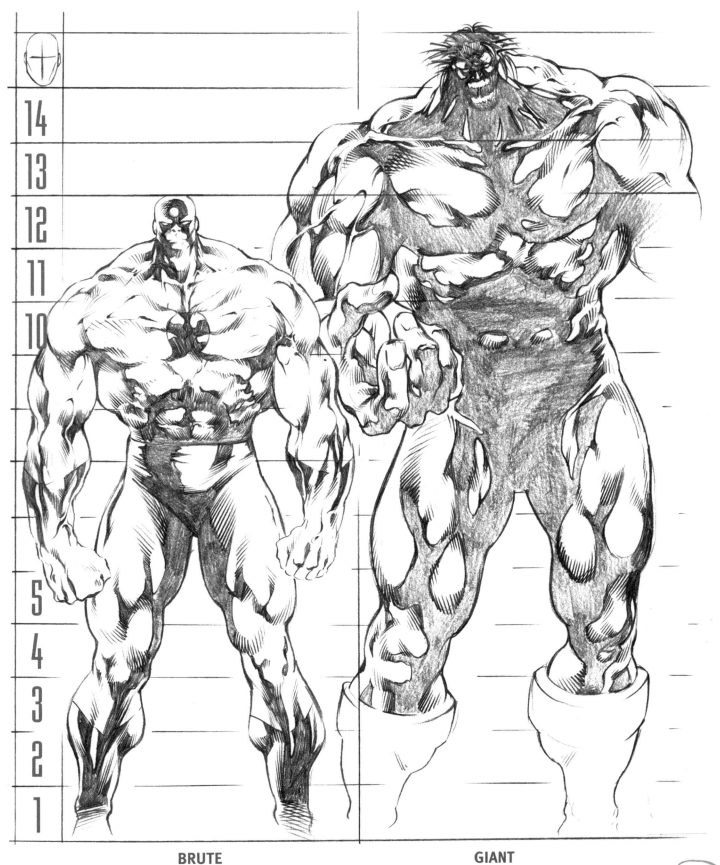

BRUTE

GIANT

BODY SHAPES: MEN . . .

In addition to age and height, body type also creates and defines specific characters. While there are some normal-looking figures in cutting-edge comics, note that the Hero, the Brute, and the Villain are all just that much more pumped up. That's what makes them cutting edge.

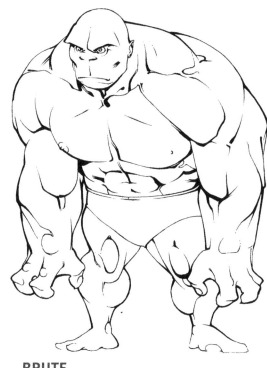

REGULAR JOE

He's not an action hero, just your typical guy. He's the type who transforms into an action hero or plays the confidant. No great muscles or definition. Slightly taller than average.

FAT GUY

Heavy people are often stereotyped as jolly; but in comics, they can play the villain, as well, working off the gluttonous angle.

BRUTE

He has a thick, massive body with apelike posture. His arms are much longer than they should be, and his legs are shorter. His head should look pasted onto his body. And leave out the neck; this gives him a hunched posture, which is good for brutish characters.

EVIL GENIUS

He's skinny, but with small, defined muscles. This gives him a crafty look. His posture is usually poor, with a sunken chest—a sure sign of comic book villainy. On skinny characters like this, the ribs stick out, but not the muscles of the ribs.

HERO

This is a V-shaped body, proud and showy. All the muscles pop.

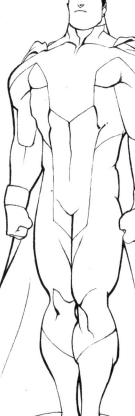

VILLAIN

Slightly more powerfully built than the hero (making for dramatic fight scenes), the villain is, however, not quite as graceful. He's got a thicker, less athletic build.

With male comics characters, you can mold their bodies into many different shapes, producing a wide range of cool characters. It's not so easy with women. Women in comics are, by and large, attractive—even the villains. Especially the villains! The Voluptuous Vixen and the Villainess are much more attractive in cutting-edge comics. So, you have less latitude in altering the body. You can't draw brutish women or you'll lose the attractiveness. Therefore, the changes rely less on body types and more on pose, costume, and attitude.

FIGHTER

She has a sturdy stance, muscular arms, and large shoulders—and is somewhat defined overall.

VOLUPTUOUS VIXEN

She possesses a large chest, slender waist, and wide hips. Her shoulders are softer than the Fighter and her arms are thinner.

ATHLETE

She often has the superpower of speed. She's small but strong, with lean, defined muscles.

GIRL NEXT DOOR

There's nothing out of proportion on her body—no exaggerated areas that make a bold statement.

VILLAINESS

She stands with an attitude of defiance and disdain. She's sharp not soft, wearing a lot of black and a severe costume.

THE INNOCENT

Smaller than the rest. Diminutive (with a cute haircut), thin, and not overtly sexy. She's a neat and proper dresser.

BODY LANGUAGE

The whole point of comics is to visually express emotions. If you're only doing that with the face, then you're missing a lot of opportunities. When you feel an emotion strongly, you feel it throughout your whole body, and your body reflects that emotion. In comics, the characters thrive on intense feelings, which means that their emotions *must* translate to the whole body. Work the body; make it communicate. Reveal the emotions in the posture.

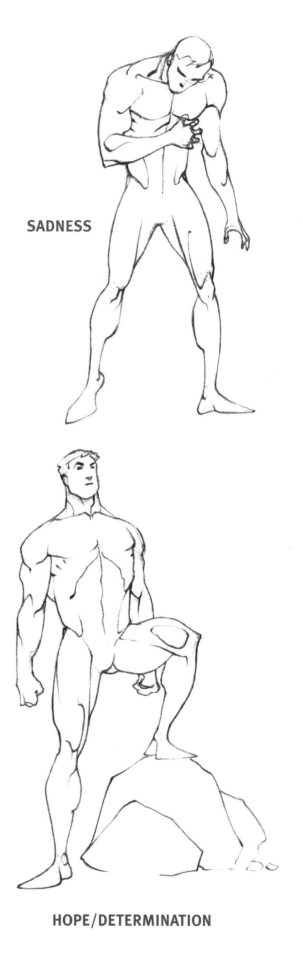

SADNESS

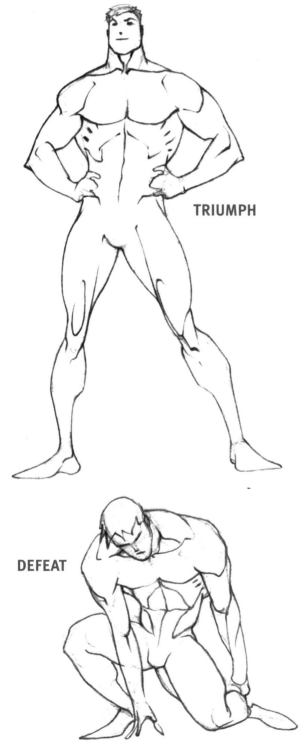

TRIUMPH

DEFEAT

HOPE/DETERMINATION

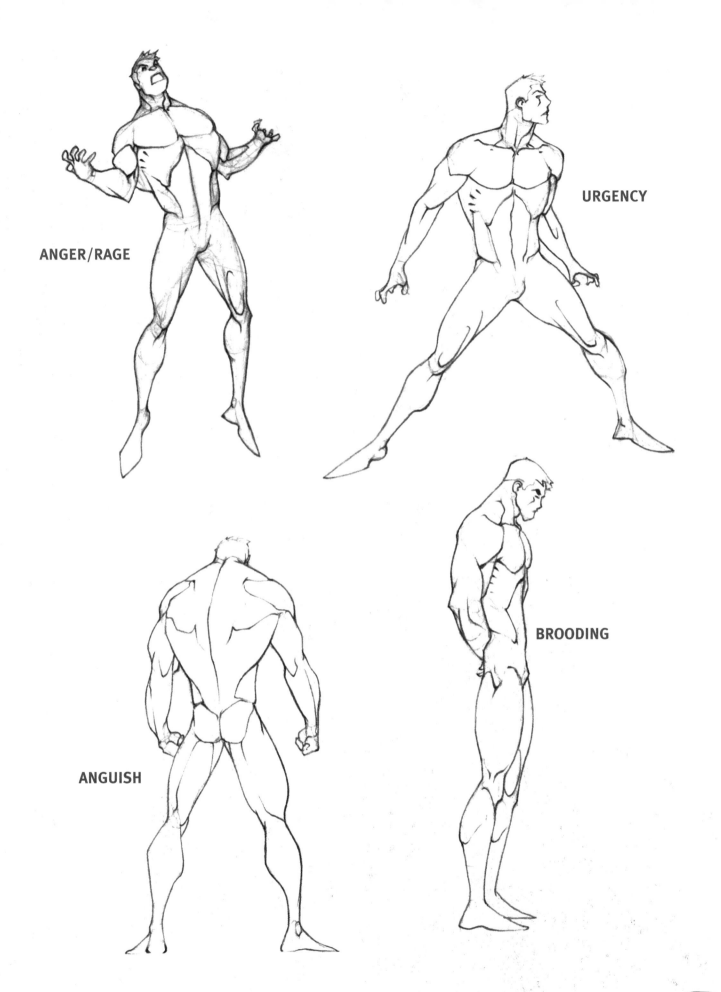

ANGER/RAGE

URGENCY

ANGUISH

BROODING

21

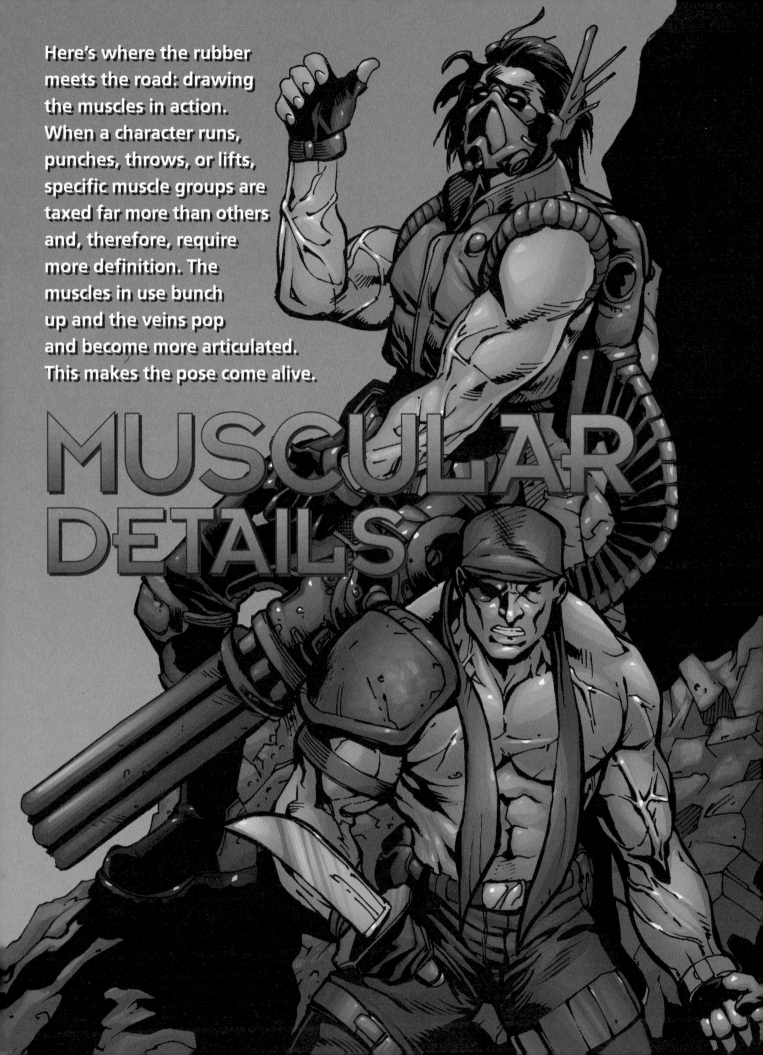

Here's where the rubber meets the road: drawing the muscles in action. When a character runs, punches, throws, or lifts, specific muscle groups are taxed far more than others and, therefore, require more definition. The muscles in use bunch up and the veins pop and become more articulated. This makes the pose come alive.

MUSCULAR DETAILS

THE PRIMARY MUSCLES IN ACTION

When a muscle is used, it is either flexed or stretched. Give those muscles added definition and, sometimes, added size. Although the muscles work in unison, not all muscle groups are used for every action. This means that although many secondary muscles may be working, we're more concerned with the primary muscles—the largest muscles under the most strain. In each of the poses here, the primary muscles in action are shaded with stripes.

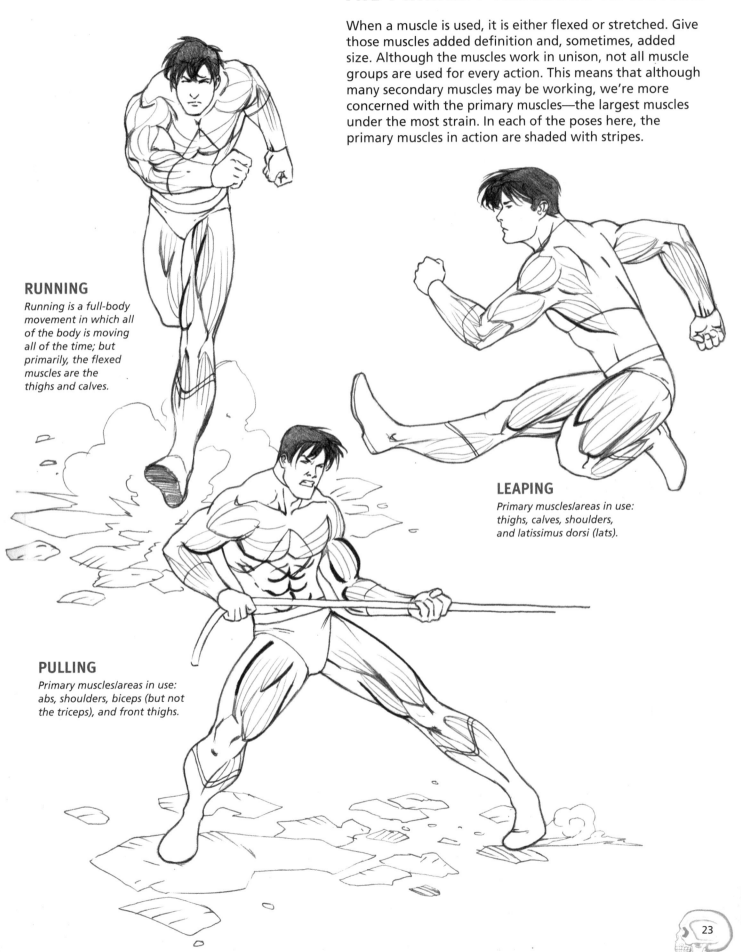

RUNNING

Running is a full-body movement in which all of the body is moving all of the time; but primarily, the flexed muscles are the thighs and calves.

LEAPING

Primary muscles/areas in use: thighs, calves, shoulders, and latissimus dorsi (lats).

PULLING

Primary muscles/areas in use: abs, shoulders, biceps (but not the triceps), and front thighs.

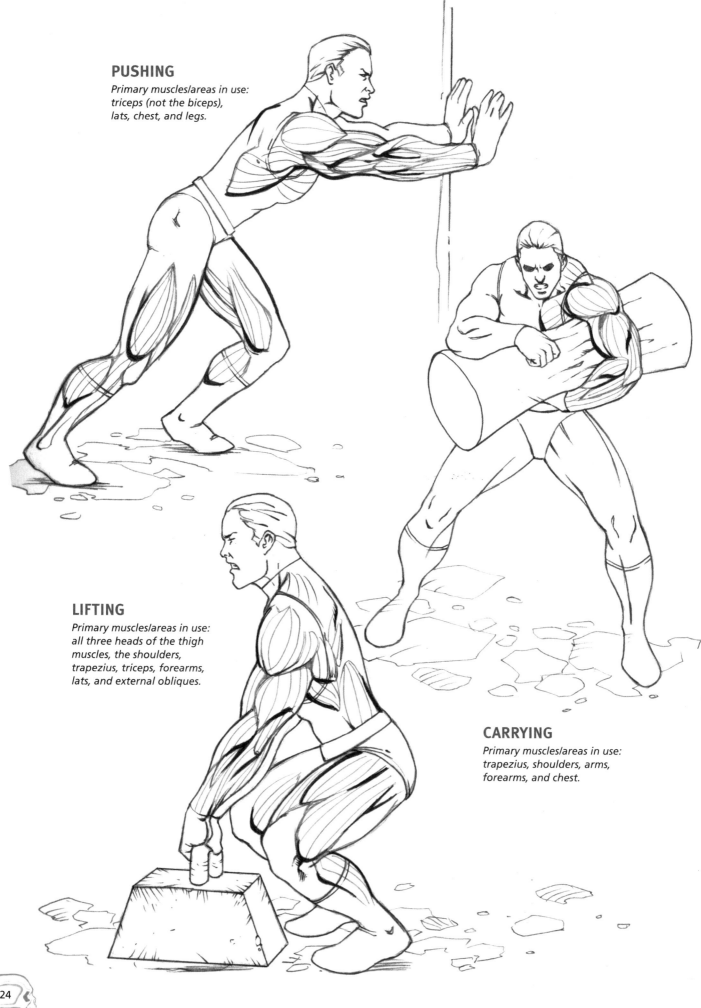

PUSHING

Primary muscles/areas in use: triceps (not the biceps), lats, chest, and legs.

LIFTING

Primary muscles/areas in use: all three heads of the thigh muscles, the shoulders, trapezius, triceps, forearms, lats, and external obliques.

CARRYING

Primary muscles/areas in use: trapezius, shoulders, arms, forearms, and chest.

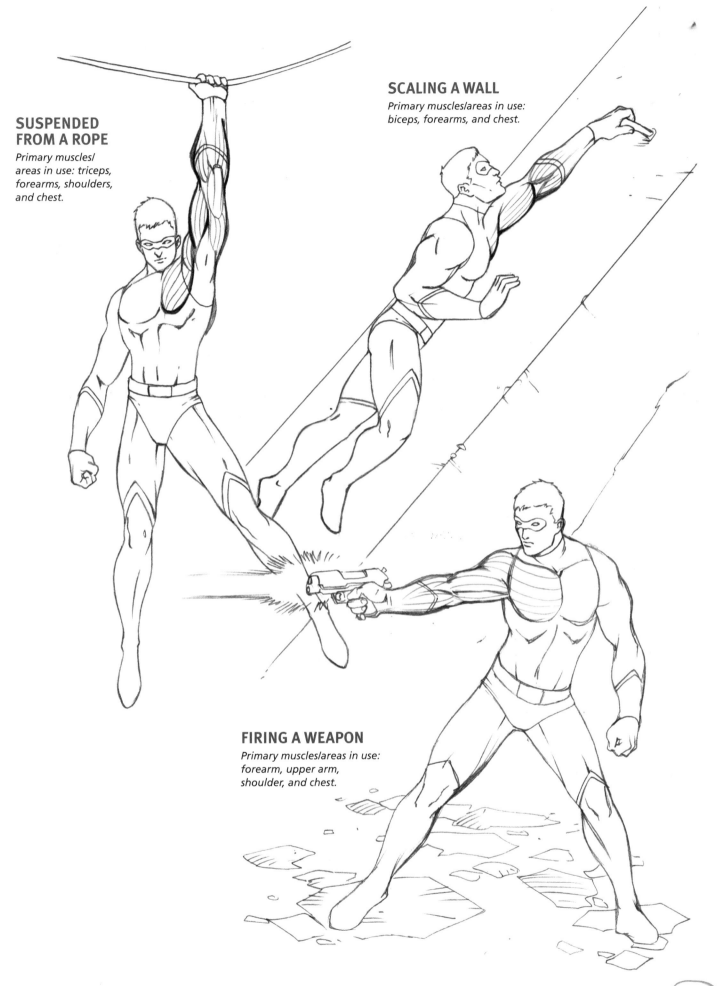

SUSPENDED FROM A ROPE

Primary muscles/ areas in use: triceps, forearms, shoulders, and chest.

SCALING A WALL

Primary muscles/areas in use: biceps, forearms, and chest.

FIRING A WEAPON

Primary muscles/areas in use: forearm, upper arm, shoulder, and chest.

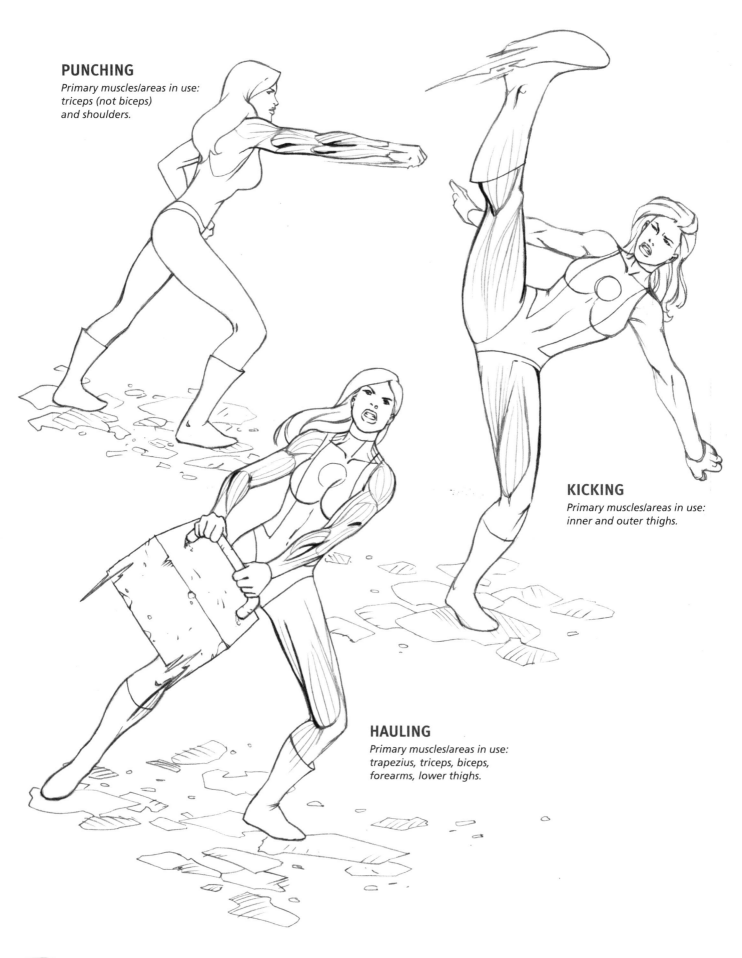

PUNCHING
Primary muscles/areas in use: triceps (not biceps) and shoulders.

KICKING
Primary muscles/areas in use: inner and outer thighs.

HAULING
Primary muscles/areas in use: trapezius, triceps, biceps, forearms, lower thighs.

EXTREME BULK

The more muscles your character has, the more impressive he or she will be. But you can't just inflate the muscles as if they were balloons. You have to fill out and adjust the frame for the greater mass. In addition to getting larger, the muscles must also become more defined and must separate more clearly into individual muscle groups. Here are the four stages of muscularity.

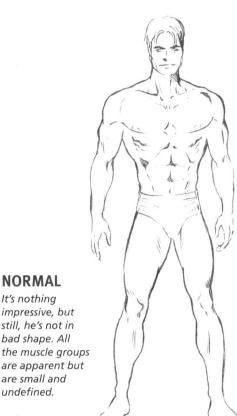

NORMAL

It's nothing impressive, but still, he's not in bad shape. All the muscle groups are apparent but are small and undefined.

BUILT UP

His muscles are pumped. The chest and abs have developed into powerful muscles. The trapezius now takes on more thickness. The shoulders broaden, and the biceps are large. The thighs curve outward due to the size of the quadriceps (the front thigh muscles).

INTIMIDATING

At this stage, all the muscles are "bunching," meaning they're in a constant state of flexing, giving each muscle group a sculpted look. This is the standard for cutting-edge comics. Note that joints like the knee and the elbow never increase in size. Therefore, they serve to highlight the size of the thigh and arm muscles by way of contrast.

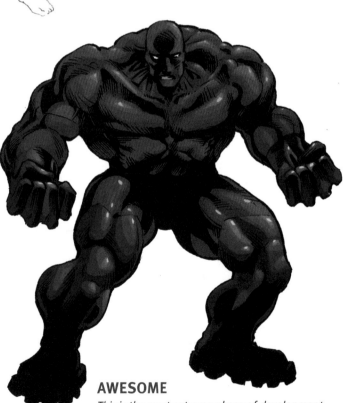

AWESOME

This is the most extreme phase of development, when the character's very framework as been warped by hypermuscularity. Note how the head sinks into the mass that is the trapezius muscle. The shoulders look like melons, almost detached from the body's frame. Smaller muscles, like those of the calf, suddenly balloon up to a gigantic size.

EXTREME VEINS

Supervascularity is a popular look in cutting-edge comics. But it's also an *accurate* look for heavily muscled, defined figures. The veins are pushed outward by the muscles, which gives the character an extreme and powerful look. This vascular chart shows where the veins and arteries concentrate throughout the body. This is not a literal representation of the actual veins; it's meant to reflect how veins are drawn in comic book art.

It's only important to note where the concentration of veins is the greatest: the neck, arms, outer chest, and legs. Notice how they weave in and out, attaching to one another, creating patterns, and feeding off of the larger main arteries. Also, note that veins are not confined to a particular muscle group; they can cross over several completely different muscle groups.

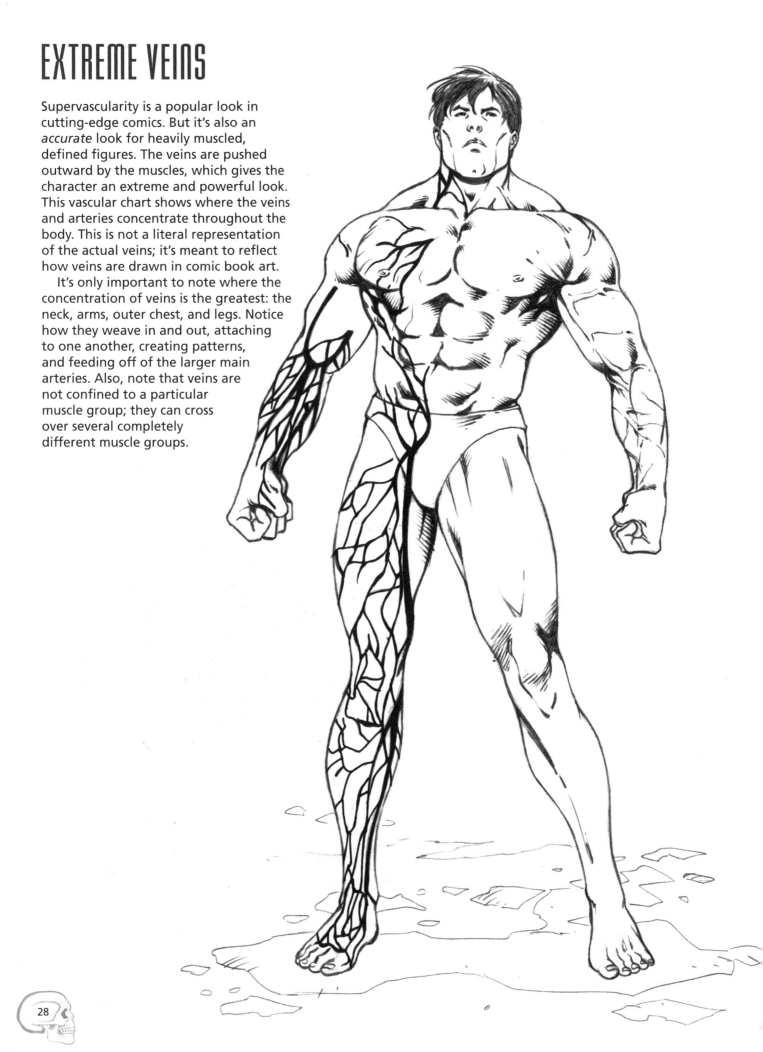

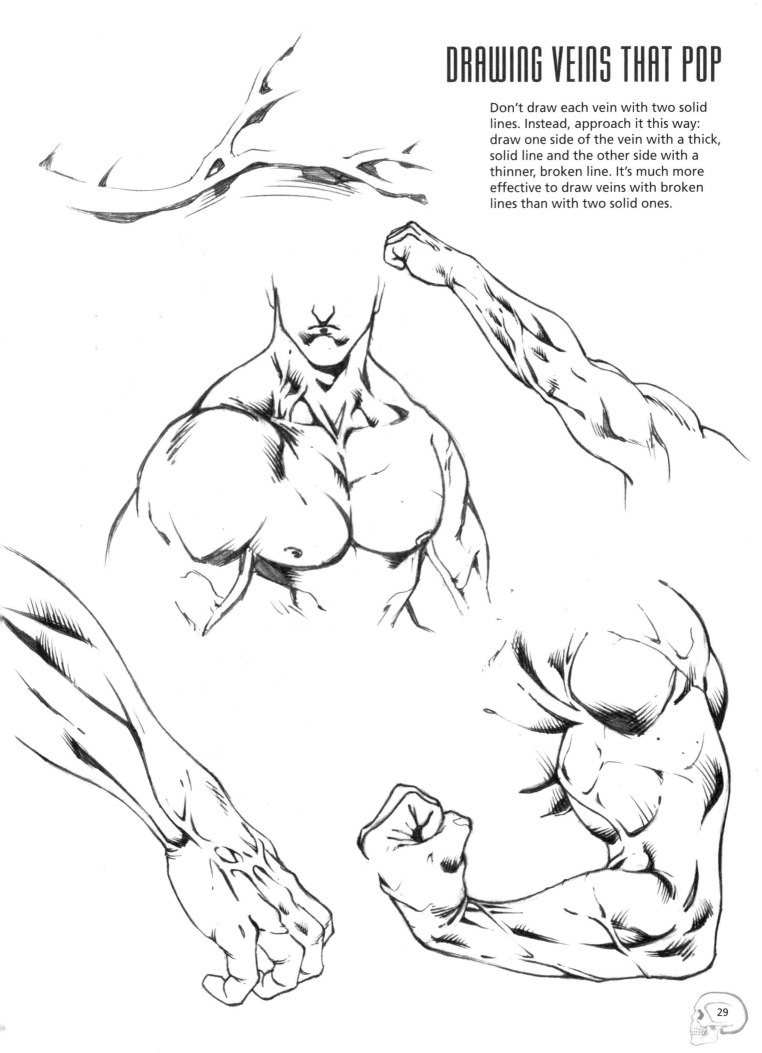

DRAWING VEINS THAT POP

Don't draw each vein with two solid lines. Instead, approach it this way: draw one side of the vein with a thick, solid line and the other side with a thinner, broken line. It's much more effective to draw veins with broken lines than with two solid ones.

PRIME LOCATIONS FOR SUPERVASCULARITY

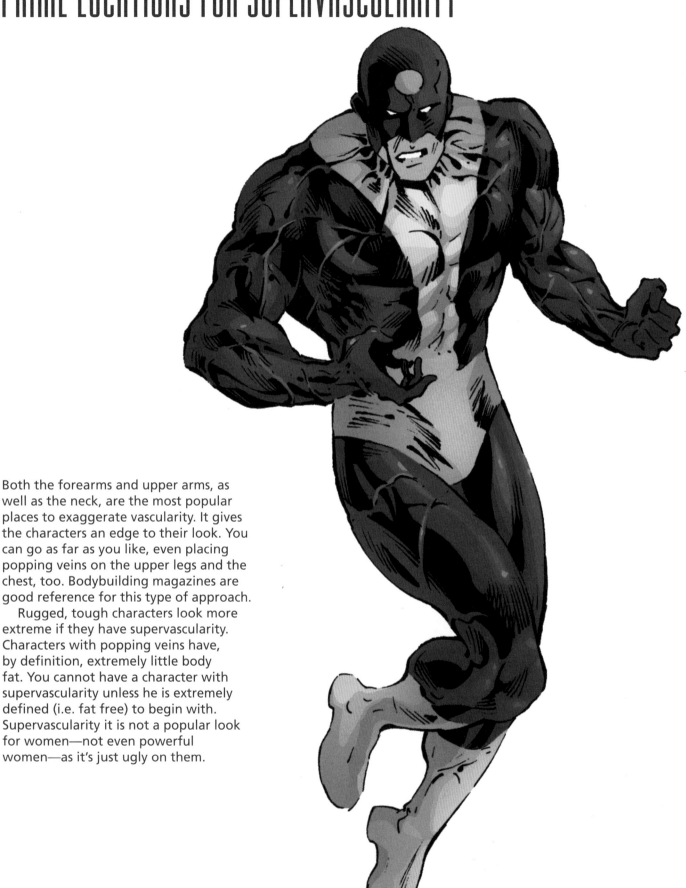

Both the forearms and upper arms, as well as the neck, are the most popular places to exaggerate vascularity. It gives the characters an edge to their look. You can go as far as you like, even placing popping veins on the upper legs and the chest, too. Bodybuilding magazines are good reference for this type of approach.

Rugged, tough characters look more extreme if they have supervascularity. Characters with popping veins have, by definition, extremely little body fat. You cannot have a character with supervascularity unless he is extremely defined (i.e. fat free) to begin with. Supervascularity it is not a popular look for women—not even powerful women—as it's just ugly on them.

One common mistake that artists make is thinking only in terms of two dimensions when what they're drawing supposedly exists in three. To successfully draw the contours of the body, artists must convey a feeling of roundness to the shapes.

To do this, start by visualizing a net draped over your character that conforms to the shape of everything it touches. When you do this, you can see how the contours of the body—and not just the body's outlines—are made up of rounded shapes. When drawing the muscles, keep the idea of netting *around* the contours of the muscles in mind.

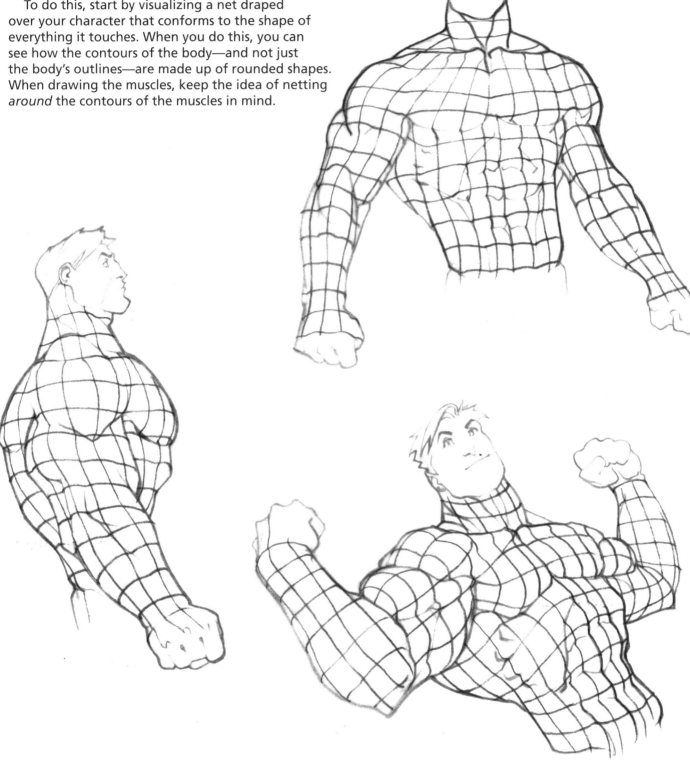

The concept of surface mapping can also help you in placing shadows and highlights. For example, notice on these female torsos how the horizontal lines of the surface map over the breasts curve slightly downward. This is the same direction that the highlights from a light source would follow. (See pages 34–35.)

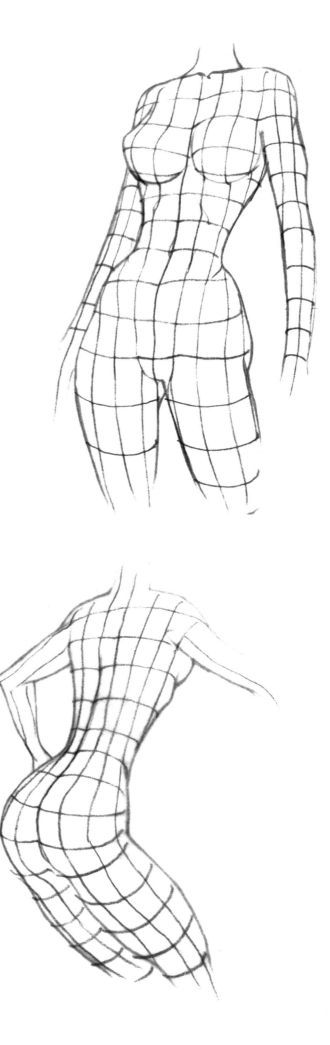

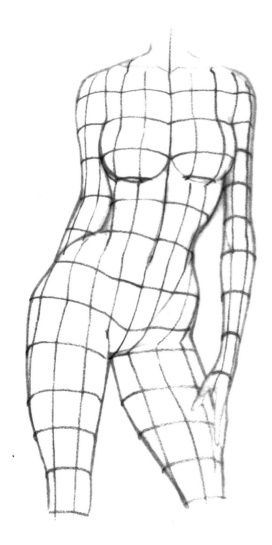

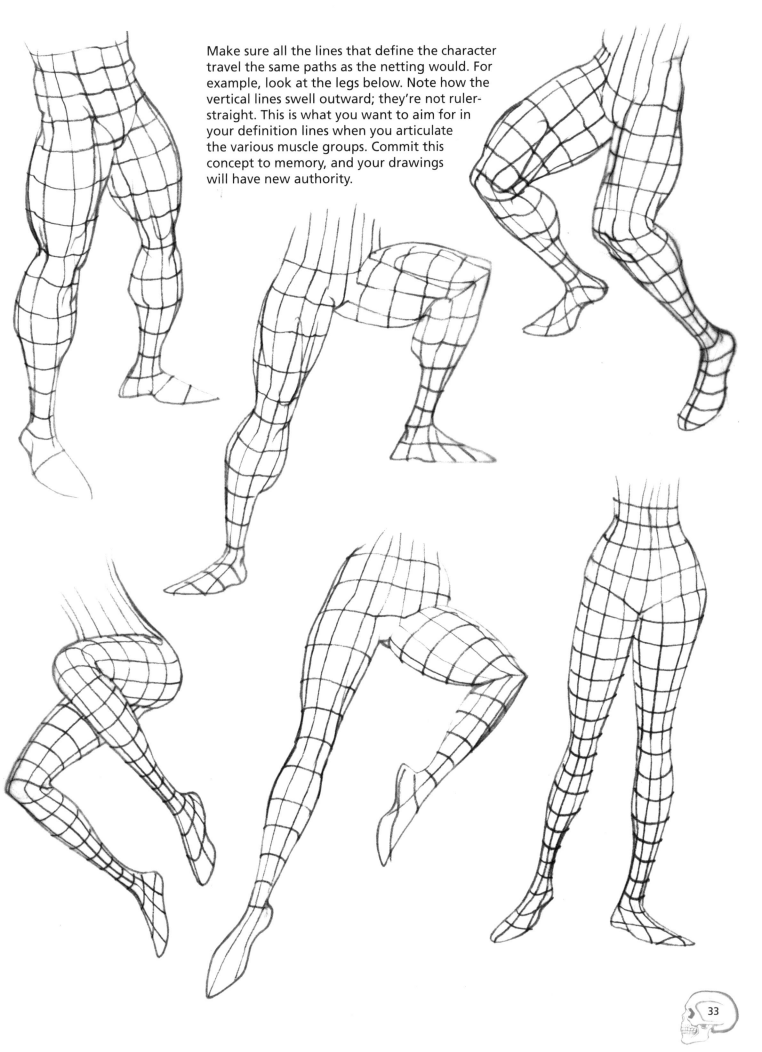

Make sure all the lines that define the character travel the same paths as the netting would. For example, look at the legs below. Note how the vertical lines swell outward; they're not ruler-straight. This is what you want to aim for in your definition lines when you articulate the various muscle groups. Commit this concept to memory, and your drawings will have new authority.

THE EFFECTS OF LIGHT ON THE BODY

When you shine a light on a character, shadows result. And, it's these shadow that add the drama to an image, not the light itself. Shadows add a cool look and a sharper edge. They highlight the contours of the body. And when you have a good-looking character with a killer body, that certainly doesn't hurt.

The typical approach is to think of a light source as coming from above. And that's usually the case, in the form of sunlight or interior overhead lighting. But to create more dramatic shadows, you must introduce more light sources. In addition, sometimes varying the intensity of the light sources achieves a moody effect.

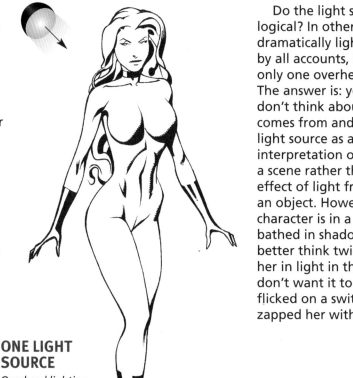

Do the light sources have to be logical? In other words, can you dramatically light someone who, by all accounts, is in a room with only one overhead light source? The answer is: yes, usually. Readers don't think about where the light comes from and will accept the light source as a figurative interpretation of the emotions of a scene rather than as the literal effect of light from a bulb hitting an object. However, if your character is in a darkened room, bathed in shadow in one panel, better think twice before you bathe her in light in the next one. You don't want it to look like someone flicked on a switch and suddenly zapped her with floods.

ONE LIGHT SOURCE

Overhead lighting creates nice shadows on the undersides of shapes. It's a plain but appealing look.

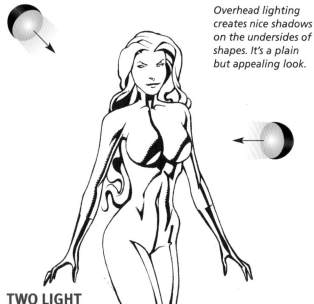

TWO LIGHT SOURCES

The major lighting is still coming from overhead, but there's also a nice, minor light source coming from the right that illuminates the right edge of the figure. It shows off her curves even more, which is an effect that you can put to good use on attractive characters.

TWO OPPOSING LIGHT SOURCES

With one light source on the left and a second one on the right directly opposite the first, the middle of the figure is bathed in shadow, giving the character intensity.

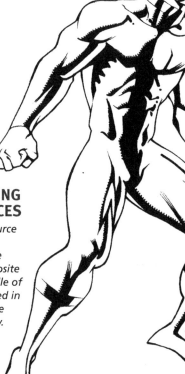

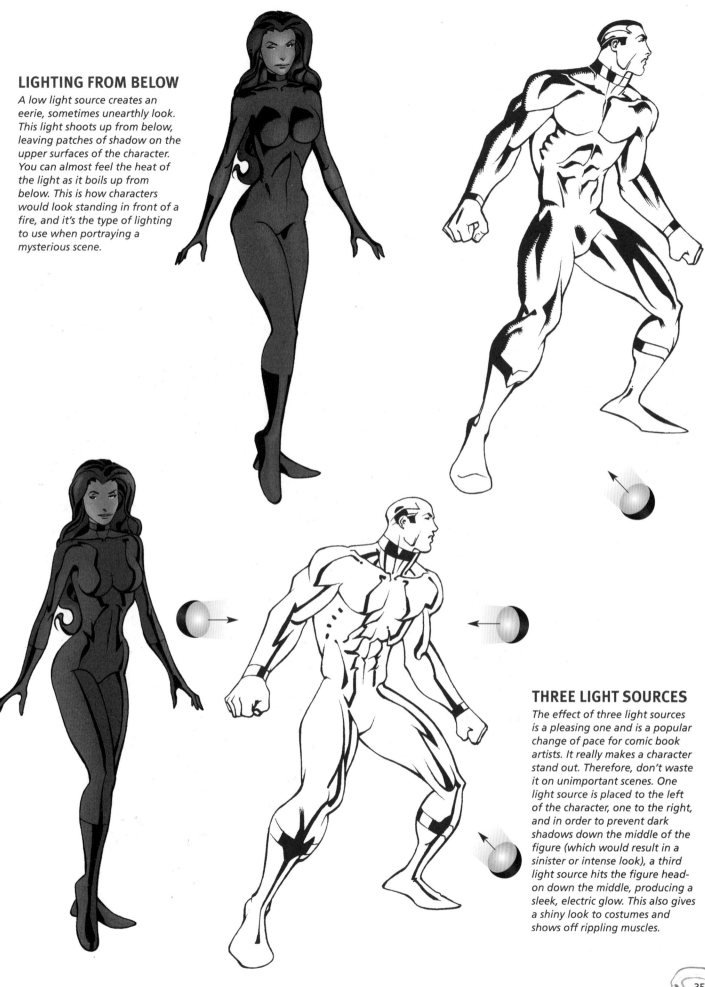

LIGHTING FROM BELOW

A low light source creates an eerie, sometimes unearthly look. This light shoots up from below, leaving patches of shadow on the upper surfaces of the character. You can almost feel the heat of the light as it boils up from below. This is how characters would look standing in front of a fire, and it's the type of lighting to use when portraying a mysterious scene.

THREE LIGHT SOURCES

The effect of three light sources is a pleasing one and is a popular change of pace for comic book artists. It really makes a character stand out. Therefore, don't waste it on unimportant scenes. One light source is placed to the left of the character, one to the right, and in order to prevent dark shadows down the middle of the figure (which would result in a sinister or intense look), a third light source hits the figure head-on down the middle, producing a sleek, electric glow. This also gives a shiny look to costumes and shows off rippling muscles.

THE HEAD AND NECK

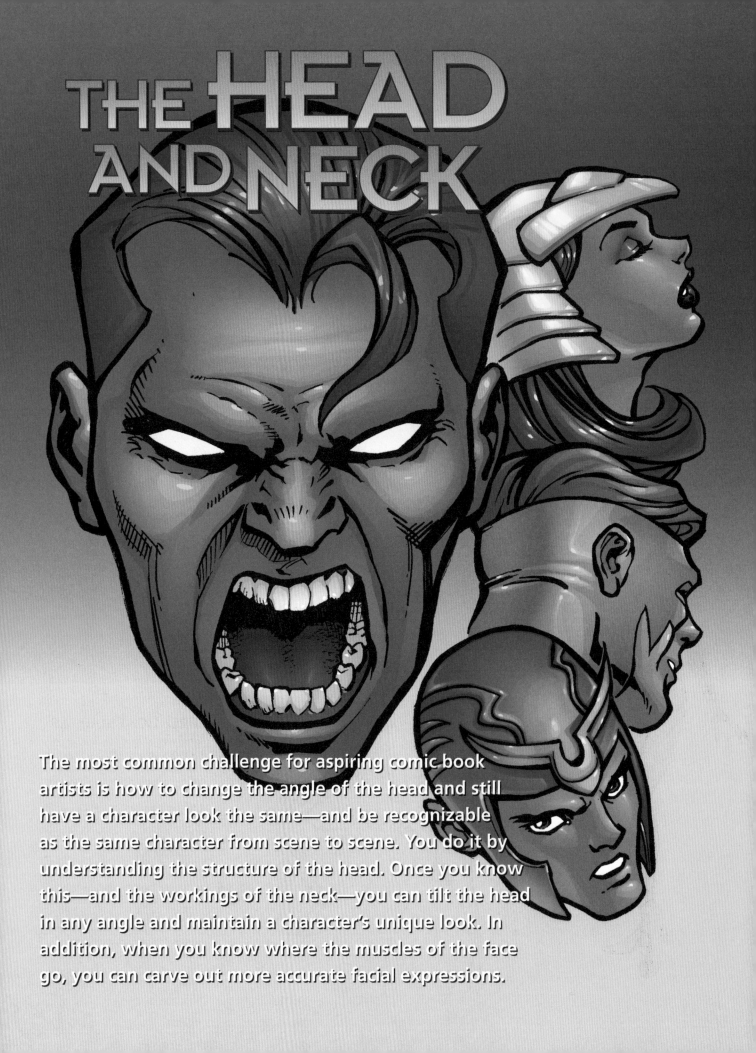

The most common challenge for aspiring comic book artists is how to change the angle of the head and still have a character look the same—and be recognizable as the same character from scene to scene. You do it by understanding the structure of the head. Once you know this—and the workings of the neck—you can tilt the head in any angle and maintain a character's unique look. In addition, when you know where the muscles of the face go, you can carve out more accurate facial expressions.

THE SKULL

Here it is: the blueprint. It all starts with the skull. All the contours of the face are greatly affected by the contours of the skull. The lines formed by the protruding cheekbones, jaw, and chin all have their foundations in the underlying skull.

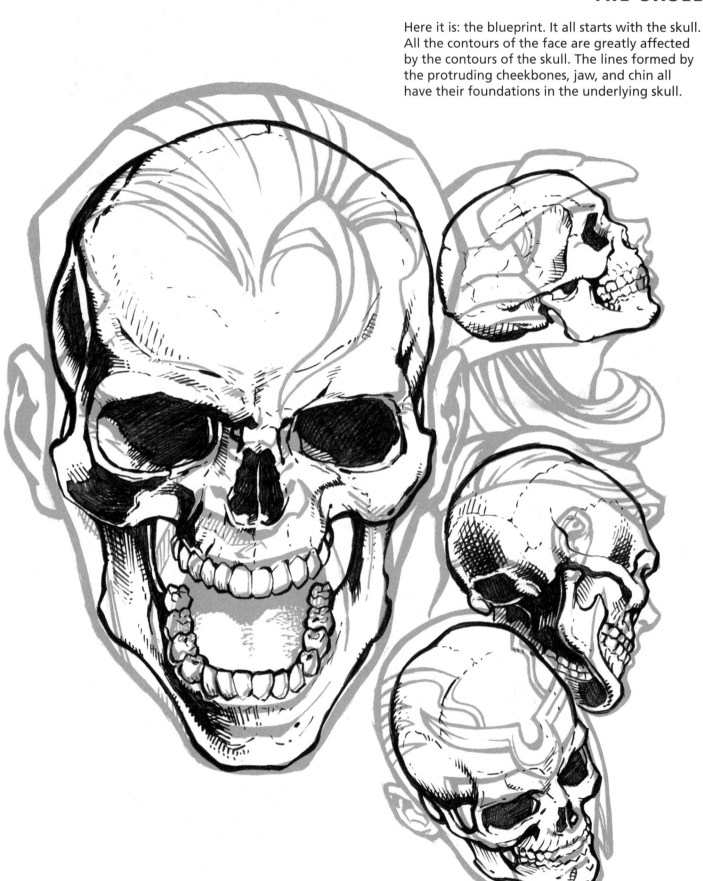

THE MUSCLES OF THE FACE

The face has many thin muscles that stretch and wrap around it. It's especially important for comic book artists to take note of the muscles that connect the cheekbones to the mouth; these are what give cool comic book characters a sleek, drawn look. Don't worry about the muscle names here; just try to familiarize yourself with the basic structure and placement of the facial muscles.

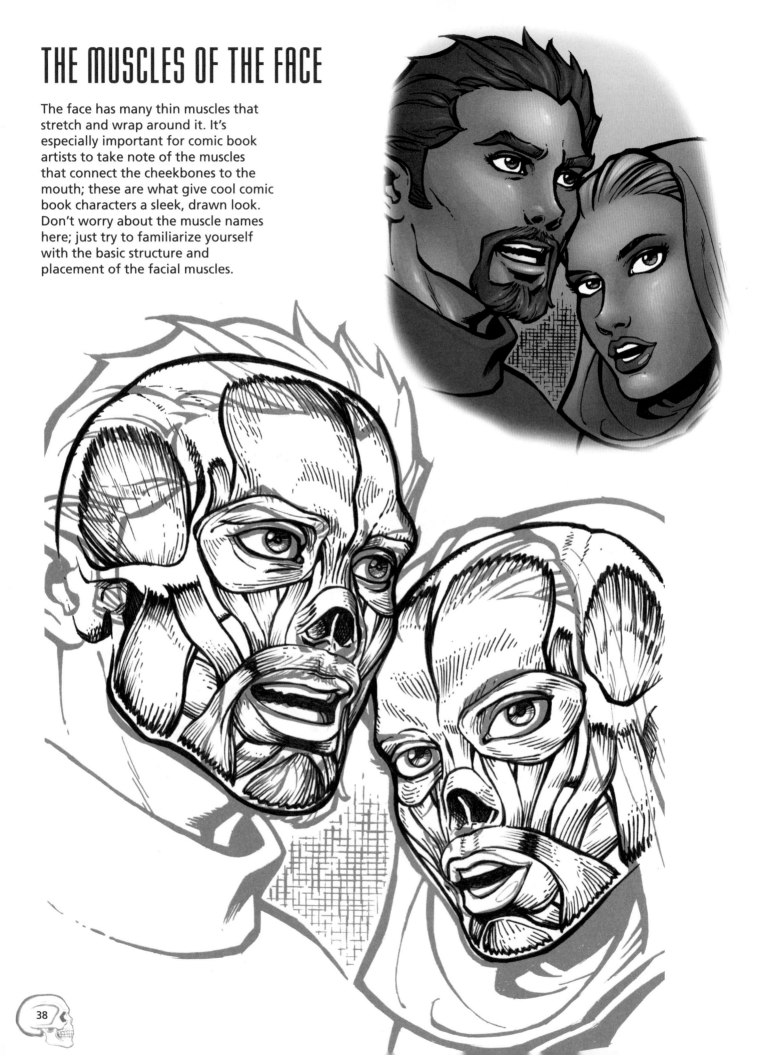

When focusing on the details of the human body, the first order of business is the most important feature of the face: the eyes. Eyes can make a character look beautiful, seductive, evil, insane, charismatic, or determined. Well-drawn eyes give characters that extra sparkle that makes them memorable.

Remember that the eye is a three-dimensional sphere inside the head. The eyelid is tugged over it. It's this stretching of the eyelid that creates the almond-shaped look of the eye. The upper eyelid slants down severely near the tear duct. Both upper and lower eyelids have thickness, so each is drawn as a double line, or with one thick black line to indicate lashes. The lashes become thicker toward the outer edge of the eye.

The eyebrow is drawn on an arch that dips at both ends. Try practicing the eyes on this page. The various angles and expressions will give you a greater understanding of the form.

1 UPPER EYELID
2 PUPIL
3 IRIS
4 LOWER EYELID
5 WHITE

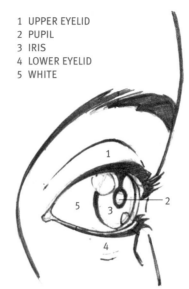

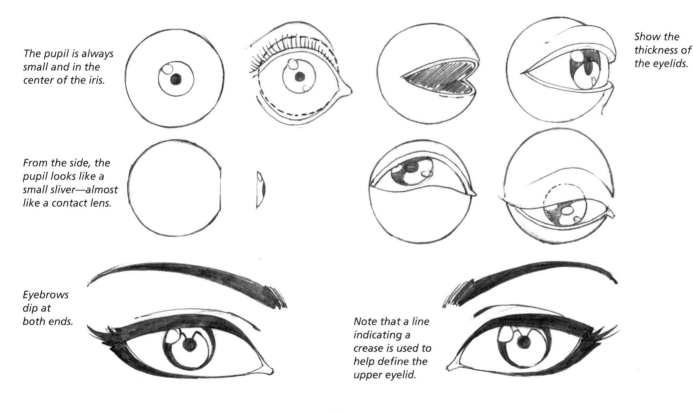

The pupil is always small and in the center of the iris.

From the side, the pupil looks like a small sliver—almost like a contact lens.

Show the thickness of the eyelids.

Eyebrows dip at both ends.

Note that a line indicating a crease is used to help define the upper eyelid.

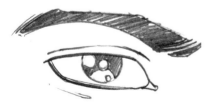

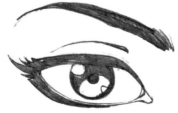

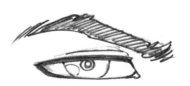

The lower eyelid has either a very light crease or no crease below it. A pronounced crease here would make your character look tired.

The iris (the colored part of the eye) often has more than one shine in it. Don't put a shine in the middle of the pupil; make it off-center so that it bleeds into the iris. You can add a shine to the white of the eye, too, but it's not as effective.

You can have the pupil touch the top eyelid to mimic the shadow that the eyelid casts onto the eye. This creates a pleasing look.

MALE EYES VS. FEMALE EYES

The male eye is narrower and more rectangular, whereas the female eye is more tear shaped. Draw the male upper eyelid with a heavy line but the lower eyelid with a thin one. Both eyelids on the female eye are drawn with heavy lines.

It's sometimes thought—erroneously—that thick eyebrows are only for men. But fuller eyebrows are great for drawing attractive women, too. Some famous models, such as Cindy Crawford and Brooke Shields, have fuller eyebrows, which draw attention to the eyes and can underscore a sultry look. Pencil-thin eyebrows have little impact.

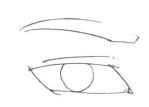 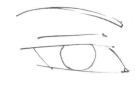 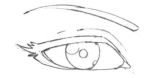 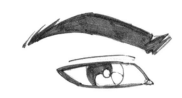

MALE

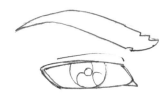 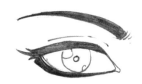

FEMALE

FEMALE LASH CONSTRUCTION

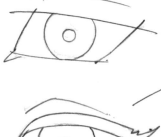

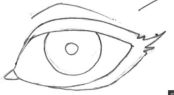

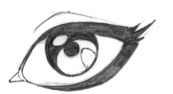

Women's eyelashes are grouped together in a thick line; if you draw each individual lash, the result will look spidery.

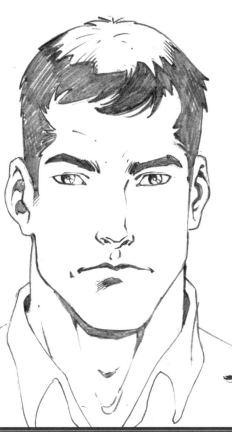

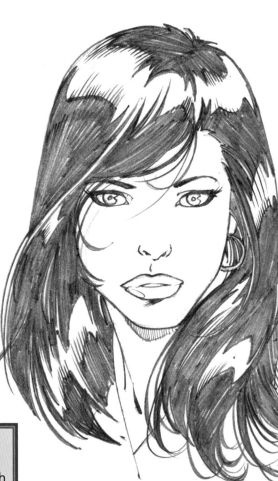

IMPORTANT EYE TIP

Whether you're drawing men's eyes or women's eyes, the top eyelid should touch or cover part of the iris. Don't leave any white space between the upper eyelid and the iris—unless it's for a specific expression, such as shock or surprise.

The shape of the eye changes as the head moves and tilts in different directions. Take a look at these examples to see how the movement and position of the head affects the shape of the eyes.

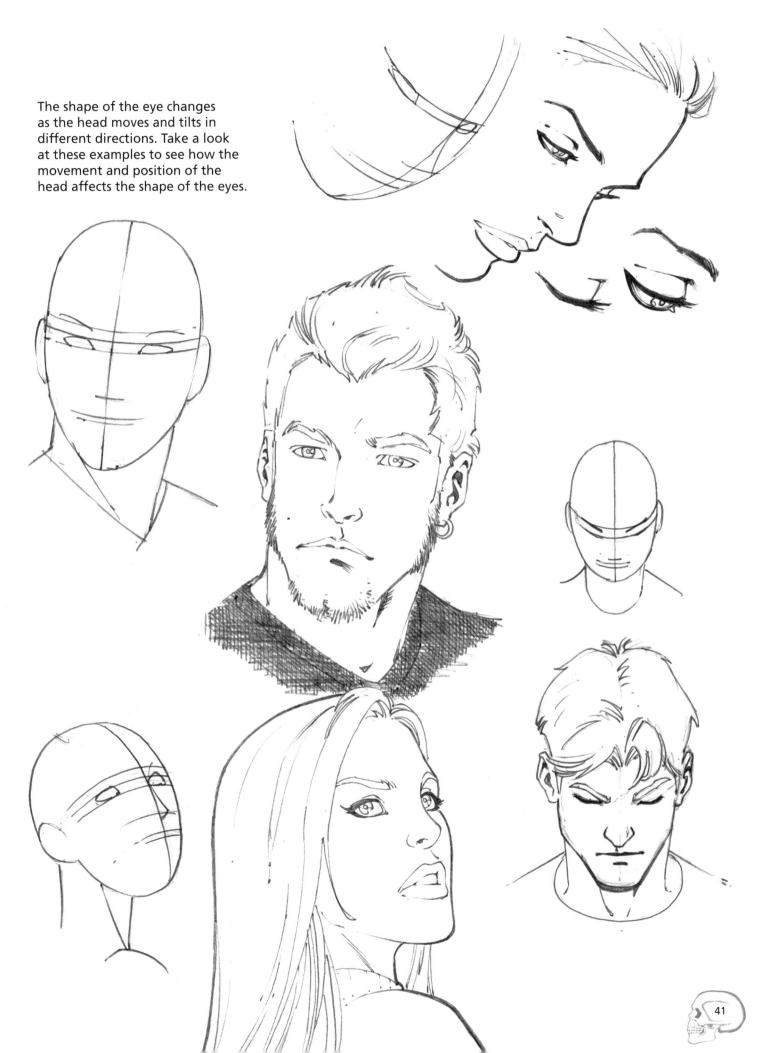

THE TYPICAL MALE HEAD

Some anatomy books start with an egg shape for the head. I want to be kind, but what can I say except, I don't suggest it. Look at this guy's head. Does it look like an egg to you? So, why start with an egg? The jaw is sleek and angular, the chin square.

Additionally, artists draw horizontal and vertical lines across the head as guidelines to help place the features evenly. You don't want one eye lower than the other. So, it's good practice. Note that the horizontal guidelines *curve around the head*, and are not—I repeat, *not*—drawn as straight lines. Additionally here are quick guides to check your proportions: The overall head width is five eyes across. The eyes fall midway down the head. The width of the bottom of the nose is equal to the space between the two eyes. The tops of the ears are even with the eyebrows (but you can't see the ears in this image). The bottoms of the ears are even with the bottom of the nose. The width of the mouth when it's at rest matches the amount of space between the pupils.

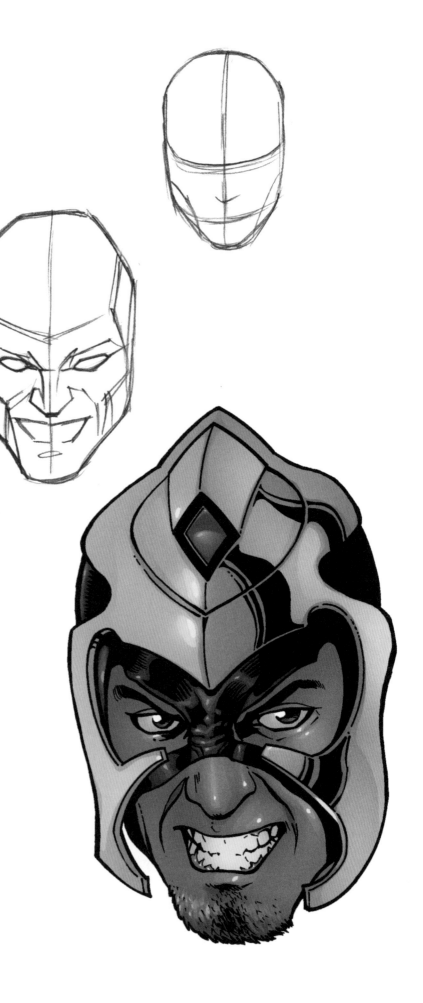

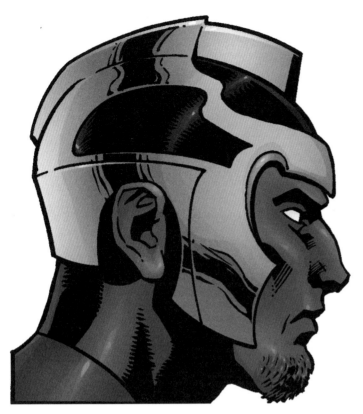

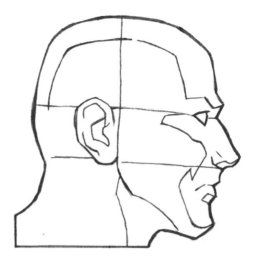

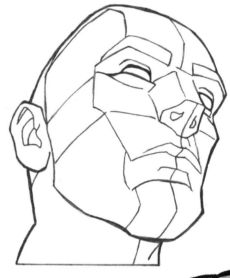

PROFILE

Drawing the eyes out of proportion is a common mistake that can immediately ruin a good drawing. In profile, the eye is even with or slightly *below* the bridge of the nose. Many people put it above the bridge and can't figure out what's wrong with their drawings. They adjust the eyebrow, the nose, the mouth. They wander the city streets at night, mumbling out loud, picking pencils out of garbage cans. Sometimes, the answer is as simple as adjusting the placement of the eye.

Note the thickness of the neck in both the profile and 3/4 views; if there's one thing most beginners get wrong, it's drawing too thin a neck.

3/4 VIEW—FROM BELOW

Ah, my favorite angle. It's fun to draw because you really feel like you're carving a sculpture on paper. Why is that? Because this view is three-dimensional. The front and side views are basically flat poses, but here we get a real sense of the roundness of the head.

The biggest pitfall to avoid if you're to lead a happy, fulfilled life is letting the features wander all over the face. And it's not easy. You no longer have the simple task of drawing the features in the center of the face, as you do in the front view. You don't have the luxury of placing all of the features on the edge of the face, as you do in the side view. So, what do you do? You draw a *centerline* vertically down the middle of the face from top to bottom (see construction drawing). This is a guideline that separates the left side of the face from the right. It curves with the angles of the face, as if you had laid a string over the head. Now you can go ahead and place the features on the centerline, and everything will line up.

43

THE TYPICAL FEMALE HEAD

The basic structure is the same as a man's head, but with a softer jawline and chin. All the proportions are the same, but the shapes of the individual features vary: The eyes are larger. The eyebrows arch up high over the eyes and drop near the bridge of the nose. (This severe angle gives her a sexy look.) The nose is smaller, and the lips are pouty.

The sultrier you want your female character, the lower her upper eyelid should fall over the iris. Here, her upper eyelid actually rests on the pupil, which is a very attractive look for a female character.

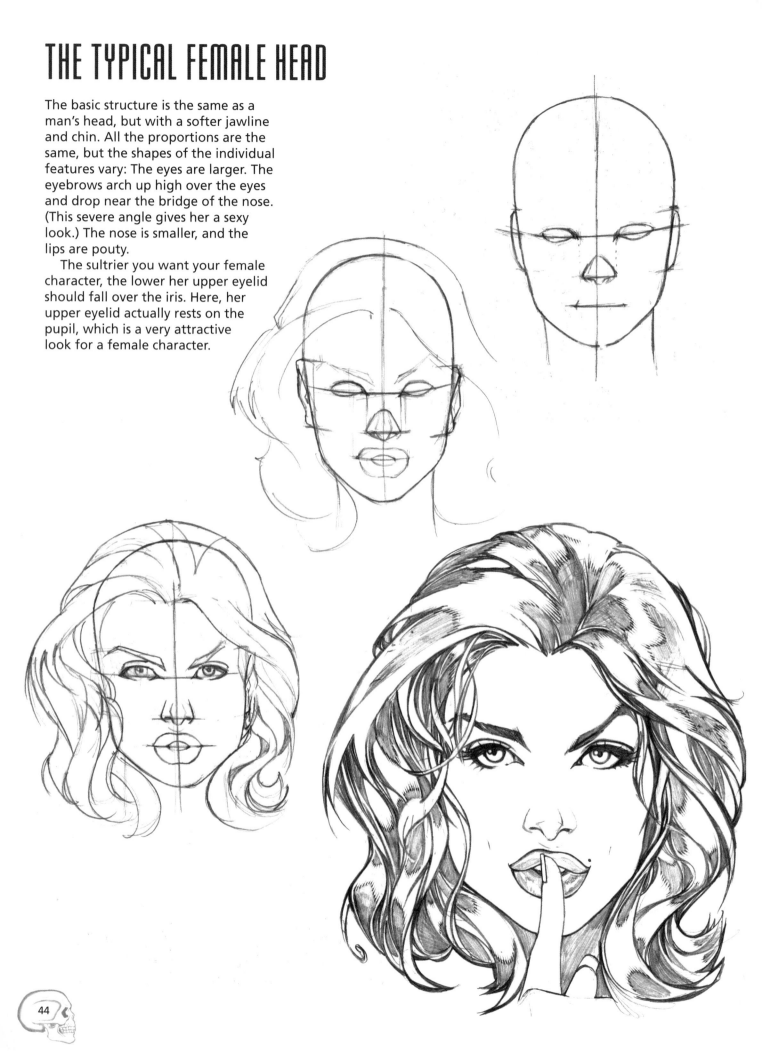

PROFILE

The main thing that gives artists trouble with the female profile is the mouth. In a side view and a relaxed pose, the mouth is quite short, extending only as far back as the nostrils. The lips are thickest at the front, creating a severe diagonal as they travel back.

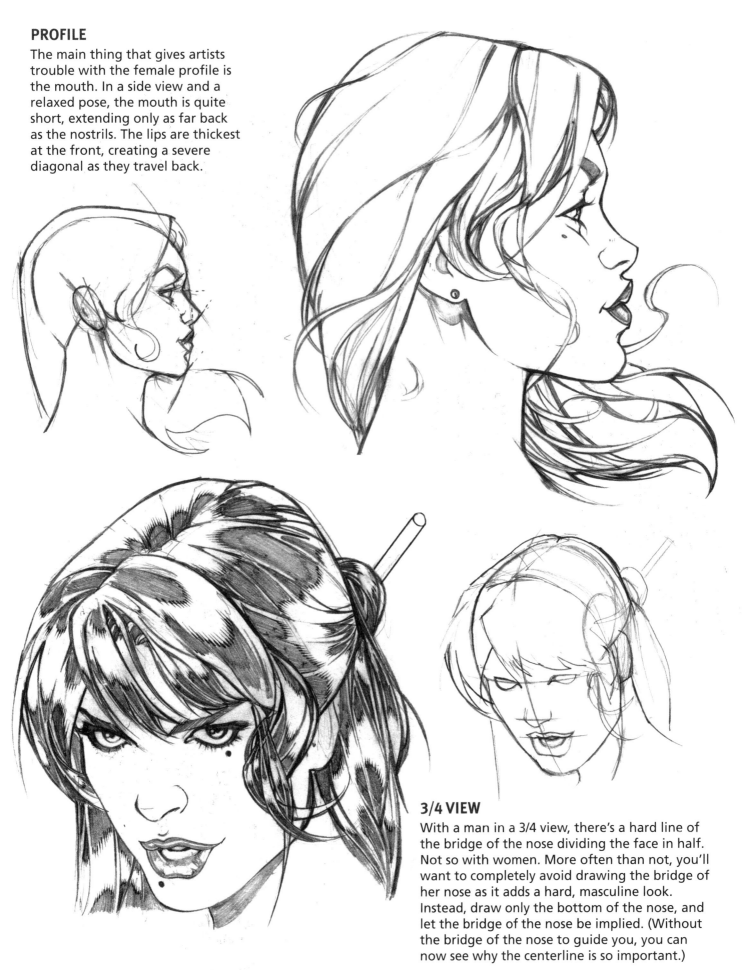

3/4 VIEW

With a man in a 3/4 view, there's a hard line of the bridge of the nose dividing the face in half. Not so with women. More often than not, you'll want to completely avoid drawing the bridge of her nose as it adds a hard, masculine look. Instead, draw only the bottom of the nose, and let the bridge of the nose be implied. (Without the bridge of the nose to guide you, you can now see why the centerline is so important.)

DROP-DEAD GORGEOUS HEAD TILTS

In general, a slight downward tilt of the head assists in creating appealing poses for women, as they must then look up from under their lashes—a seductive pose. The mouth is slightly opened (another seductive mannerism). Add a shine to the lips for a wet look. Sexy comic book women have pronounced cheekbones, not narrow faces. The severe angle of the eyebrows gives her a hungry look.

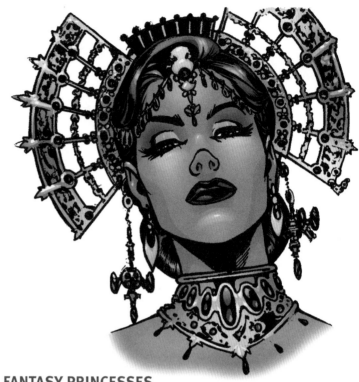

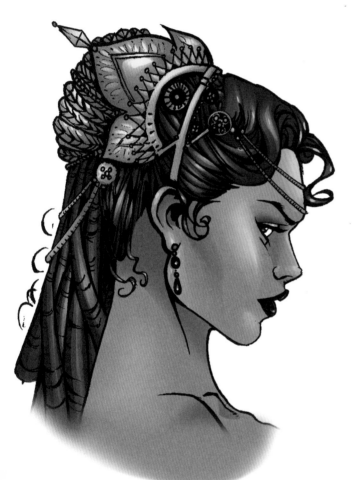

FANTASY PRINCESSES

Goddesses and princesses in comics are drawn with plenty of ornaments and a heavily worked hairstyle. Again, notice how the slight downward tilt of the head is an attractive look on the character to the left. In the image above, we are looking up at the character; therefore, we see the underside of the nose. This type of angle denotes a woman in a position of authority and power. Note: The eyelashes on these elegant characters can extend well beyond the eyes, which is especially evident in profile.

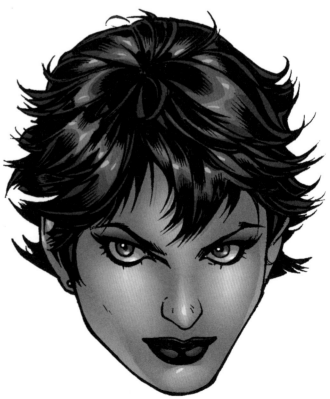

INTENSE BEAUTY

The more intense the character, the more windblown and ruffled the hair. The extra mascara treatment adds to the intensity. And, here's a little known hint to help you out: the closer the eyebrows are to the eyes, the more intense your female character will appear. And note the lip shines. The bottom lip shines separate the lip into two sections.

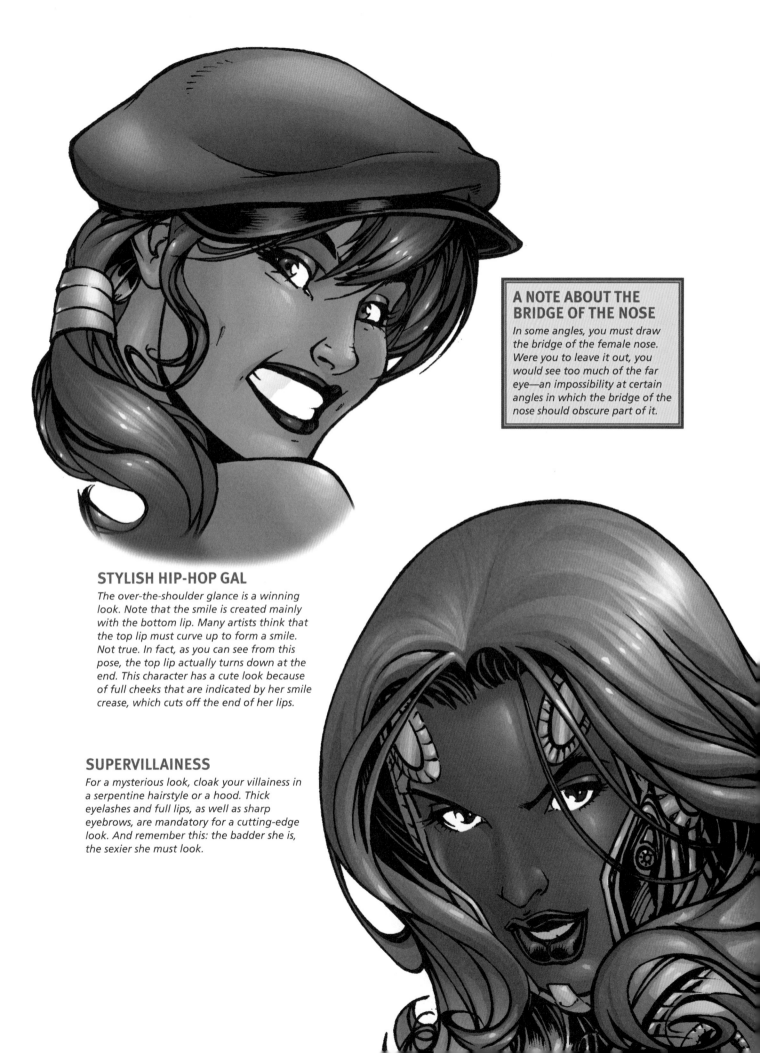

A NOTE ABOUT THE BRIDGE OF THE NOSE

In some angles, you must draw the bridge of the female nose. Were you to leave it out, you would see too much of the far eye—an impossibility at certain angles in which the bridge of the nose should obscure part of it.

STYLISH HIP-HOP GAL

The over-the-shoulder glance is a winning look. Note that the smile is created mainly with the bottom lip. Many artists think that the top lip must curve up to form a smile. Not true. In fact, as you can see from this pose, the top lip actually turns down at the end. This character has a cute look because of full cheeks that are indicated by her smile crease, which cuts off the end of her lips.

SUPERVILLAINESS

For a mysterious look, cloak your villainess in a serpentine hairstyle or a hood. Thick eyelashes and full lips, as well as sharp eyebrows, are mandatory for a cutting-edge look. And remember this: the badder she is, the sexier she must look.

DRAWING THE EARS

Ever wonder why you can draw noses and eyes, but have trouble with ears? It's because you never see the inside of your own ear when you look in the mirror. And, you don't see the inside of the ear when someone else faces you, either. You only see it when they turn to walk away, and then, only fleetingly. In other words, it's not your fault. You're not to blame. Stop beating yourself up about it. I think I've been watching too much Dr. Phil.

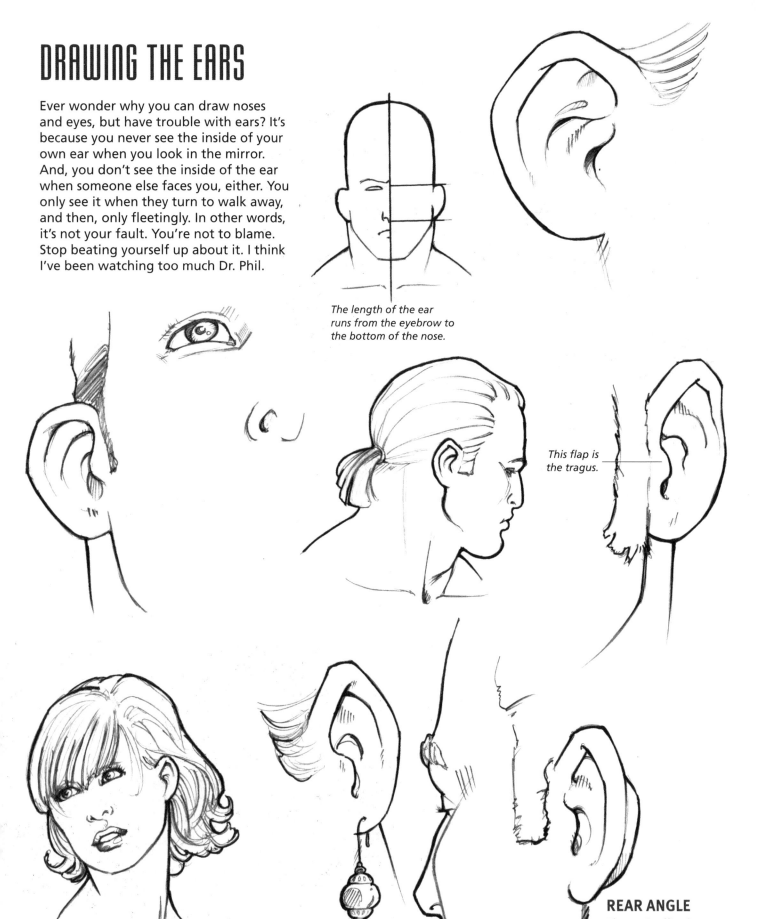

The length of the ear runs from the eyebrow to the bottom of the nose.

This flap is the tragus.

REAR ANGLE
The ear is affixed to the head with a half-cup shaped piece of cartilage, which you can only see from the rear.

At first glance, the neck looks like a web of small muscles that are impossibly complex and beyond the powers of mere mortals to comprehend. But as with all parts of the body, very few of the muscles actually show through to the surface of the skin—and we're only concerned with the muscles that do. The neck is no exception to this. So, what you really need to remember is the most important muscle of the neck. It's called— are you ready for this?—the sternocleidomastoideus. Say that five times fast. It occurs on both sides of the body and attaches to the pit of the neck, where the collarbones meet in the middle. Whichever way the head turns, the sternocleidomastoideus will always travel to the pit of the neck. Take a look at the examples.

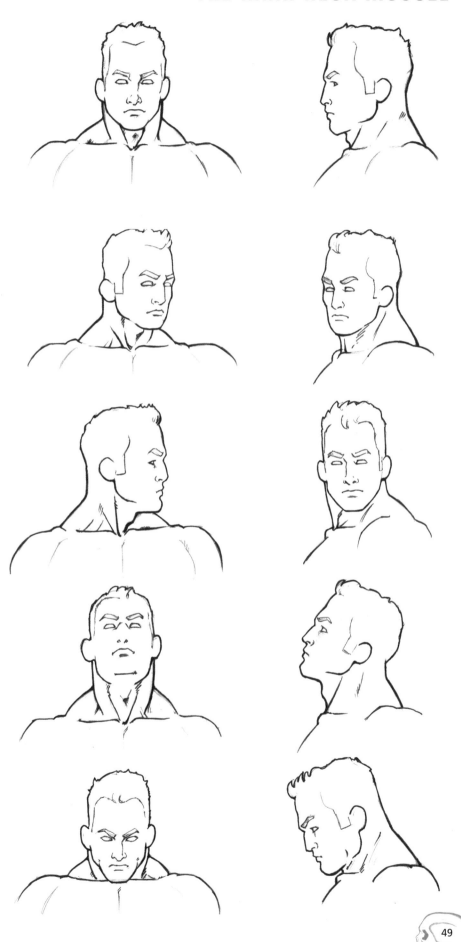

THE MAIN NECK MUSCLE IN MOTION

Take a look at how head and shoulder movement affects the sternocleidomastoideus. Note that, despite the pose, it always travels from the mastoid process (the bone just below/behind the ear) to the pit of the neck. And, it shows equally on men and women, though you should give it less mass and less definition on a woman.

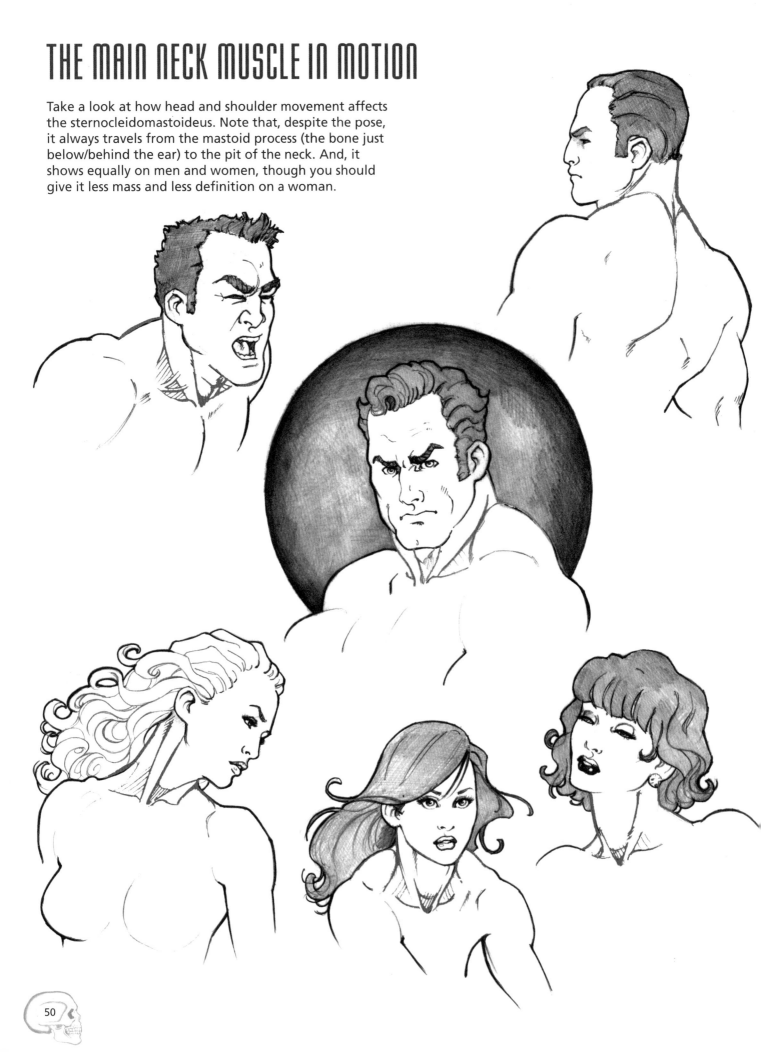

To define the neck muscles even further, take a look at these drawings. Again, the sternocleidomastoideus—the largest neck muscle—runs from the base of the ear to the pit of the neck. Then it branches off as it travels toward the collarbone a few inches away. The muscles traveling from the shoulders to the neck are the trapezius muscles, but they're more back muscles than neck muscles and are covered in greater detail on pages 71–73.

Women's neck muscles are downplayed; showing too many neck muscles would make her look old, not strong. Only the two main neck muscles need to be there—and even then, only at the pit of the neck. If, however, you were to turn her head all the way to one side, the entire neck muscle would show because it would be stretched. But when she's at rest, leave her like this.

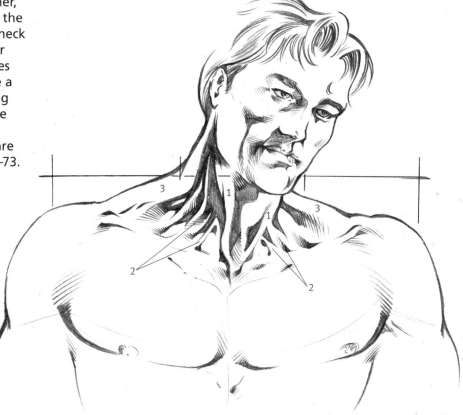

1 STERNOCLEIDOMASTOIDEUS
2 OFFSHOOTS OF STERNOCLEIDOMASTOIDEUS
3 TRAPEZIUS

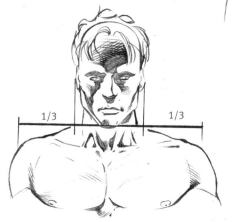

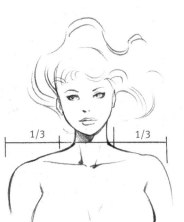

When you think of anatomy in terms of proportions, it can be quite simple. For example, the head takes up a third of the width of the shoulders.

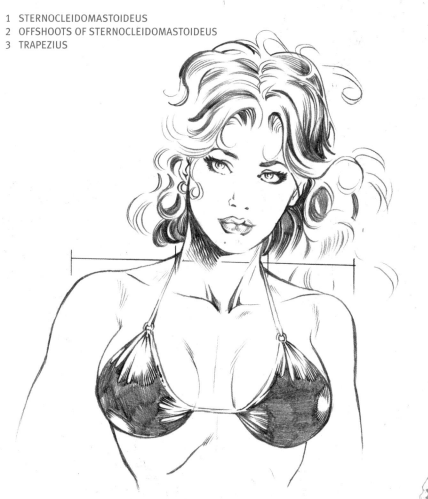

THE CHEST AND ABS

The chest and abs of cutting-edge comic book characters are like fortresses: powerful and designed to intimidate. These are the hyperdeveloped muscles of the body, and they form highly *dynamic* muscle groups—meaning that their shape and definition change as the body moves.

The rib cage is an oval-shaped enclosure that protects many of the body's vital organs. The strongest ribs attach to the sternum (the bone in the middle of the chest. The lower ribs, which attach to the other ribs, are often referred to as "floating ribs." Note how the collarbone attaches to the sternum as well. There is also a little "tab" at the bottom of the sternum that's often visible in the surface anatomy of men who have sharply defined muscles. The official name for this tab is the xiphoid process. Who thinks up these names?

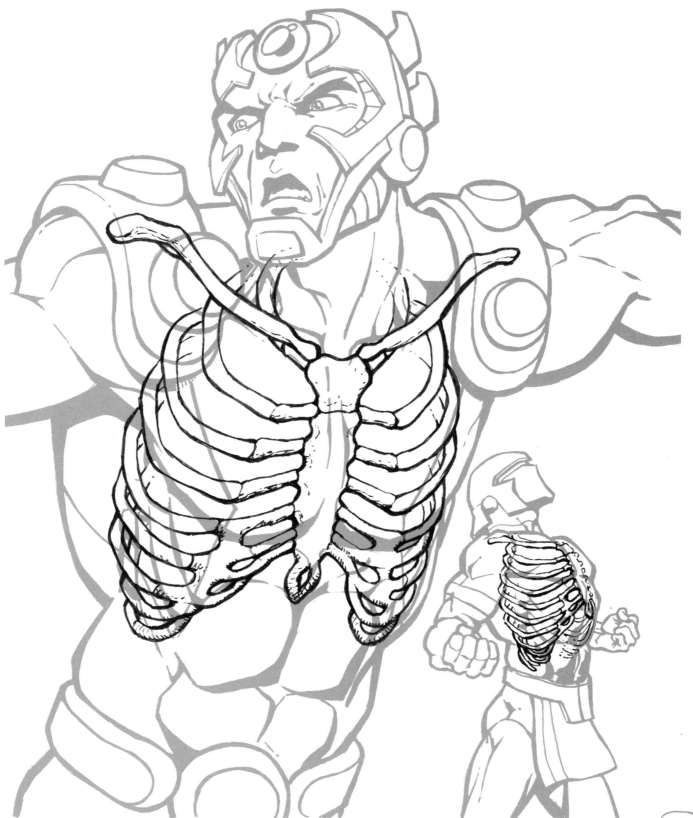

BASIC CHEST STRUCTURE

The rib cage has a rounded, three-dimensional shape. That means that the chest muscles must travel *around* the rib cage. Therefore, any guidelines you use when sketching are going to be curved.

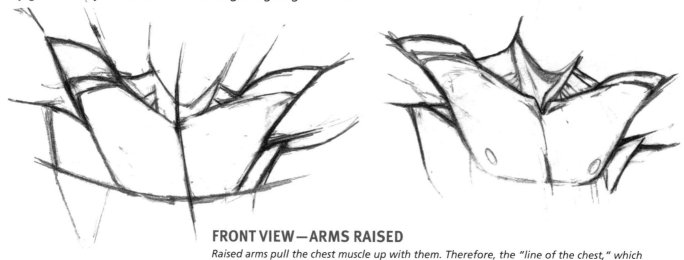

FRONT VIEW—ARMS RAISED

Raised arms pull the chest muscle up with them. Therefore, the "line of the chest," which is actually under the chest, curves upward toward the shoulders in response to the stress.

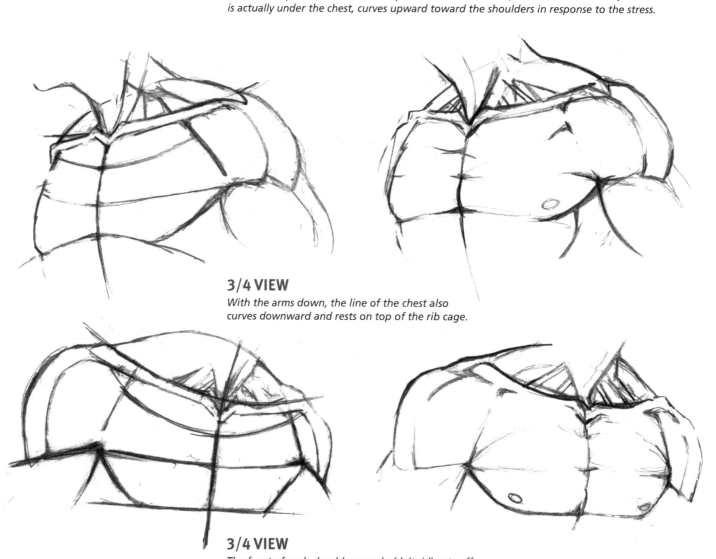

3/4 VIEW

With the arms down, the line of the chest also curves downward and rests on top of the rib cage.

3/4 VIEW

The front of each shoulder muscle (deltoid) cuts off the line of the chest as it travels toward the armpit.

On men, the chest is the power center of the torso. A well-developed chest conveys a sense of might. Without it, male characters are not impressive. (In fact, cowardly characters often have sunken chests.) A proud chest needs size and a good shape, but more than that, the chest also needs to fit correctly into the adjacent muscle group—the shoulders.

While impressive chest muscles indicate power—even brute force—the abdominals (or abs, for those of you who watch way too many infomercials) convey a sense of inner strength. Lean abs are a sign of virility. By combining defined chest muscles with washboard abs, you can create formidable, cutting-edge comic book characters.

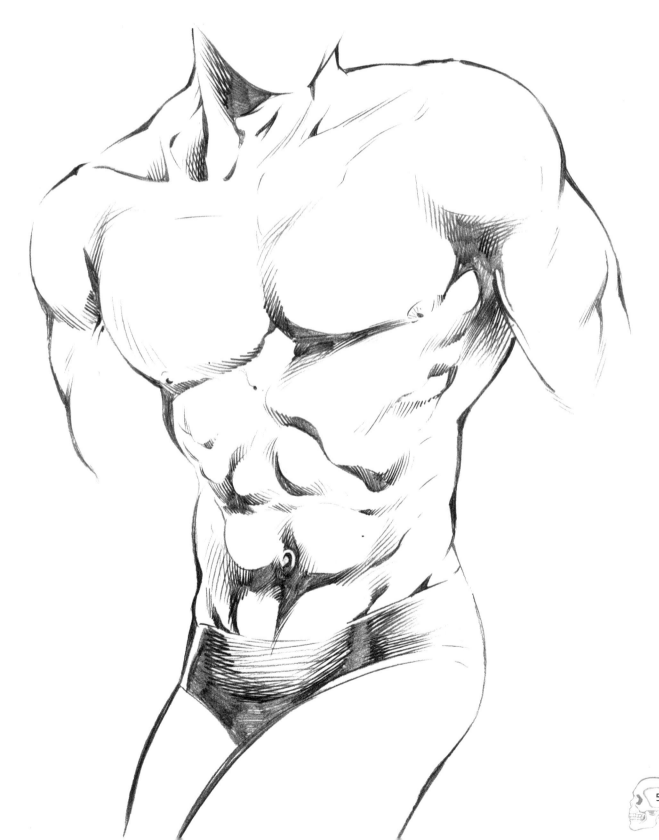

WASHBOARD ABS

The abdominal muscle group is made up of four muscles, sectioned into two columns. These columns travel up the front of the body in the hollow of the rib cage. To create this ideal comic book look, keep in mind the following three positioning benchmarks:

(1) the line of the collarbone and the line of the chest are roughly parallel; (2) the nipples are at a 45-degree diagonal from the pit of the neck; and (3) the belly button appears just above the lowest pair of abdominal muscles.

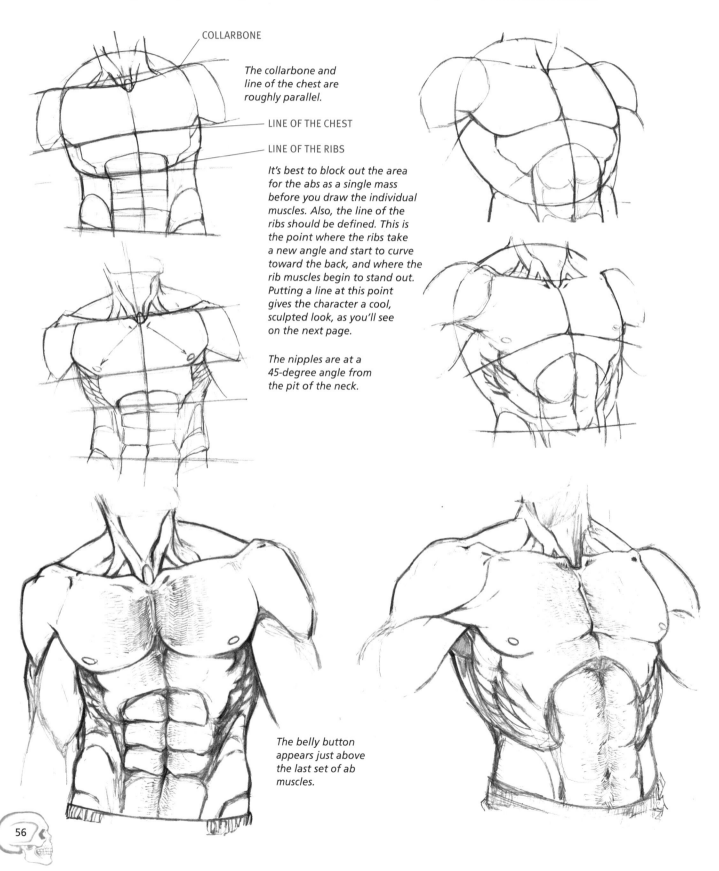

COLLARBONE

The collarbone and line of the chest are roughly parallel.

LINE OF THE CHEST

LINE OF THE RIBS

It's best to block out the area for the abs as a single mass before you draw the individual muscles. Also, the line of the ribs should be defined. This is the point where the ribs take a new angle and start to curve toward the back, and where the rib muscles begin to stand out. Putting a line at this point gives the character a cool, sculpted look, as you'll see on the next page.

The nipples are at a 45-degree angle from the pit of the neck.

The belly button appears just above the last set of ab muscles.

THE MUSCLES ON TOP OF MUSCLES

Superheroes have muscles on top of their muscles. The muscles around the rib cage (which make up the line of the ribs that I referred to on the previous page) are a good example. The rib cage muscles (called the serratus anterior by everyone who speaks conversational Latin at home) are a small series of muscles that appear to be interlaced on top of the external obliques. They are seen only on very intensely developed bodybuilders and male comic book characters. When drawn correctly, this concept of muscles on muscles results in a cutting-edge look.

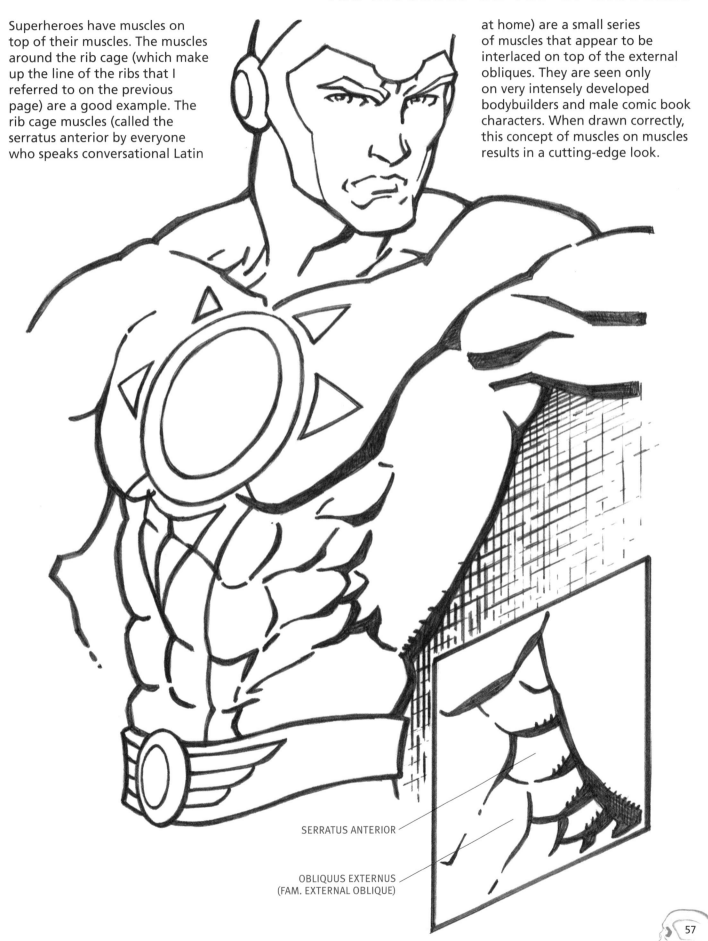

SERRATUS ANTERIOR

OBLIQUUS EXTERNUS
(FAM. EXTERNAL OBLIQUE)

ARMS DOWN

Okay, here's the chest, rib muscles, abs, and neck muscles all in the same picture. Note that when the arms are down, the shoulders overlap the chest muscles, cutting off the line of the chest.

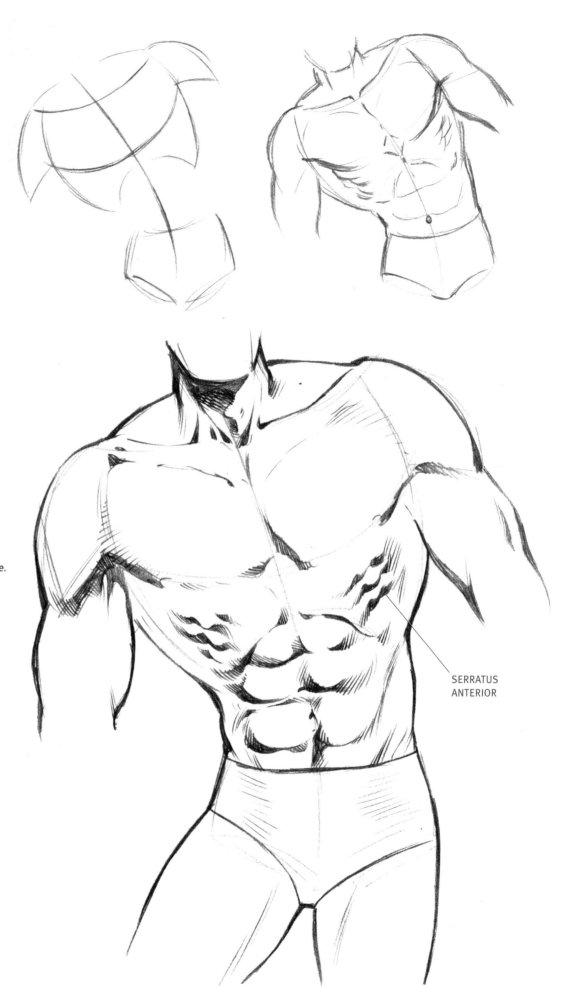

The shoulder muscle cuts off the chest muscle.

SERRATUS ANTERIOR

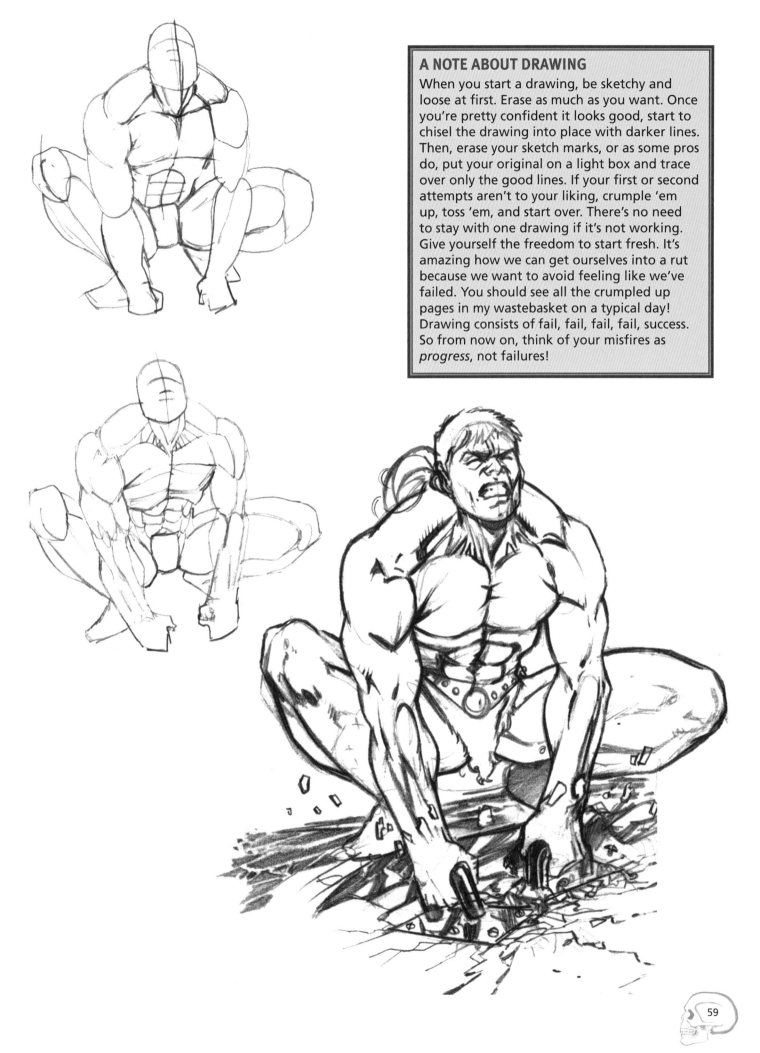

A NOTE ABOUT DRAWING

When you start a drawing, be sketchy and loose at first. Erase as much as you want. Once you're pretty confident it looks good, start to chisel the drawing into place with darker lines. Then, erase your sketch marks, or as some pros do, put your original on a light box and trace over only the good lines. If your first or second attempts aren't to your liking, crumple 'em up, toss 'em, and start over. There's no need to stay with one drawing if it's not working. Give yourself the freedom to start fresh. It's amazing how we can get ourselves into a rut because we want to avoid feeling like we've failed. You should see all the crumpled up pages in my wastebasket on a typical day! Drawing consists of fail, fail, fail, fail, success. So from now on, think of your misfires as *progress*, not failures!

ARMS UP

As you can see, the chest muscles lose some of their "pump" and definition when the arms are raised (because the muscles are stretched out). In this position, the "pecs" (the pectorals, or chest muscles) will appear leaner. Notice also how, when the arms are up, the line of the ribs continues upward, meeting with the line of the chest and then the line of the shoulder. In this way, the muscle groups appear to flow together.

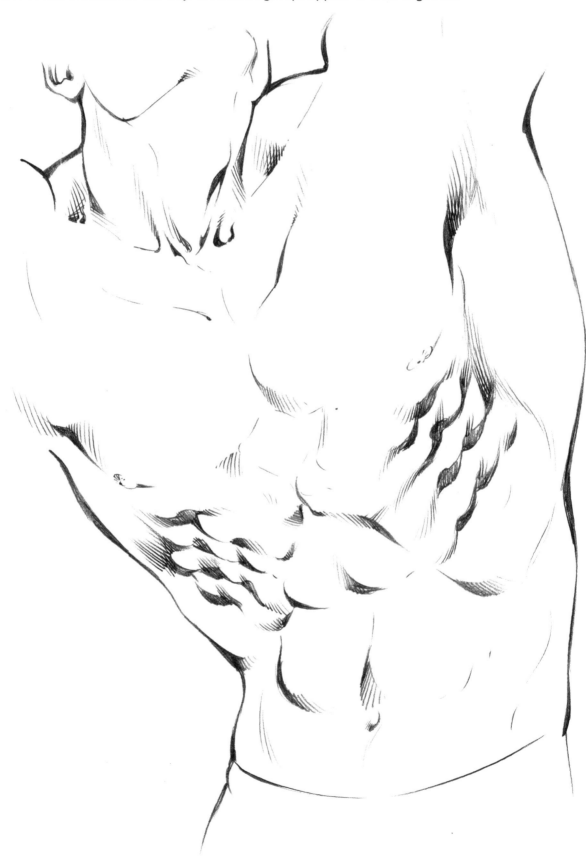

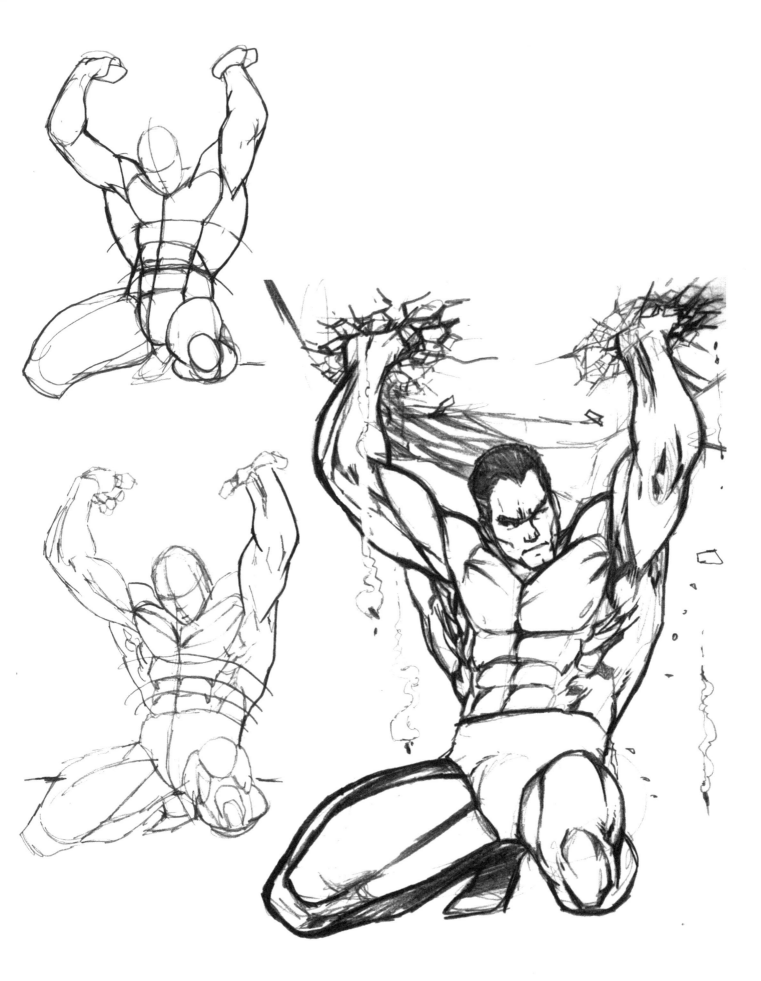

THE MALE TORSO IN MOTION

The rib cage and chest move in two ways: First, the rib cage itself moves when the spine flexes, twists, and bends. Second, the muscles *on* the rib cage—most notably the chest muscles and abs—move. They rise and fall, contract and loosen. All of this changes their shape.

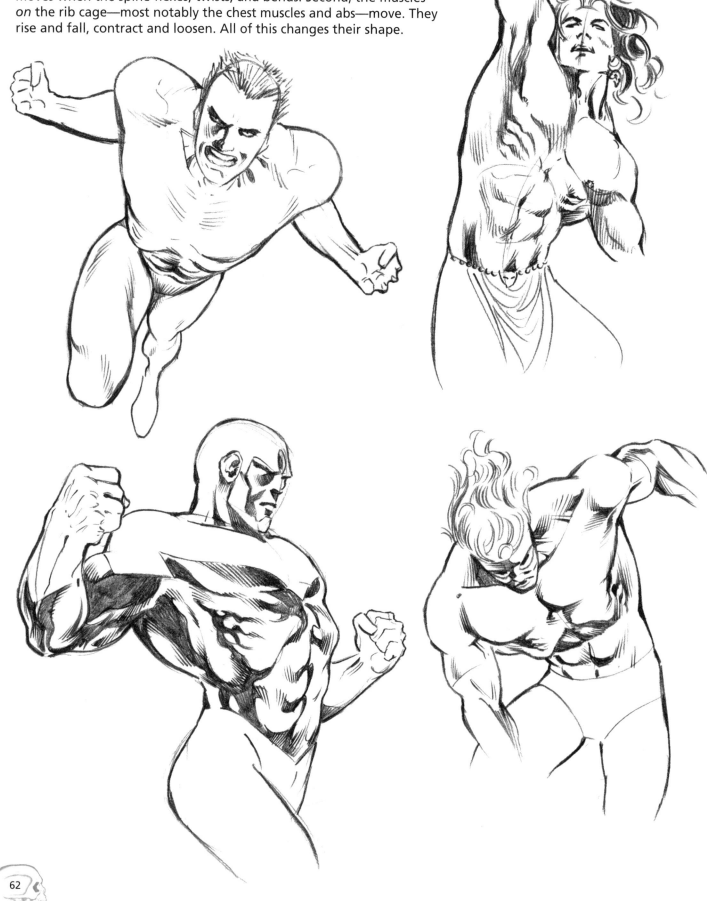

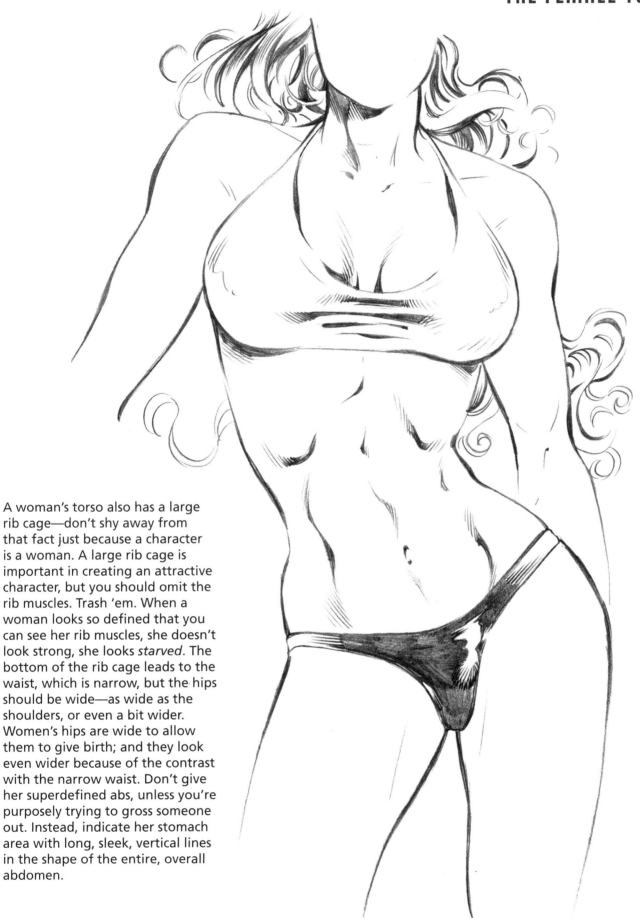

A woman's torso also has a large rib cage—don't shy away from that fact just because a character is a woman. A large rib cage is important in creating an attractive character, but you should omit the rib muscles. Trash 'em. When a woman looks so defined that you can see her rib muscles, she doesn't look strong, she looks *starved*. The bottom of the rib cage leads to the waist, which is narrow, but the hips should be wide—as wide as the shoulders, or even a bit wider. Women's hips are wide to allow them to give birth; and they look even wider because of the contrast with the narrow waist. Don't give her superdefined abs, unless you're purposely trying to gross someone out. Instead, indicate her stomach area with long, sleek, vertical lines in the shape of the entire, overall abdomen.

OPPOSING FORCES

The rib cage and pelvis can move in opposite directions, causing one side of the body to contract or crunch and the other side to expand or stretch. Poses that involve these opposing forces have the potential to be very dynamic. Anytime you can give your character a bend, twist, or stretch, do it—it adds drama to the pose. That's not to say that there aren't effective static poses, such as a man standing still in grief with his head hanging low. But there's something inherently compelling about watching the human form striving, reaching, or struggling, even though it may be only a subtle movement.

FRONT VIEW

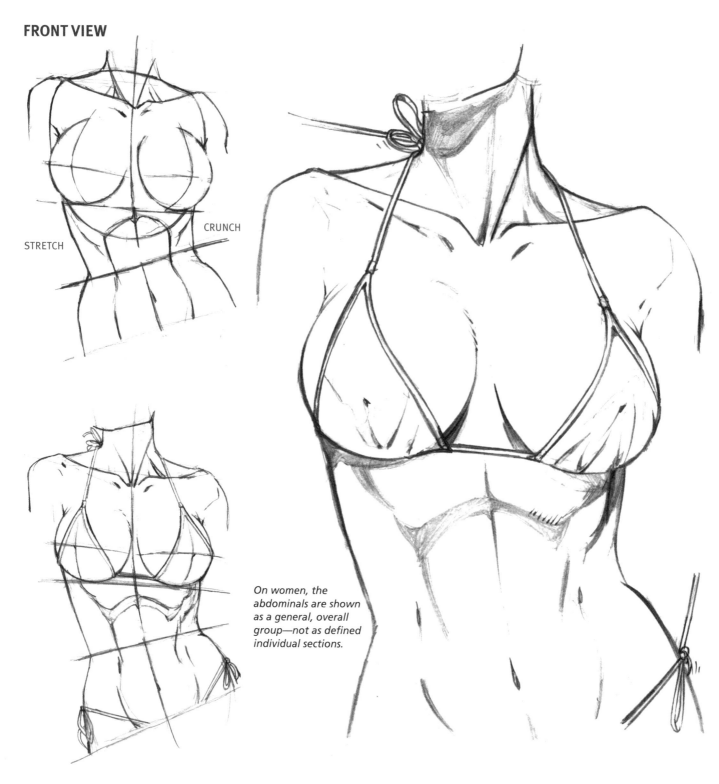

STRETCH

CRUNCH

On women, the abdominals are shown as a general, overall group—not as defined individual sections.

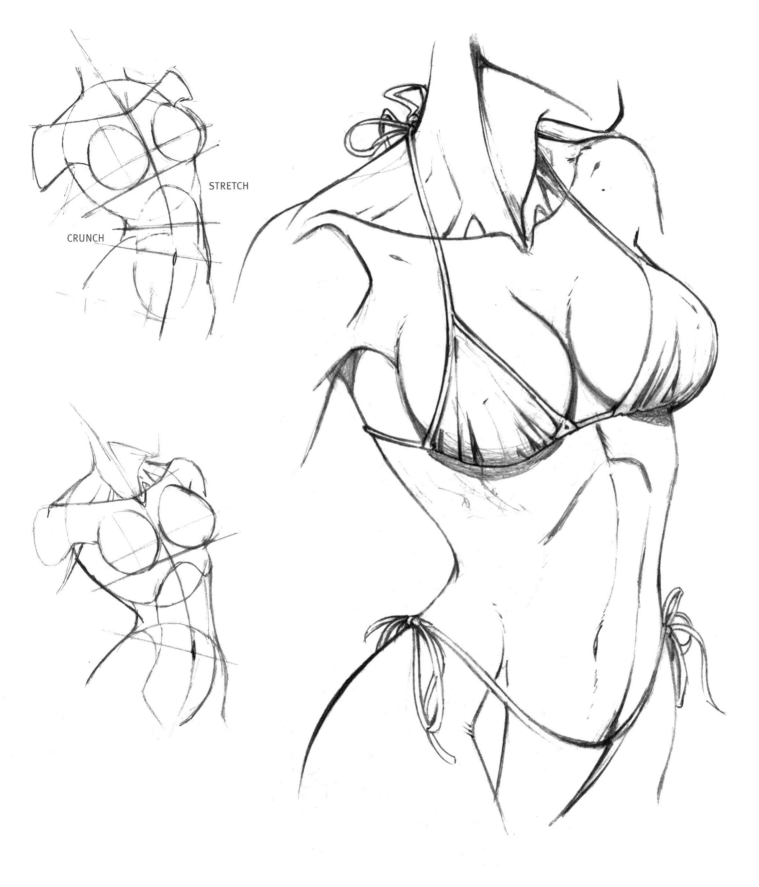

STRETCH

CRUNCH

THE FEMALE TORSO IN MOTION

Take a look at the construction drawings for each of these poses. You'll see opposing forces at work in every one. This stretching and contracting helps convey motion. In addition, poses in which the chest and hips are angled away from each other result in a seductive look, even if the actual action in the scene has nothing to do with sex appeal. Notice how sexy these images are due to the posing.

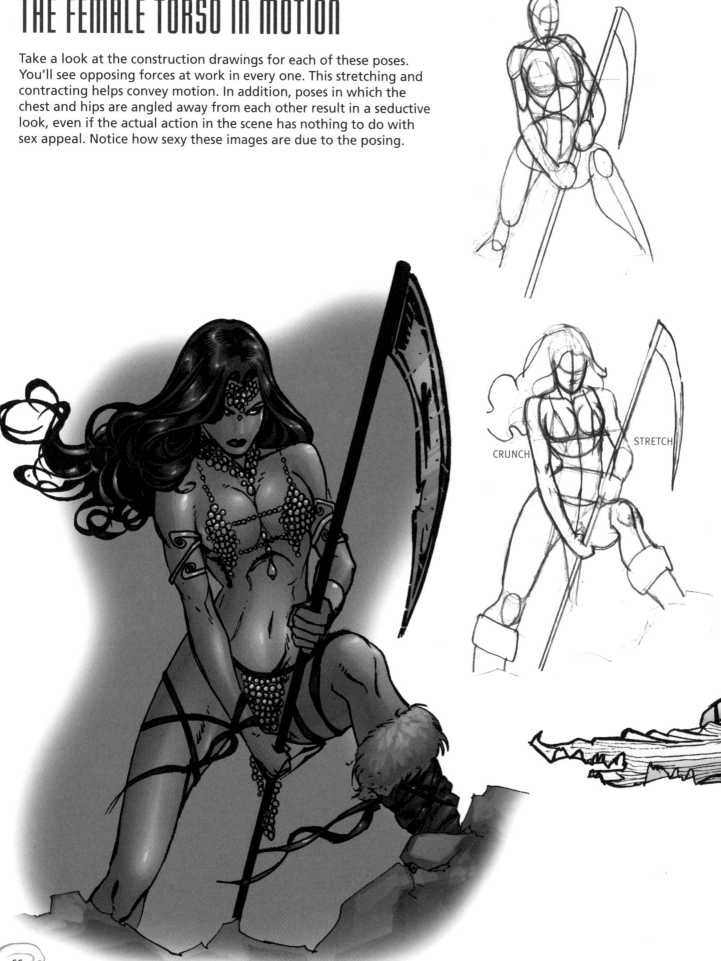

CRUNCH

STRETCH

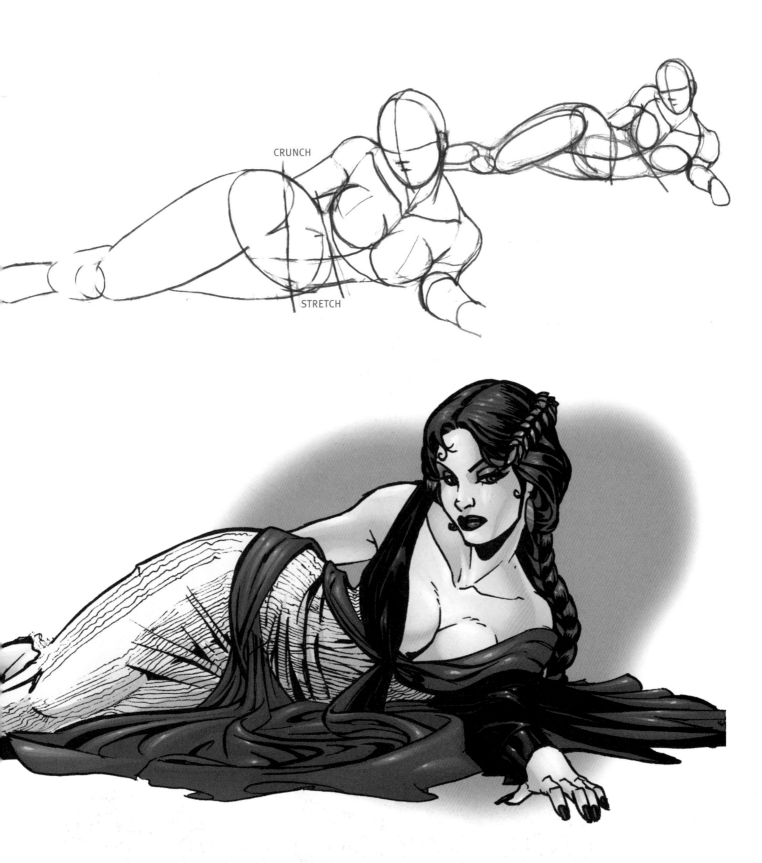

CRUNCH

STRETCH

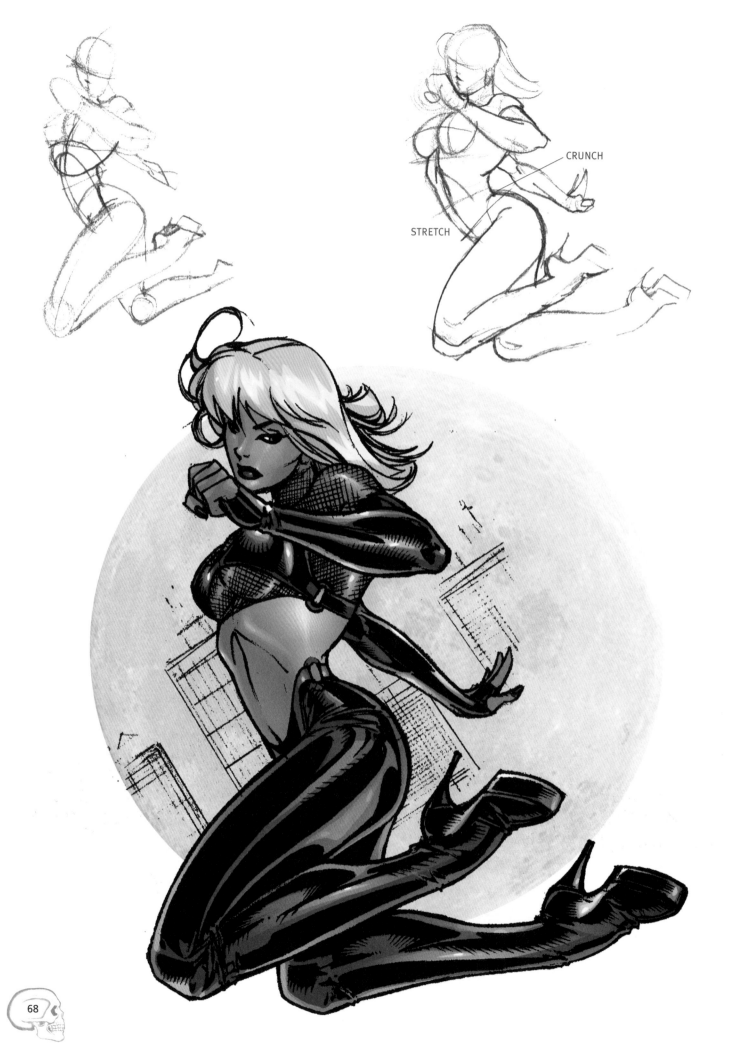

CRUNCH

STRETCH

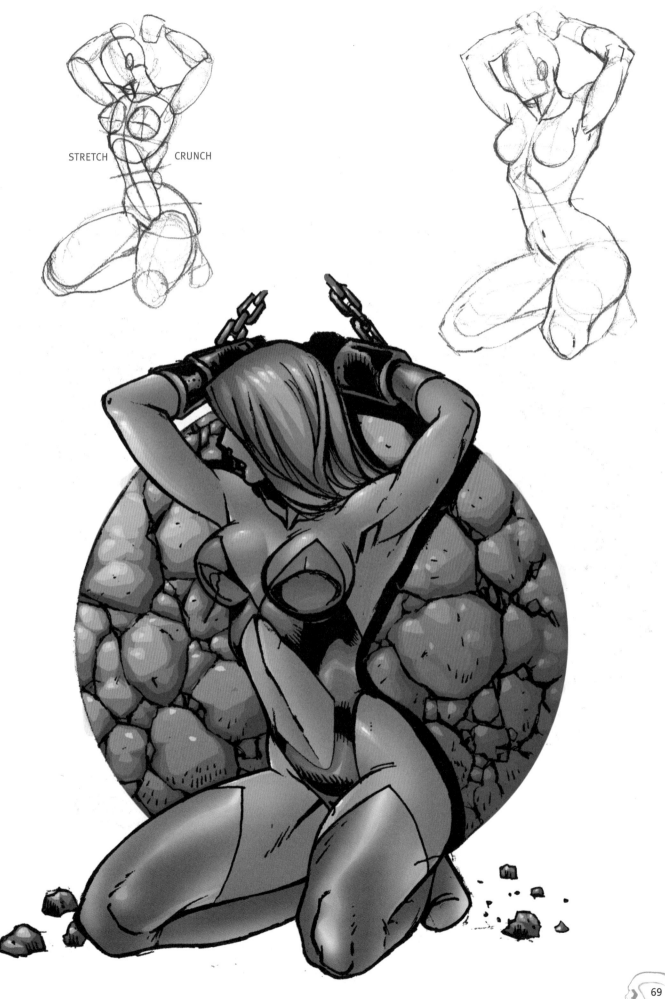

STRETCH CRUNCH

THE BACK AND SHOULDERS

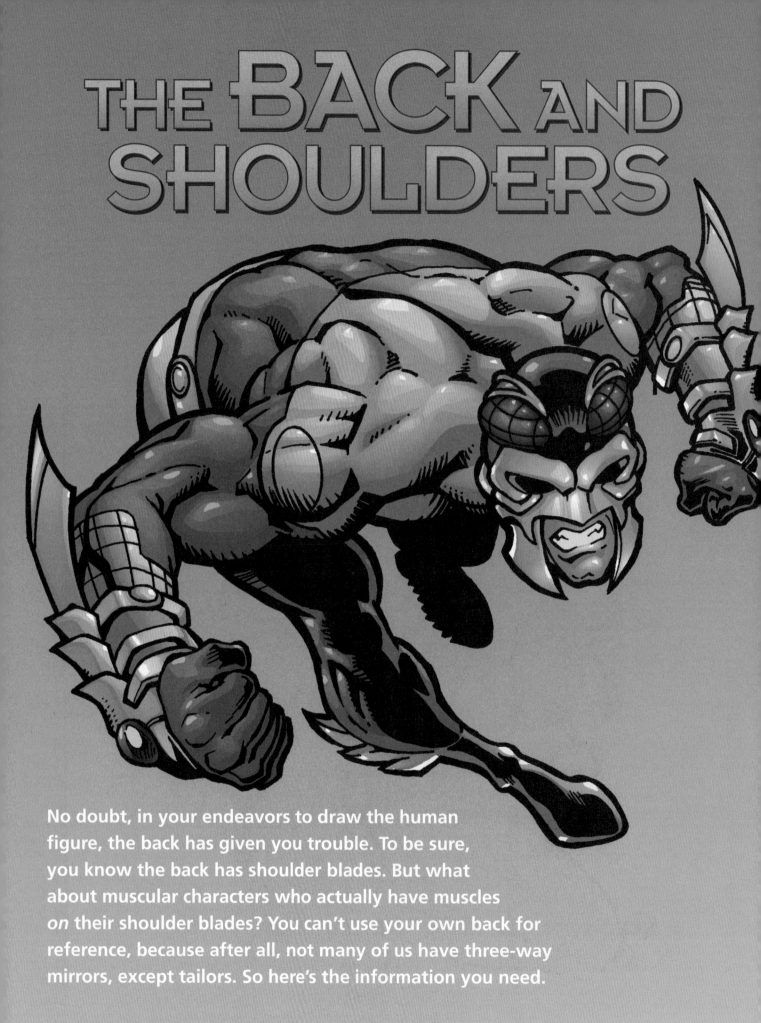

No doubt, in your endeavors to draw the human figure, the back has given you trouble. To be sure, you know the back has shoulder blades. But what about muscular characters who actually have muscles *on* their shoulder blades? You can't use your own back for reference, because after all, not many of us have three-way mirrors, except tailors. So here's the information you need.

The back is a contradiction—a blending of massive muscles, long muscles, and smaller muscles. In addition, some of the muscles have quirky characteristics. For example, the trapezius muscle is a long one that starts at the base of the skull, bunches at the upper back, but then is long and lean in the small of the back. Same muscle, but it acts almost as three separate muscle groups. Note that the shoulder blades push the trapezius muscles up.

The shoulders are a unique group of muscles in that they are equally visible from the front, side, and back of the body. The shoulder blades are covered by three muscles (the infraspinatus, teres minor, and teres major) that can bunch together or stretch, depending on the position of the arms.

1 TRAPEZIUS
2 DELTOID (MIDDLE PORTION)
3 DELTOID (POSTERIOR PORTION)
4 OBLIQUUS EXTERNUS
 (FAM. EXTERNAL OBLIQUE,
 OR "LOVE HANDLES")
5 LATISSIMUS DORSI
6 TERES MAJOR
7 TERES MINOR
8 INFRASPINATUS

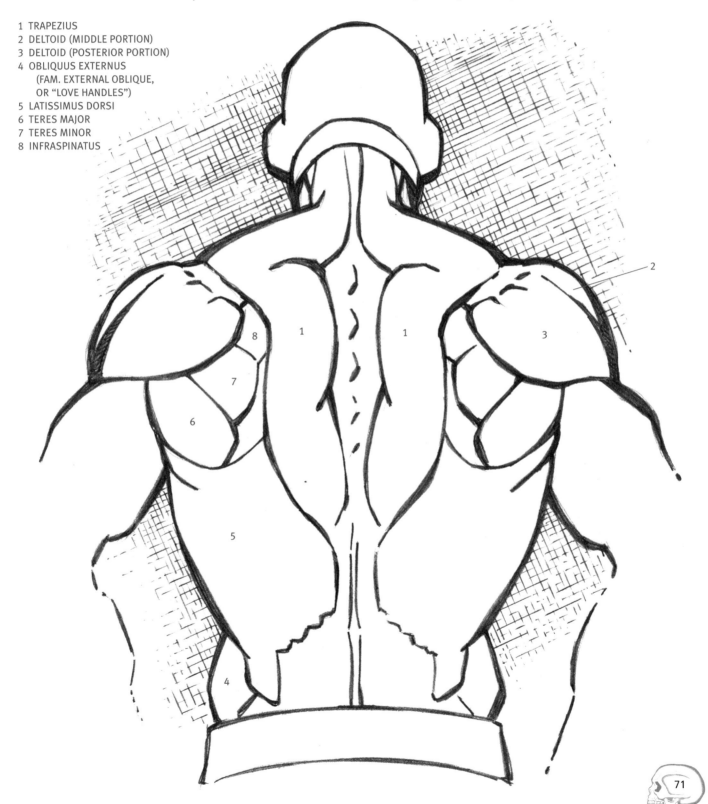

UPPER BACK, FLEXED (ARMS UP)

Raising the arms causes significant flexing of the trapezius muscles along the neck and upper and middle back. Note that there are no muscles covering the spine. Also note that the muscles of the shoulder blade area form steeper diagonals when the arms are raised. The area labeled *bone* is the ridge of the shoulder blade. The deltoids and trapezius muscles attach to these bones, so the muscles indent at this point.

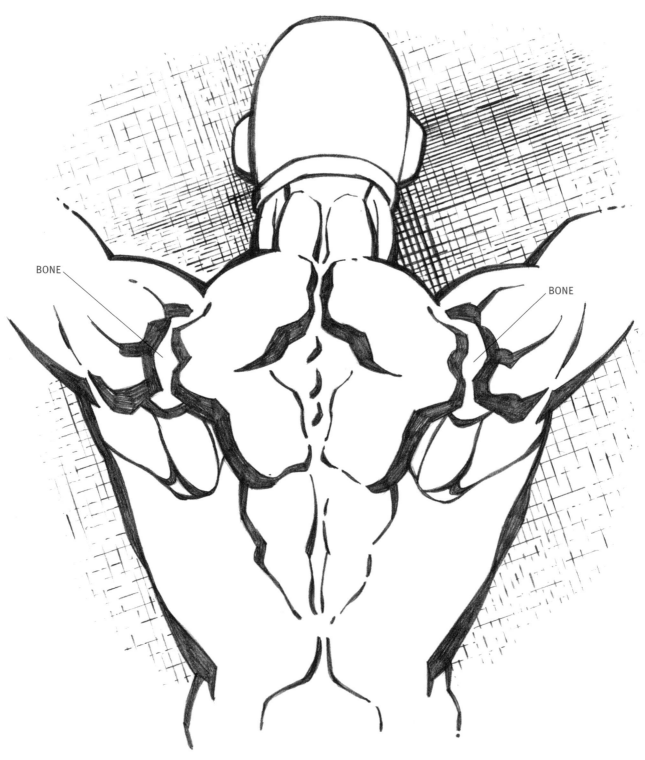

BONE

BONE

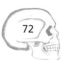

LOWER BACK

The trapezius muscle and the latissimus dorsi, which begin at the upper back, are long muscles that travel down to the lower back.

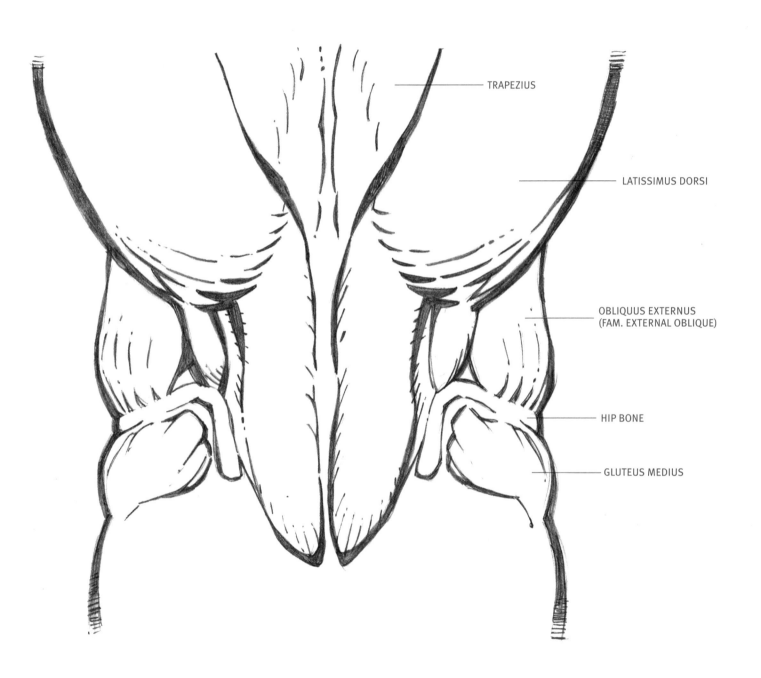

TRAPEZIUS

LATISSIMUS DORSI

OBLIQUUS EXTERNUS
(FAM. EXTERNAL OBLIQUE)

HIP BONE

GLUTEUS MEDIUS

SURFACE RENDERING

When you draw the figure, remember that there's a layer of fat and skin covering the muscles. Therefore, you have to be a little less specific about each muscle group—even on well-defined figures—than the anatomical drawings earlier in the book. This approach requires some artistry. There's no "correct" way to render the back. Some artists want to bulk up certain muscles while minimizing others. Let your knowledge of anatomy be guided by your creative decisions. The image here shows one approach, alternating thin lines with heavy ones.

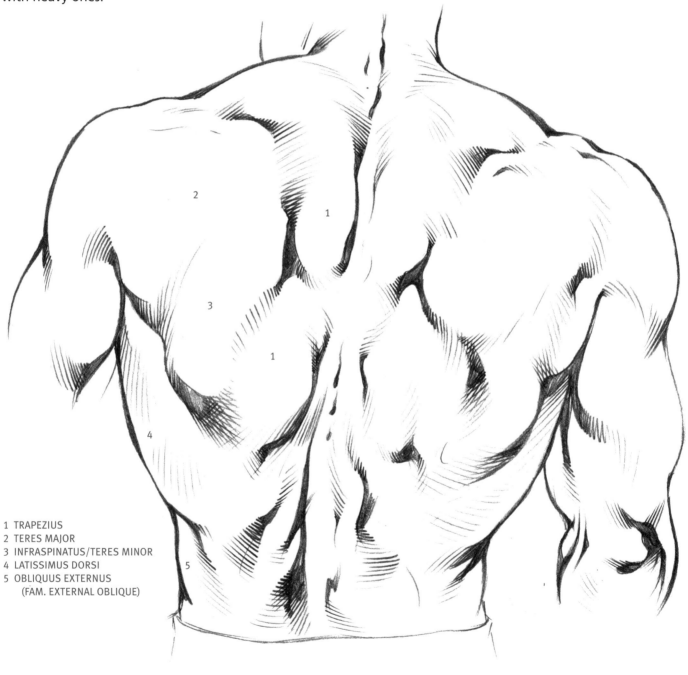

1 TRAPEZIUS
2 TERES MAJOR
3 INFRASPINATUS/TERES MINOR
4 LATISSIMUS DORSI
5 OBLIQUUS EXTERNUS
 (FAM. EXTERNAL OBLIQUE)

Contracting, or crunching, the back muscles together makes them become incredibly defined. It also creates a deep ridge along the spine, which is shown as a heavily shadowed line here.

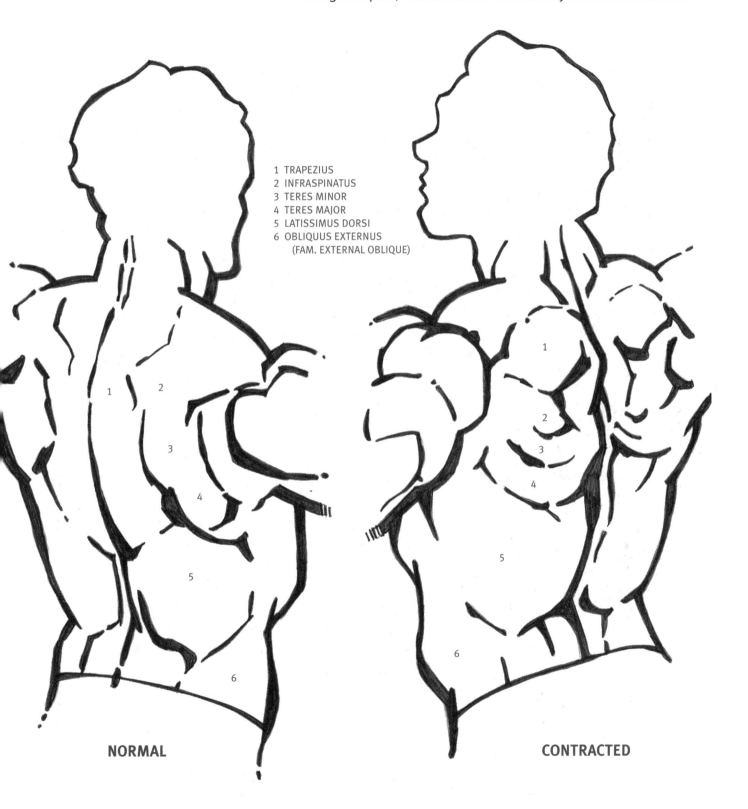

1 TRAPEZIUS
2 INFRASPINATUS
3 TERES MINOR
4 TERES MAJOR
5 LATISSIMUS DORSI
6 OBLIQUUS EXTERNUS
 (FAM. EXTERNAL OBLIQUE)

NORMAL

CONTRACTED

COOL COMIC BOOK POSES FOR THE BACK

Take a look at the anatomical principles at work in these cool comic book poses. Notice how the artist starts by blocking in the major muscle masses, then starts to get more specific and define the individual muscle groups, and ultimately, ends up with the finished figure.

Both arms are extended in front of this figure, pulling the lats forward and giving a significant curve to the back. This stretching of the back results in less muscular definition, but some of the anatomical landmarks must still be visible.

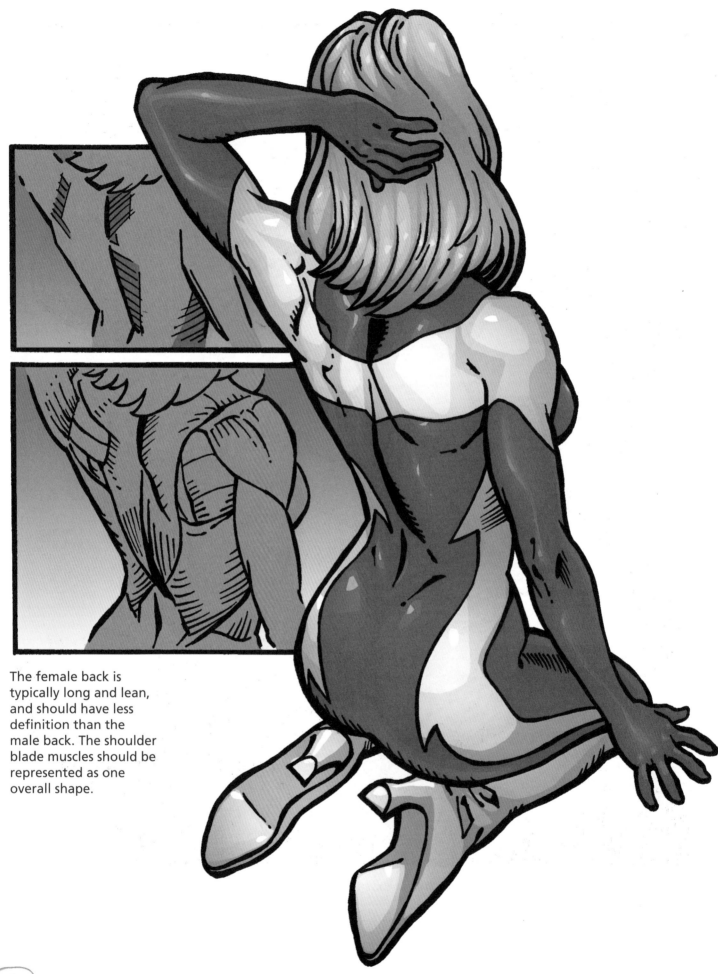

The female back is typically long and lean, and should have less definition than the male back. The shoulder blade muscles should be represented as one overall shape.

We've already covered a good deal about the shoulders, but we need to go further because there are a few other points to understand. The shoulder blade is shaped like a pie wedge carved by a moron. Doesn't help? Well, give it any metaphor you like, but it's wide on top, pointed at the bottom, with a bony ridge running across the top that's called the *spine of the scapula* (remember, the scapula is the shoulder blade). That bony ridge is what the deltoids (the shoulder muscles) attach to. The deltoids have many muscular striations but only three basic parts: anterior (front), middle, and posterior (rear).

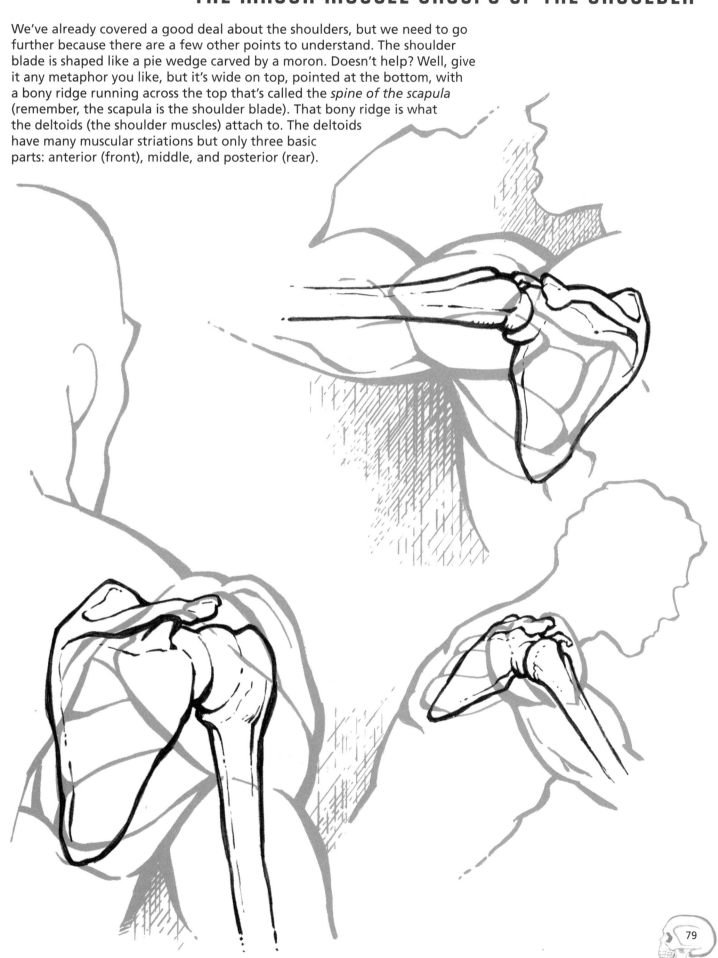

DELTOID MUSCLES—REAR VIEW

Notice how the deltoid seems to wrap around the arm muscle. If you look at the illustrations, you'll see that the deltoid is really a teardrop shape that wedges into the arm, between the biceps and triceps.

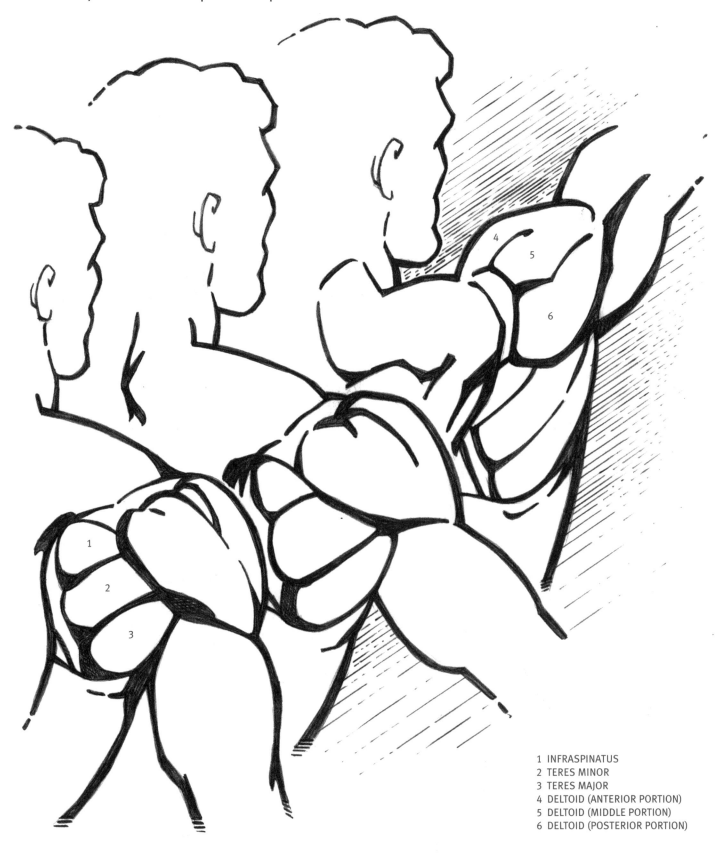

1 INFRASPINATUS
2 TERES MINOR
3 TERES MAJOR
4 DELTOID (ANTERIOR PORTION)
5 DELTOID (MIDDLE PORTION)
6 DELTOID (POSTERIOR PORTION)

SURFACE RENDERING OF DELTOIDS—FRONT VIEW

In the front view, the shoulder has a well-rounded look and shows itself to be a sizeable muscle group. Even though there are three heads to a deltoid, you should not think of them as separate muscle groups. Rather, use the three heads as places where you can add definition lines to the shoulders.

Note the acromion on the larger image. The spot where the acromion bone meets the clavicle causes this small but noticeable bump that's apparent even on muscular figures and women. It's the knob where the spine of the scapula attaches to the clavicle (collarbone). That's right, your shoulder blade is attached only to your collarbone, and nowhere else on the body! Amazing!

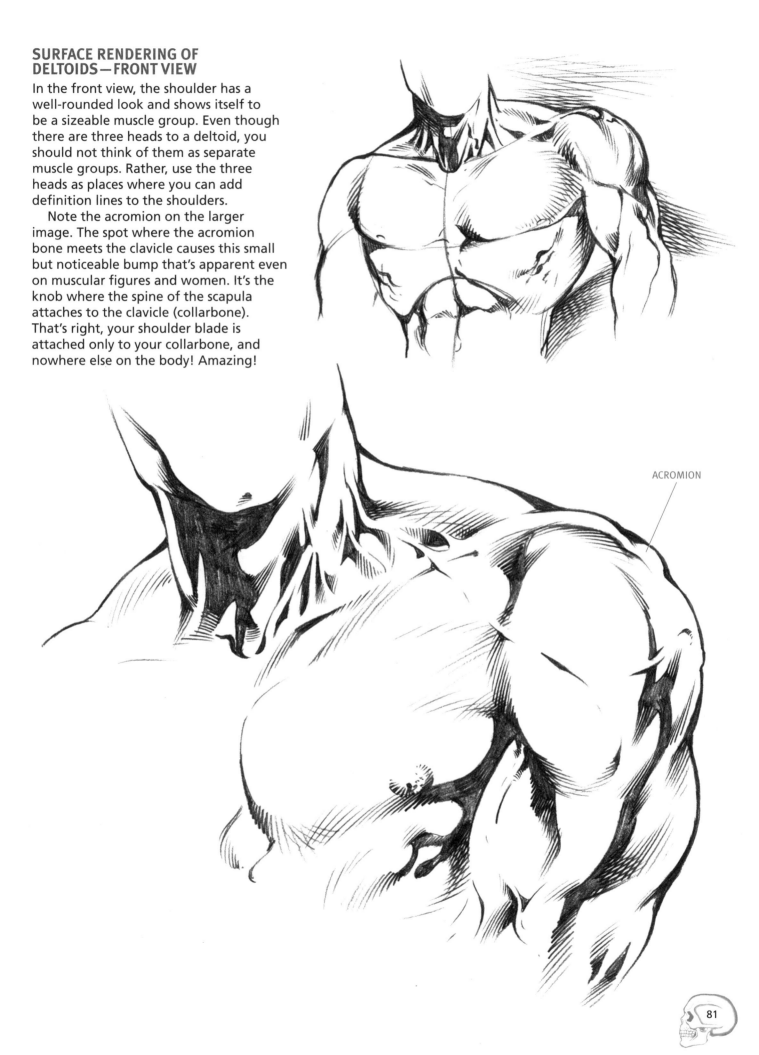

ACROMION

THE SHOULDERS IN MOTION

Here are some dramatic poses showing a variety of shoulder positions. Practice "quick-sketching" these just to get the feel of the shoulders from a variety of angles.

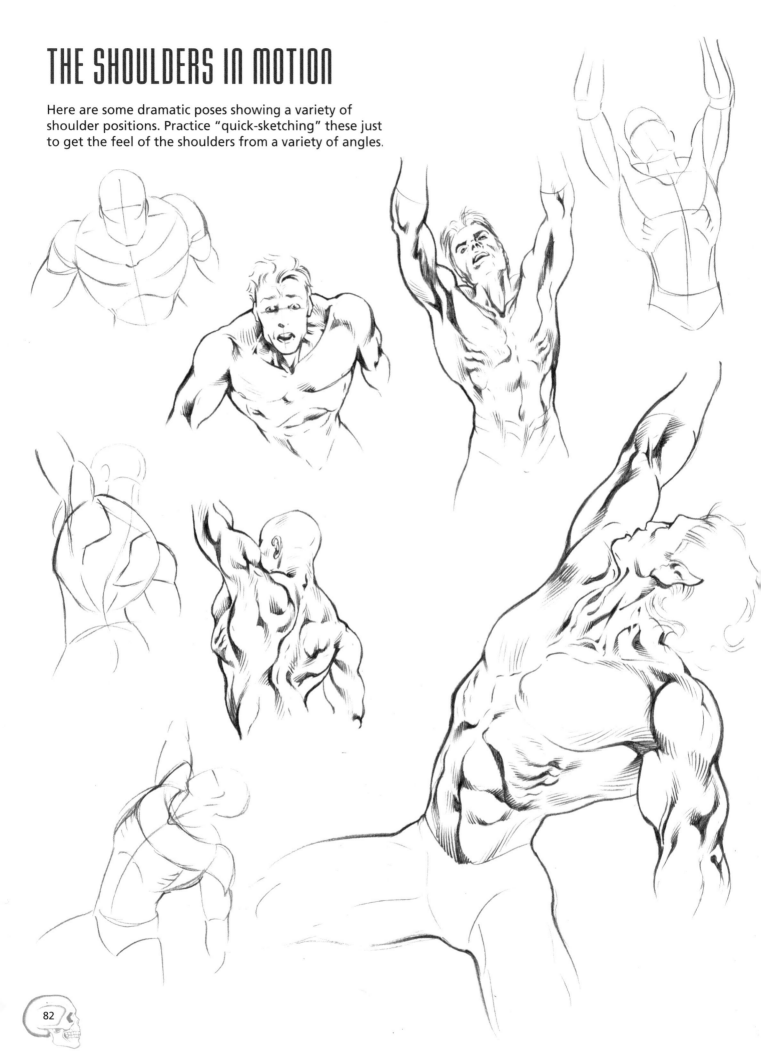

COOL COMIC BOOK POSE FOR THE SHOULDERS

As with the examples for the back on pages 76–78, start by blocking in the general muscle areas, then define the muscle groups, and end up with a finished image. *Note*: Not all figures require detailed definition of the shoulder area; sometimes, a relaxed shoulder is best drawn with a soft, gently curving line.

THE ARMS AND HANDS

Arm muscles are the showpiece for heroes and brutes. On women, they must be athletic, yet long and attractive. Everyone is familiar with the body's most famous muscle: the biceps. But, there are several other smaller, yet prominent, arm muscles without which the figure would look simplistic. Drawing all the arm muscles correctly creates comic book characters with impressive figures.

ARM BONES

Even though the arms can be quite muscular, there are several areas of the arm where the bones "show through" to the surface, right below the skin. So, it's doubly important that you familiarize yourself with the bones of the arms and not just worry about the muscles here.

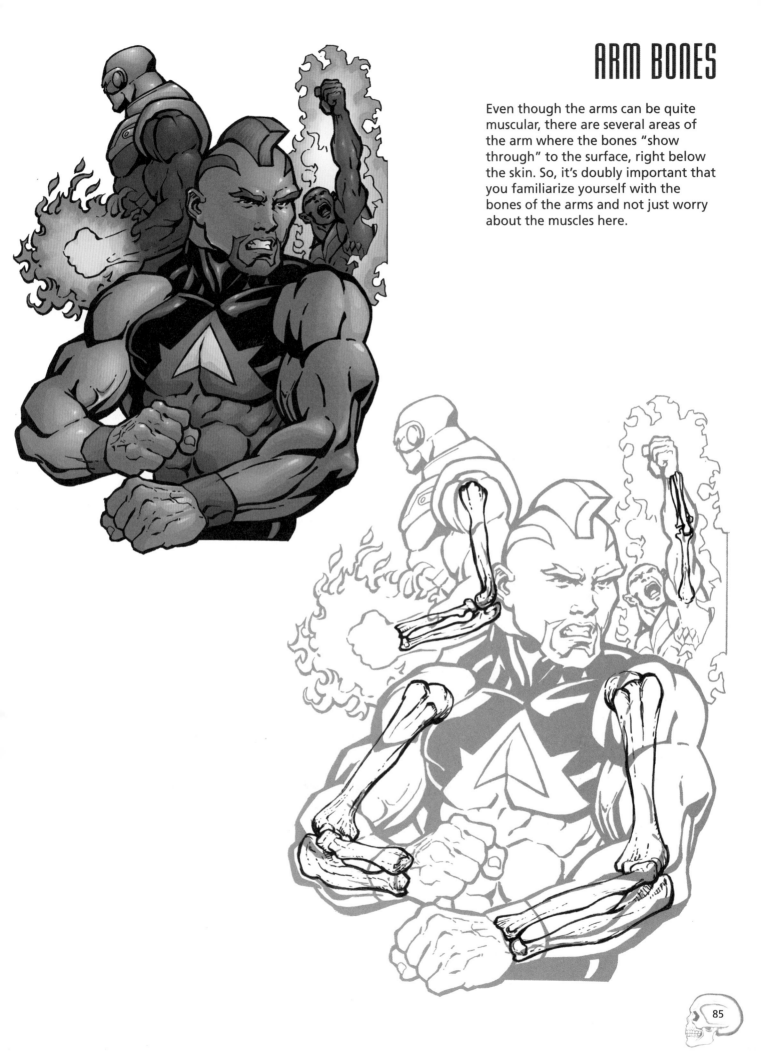

GENERAL MUSCLE INFO

We're all familiar with the names for the major upper arm muscles: the biceps and triceps. But there are other important muscles that appear *between* these two that are always visible to some extent but are often overlooked by beginning artists. In addition, the triceps has three sections (a lateral head, long head, and medial head) that become more defined when the arm is straightened and flexed.

And then there are the forearms, where the muscles twist around the arm depending on which way the palms face. (See pages 90–93 for more on the forearm.)

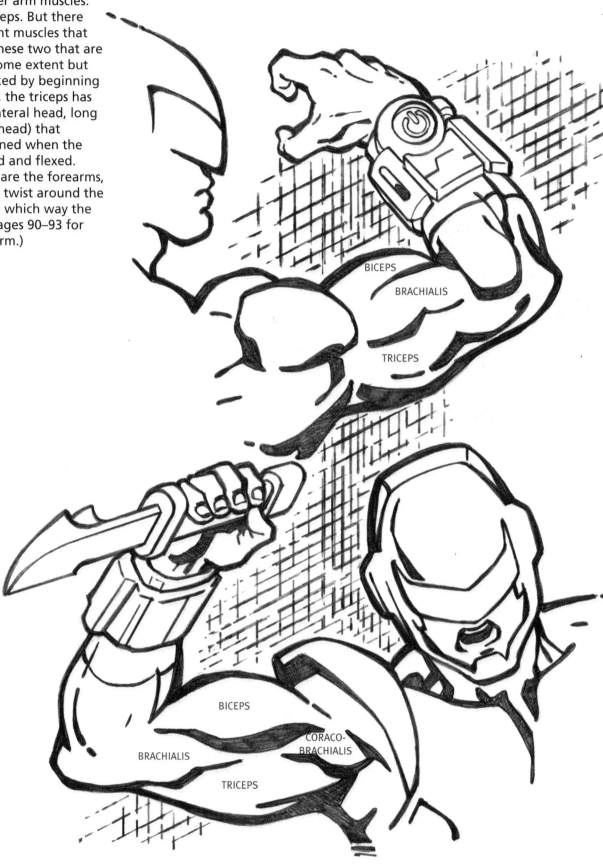

BICEPS

BRACHIALIS

TRICEPS

BICEPS

BRACHIALIS

CORACO-BRACHIALIS

TRICEPS

THE MUSCLES BETWEEN THE BICEPS AND TRICEPS

The brachialis is the muscle between the biceps and the triceps. It can be seen on the outer arm as well as the inner arm. However, on the inner arm there's an additional muscle—the coracobrachialis—which starts at the armpit and tapers off to nothing as it wedges neatly between the biceps and triceps. Then, when it looks as if the coracobrachialis is extinct and gone forever, the brachialis appears, along the same path, to take over.

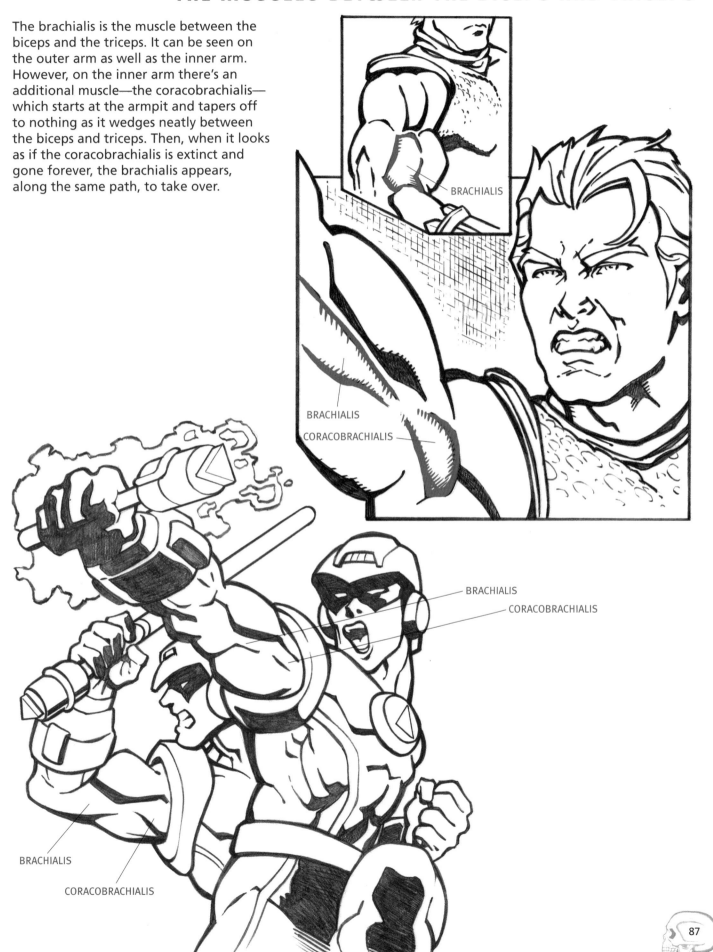

BRACHIALIS

BRACHIALIS

CORACOBRACHIALIS

BRACHIALIS

CORACOBRACHIALIS

BRACHIALIS

CORACOBRACHIALIS

THE TRICEPS IN ACTION

When the arm is straightened, the lateral and the long and medial heads of the triceps become apparent. The heads, combined, form an upside down V. (The brachialis is still apparent between the biceps and triceps.) Just below the triceps is tendon, not muscle, so it never flexes or bunches.

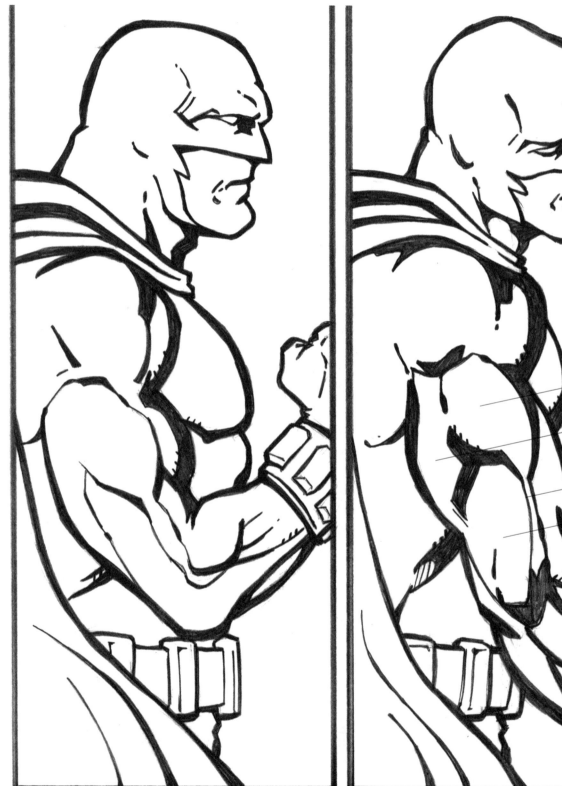

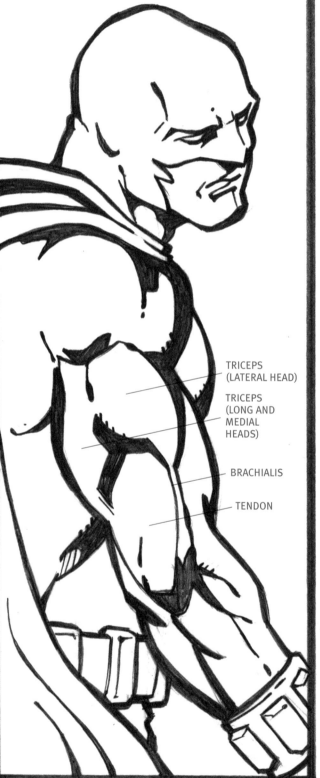

TRICEPS
(LATERAL HEAD)

TRICEPS
(LONG AND MEDIAL HEADS)

BRACHIALIS

TENDON

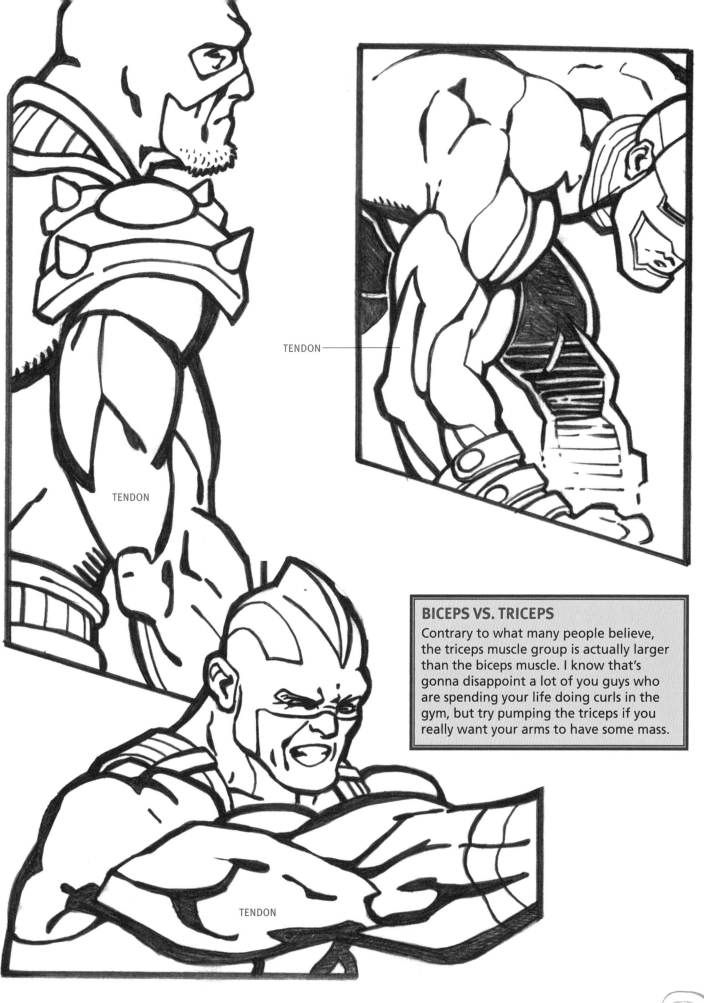

TENDON

TENDON

TENDON

TENDON

BICEPS VS. TRICEPS

Contrary to what many people believe, the triceps muscle group is actually larger than the biceps muscle. I know that's gonna disappoint a lot of you guys who are spending your life doing curls in the gym, but try pumping the triceps if you really want your arms to have some mass.

THE FOREARM

When the palm faces up, the muscles of the forearms are pretty straightforward: They start close to the elbow and travel to the hands in straight lines, becoming tendons when they reach the hands. The only forearm muscle that isn't parallel to the rest is the pronator teres, but it's really not articulated in the surface anatomy.

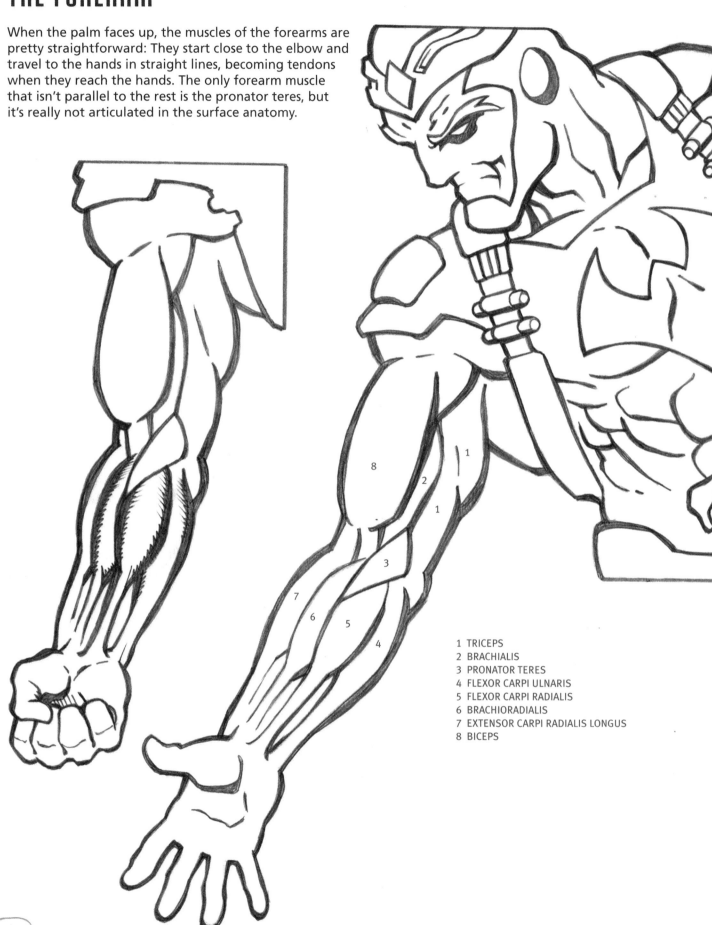

1 TRICEPS
2 BRACHIALIS
3 PRONATOR TERES
4 FLEXOR CARPI ULNARIS
5 FLEXOR CARPI RADIALIS
6 BRACHIORADIALIS
7 EXTENSOR CARPI RADIALIS LONGUS
8 BICEPS

THE FOREARM TWIST

This sounds like a new dance step, but actually, it's a very important concept—and you can't draw the forearm without it. If you don't pay attention to this, your drawings will look wrong—because they are! So, here it is: When the palm faces up, the forearm muscles basically run in a straight line from the elbow to the hand, as on the previous page. However, when the palm faces down, or the hand is held sideways (as if holding a hammer), the brachioradialis and the extensor carpi radialis longus wrap *around* the forearm, causing a noticeable flexing. The stronger the character, the bigger these muscles.

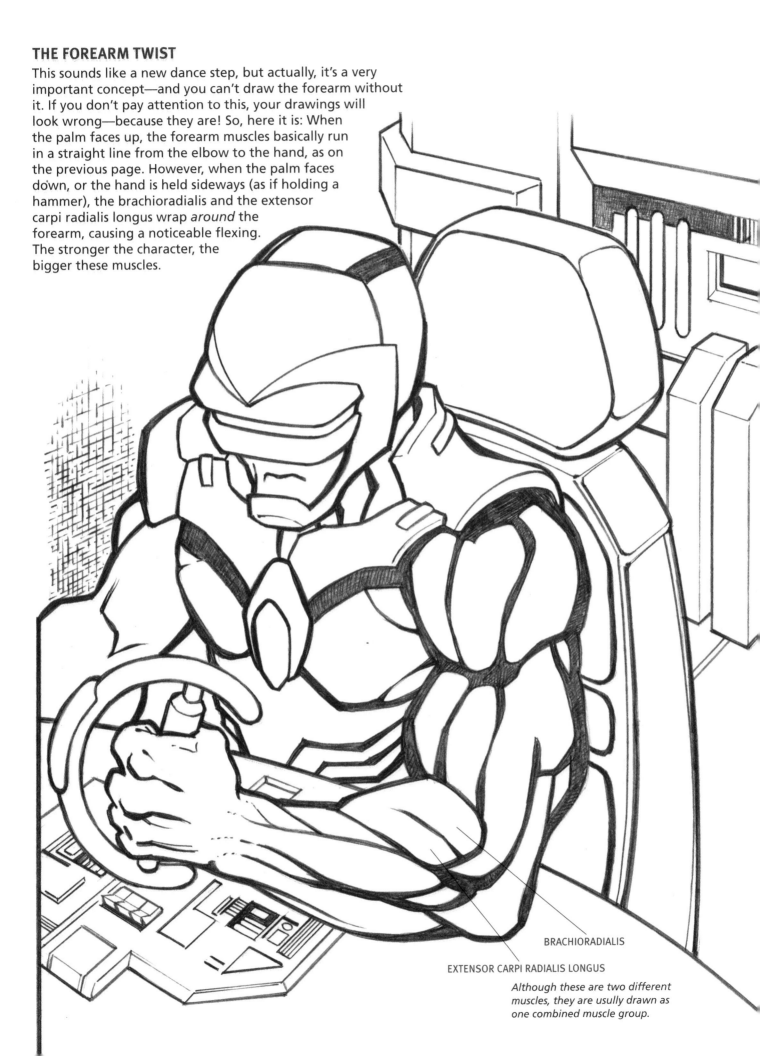

BRACHIORADIALIS

EXTENSOR CARPI RADIALIS LONGUS

Although these are two different muscles, they are usully drawn as one combined muscle group.

Here's another look at the wraparound forearm muscles. Note that the palm is sideways, causing the twisting action. The two twisting forearm muscles work in tandem, so you can think of them as one muscle, not two, but separated by a line of definition.

BRACHIORADIALIS

EXTENSOR CARPI RADIALIS LONGUS

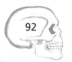

PUNCHING: THE FOREARM TWIST IN ACTION

When the palm faces down, the muscles do their tightest wrap around the forearm. In this pose, you can see that these muscles are actually quite thick, which gives the character a look of great power.

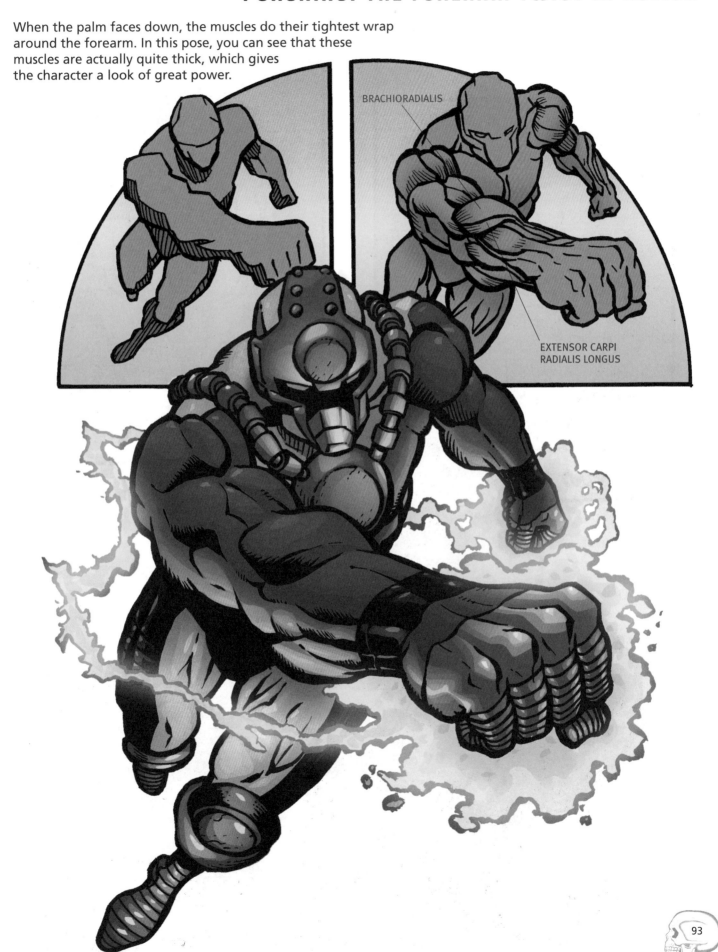

BRACHIORADIALIS

EXTENSOR CARPI
RADIALIS LONGUS

COOL COMIC BOOK POSES FOR THE ARMS

This pose clearly shows the muscle groups of both the upper and lower arms, as well as the shoulders. Since the hands are not quite in the "palms up" position, there's some twisting of the forearm muscles, but it's not extreme.

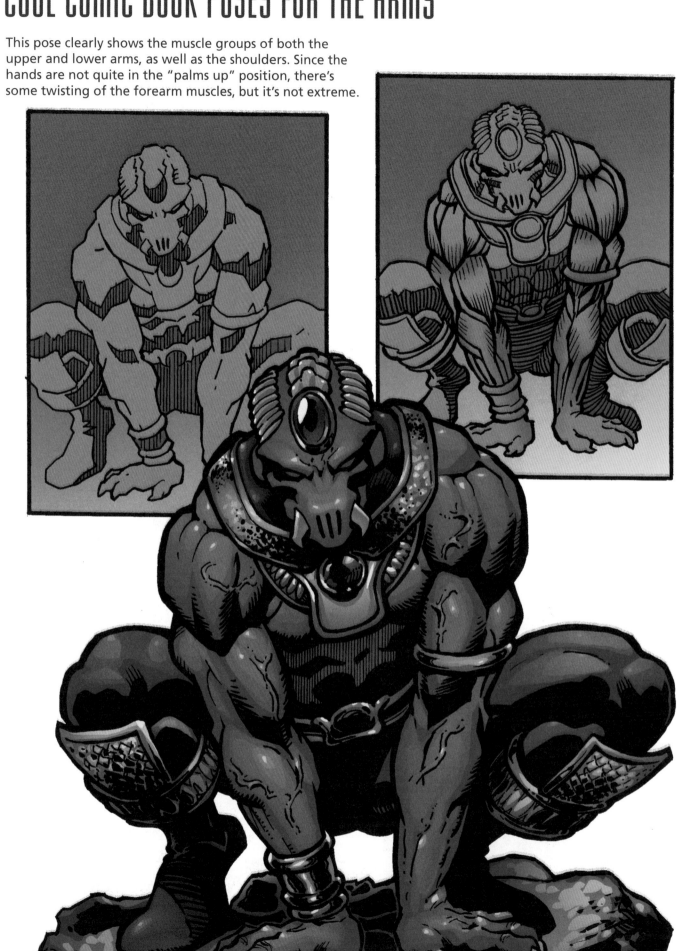

Notice how the arm rendering differs on a female character. Even though the arm muscles have definition, they're not drawn bulky or bunching, as they would be on male comic book characters. In addition, the lines depicting muscular definition aren't continuous; they break up. This gives the muscles more of a natural look. It also prevents female characters from appearing too muscular. Skin and fat blunt some muscular definition, and the broken lines are a way of showing that.

THE HANDS

Expressive hands can underscore a character's mood—or betray it. A mysterious hand gesture can lend a spooky effect to a scene. Nervous, twitchy hands can reveal the inner thoughts of a fast-talking con man. More than any other part of the body, except perhaps the skull, the hands rely on the skeleton for their form. Take a look.

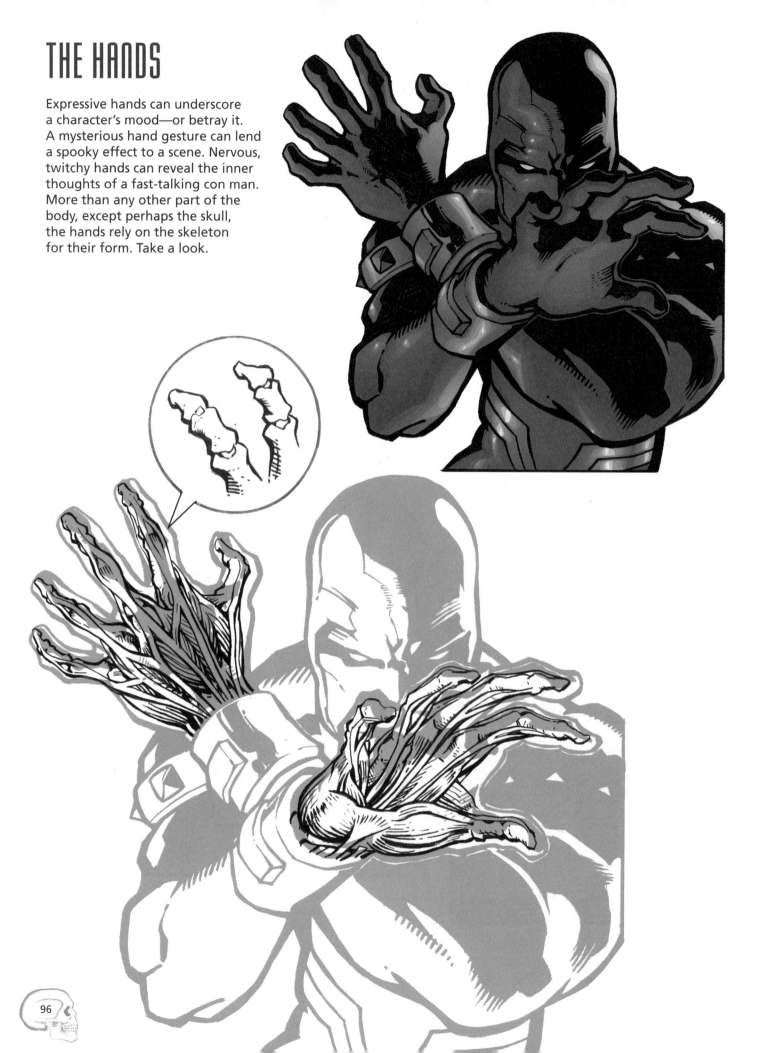

Hands express dramatic attitudes. So, it's not enough to get the anatomy of the hand right; hands must also reflect a character's inner thoughts or intentions. Sometimes, a fidgeting hand may tell you what a character is feeling when his face reveals nothing. So, what makes hands so *difficult* to draw? Really, it's *the placement of the knuckles*, or joints. You have to tackle that before you draw the fingers.

Note the rounded triangle at the base of the thumb; this is what gives the palm its width.

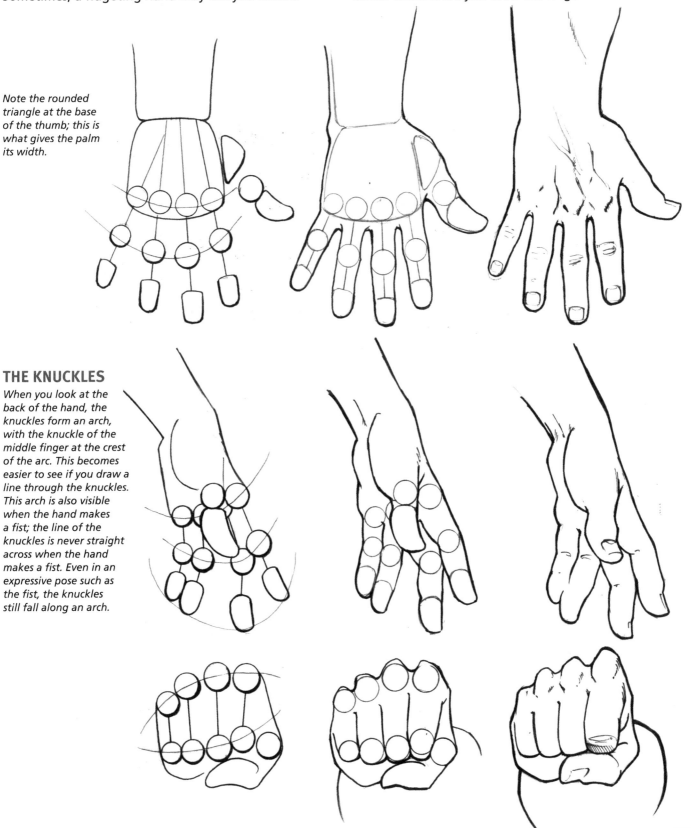

THE KNUCKLES

When you look at the back of the hand, the knuckles form an arch, with the knuckle of the middle finger at the crest of the arc. This becomes easier to see if you draw a line through the knuckles. This arch is also visible when the hand makes a fist; the line of the knuckles is never straight across when the hand makes a fist. Even in an expressive pose such as the fist, the knuckles still fall along an arch.

VARIOUS HAND POSES

The cool thing about drawing hands for comics is all the costume accessories and props that can accompany them. For example, costumes frequently extend all the way to the hands. Weapons need to be handled. And comic book women need their jewelry. Here's a good assortment of hand positions, straight from the wardrobe department.

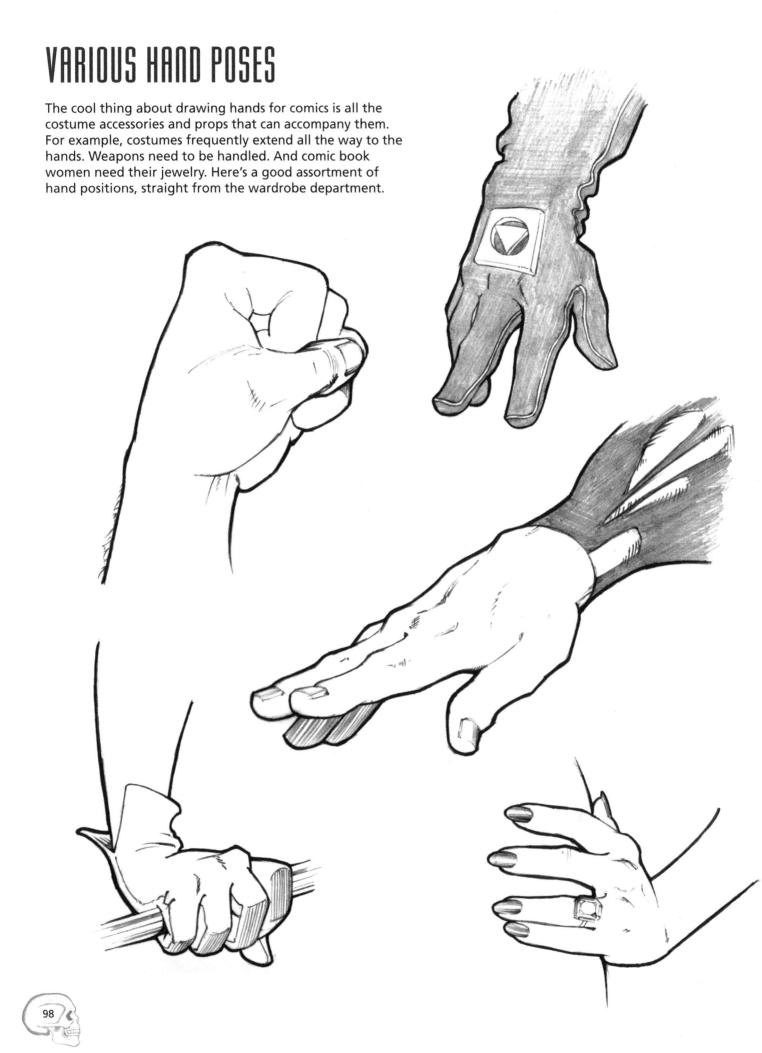

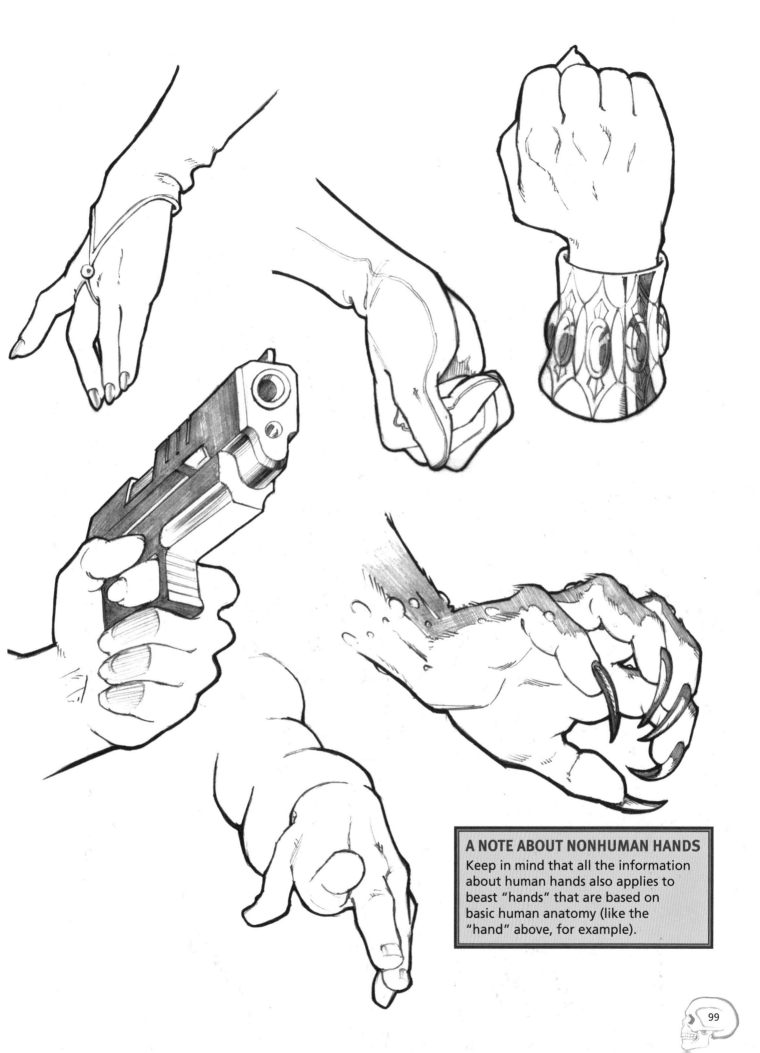

A NOTE ABOUT NONHUMAN HANDS
Keep in mind that all the information about human hands also applies to beast "hands" that are based on basic human anatomy (like the "hand" above, for example).

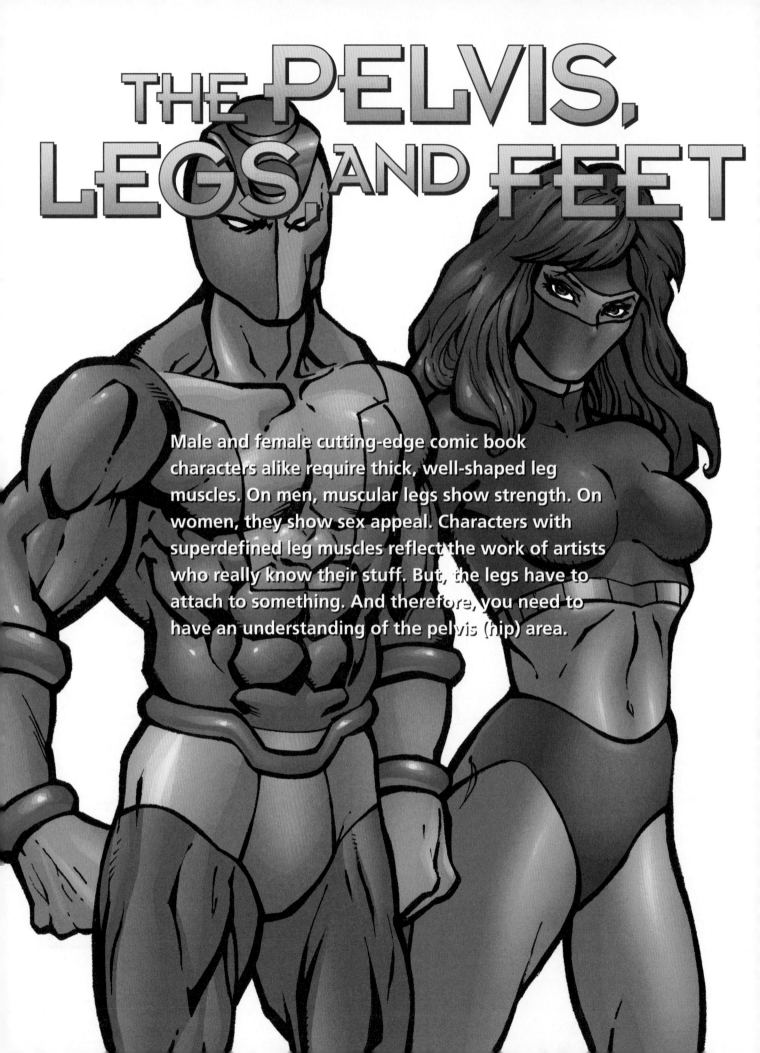

THE PELVIS, LEGS AND FEET

Male and female cutting-edge comic book characters alike require thick, well-shaped leg muscles. On men, muscular legs show strength. On women, they show sex appeal. Characters with superdefined leg muscles reflect the work of artists who really know their stuff. But, the legs have to attach to something. And therefore, you need to have an understanding of the pelvis (hip) area.

THE PELVIS

The pelvis has tremendous bone density. It has to. The thickest parts of the spine and the thigh muscles connect to it. The pelvis withstands all the stress of the body. The spine wedges firmly into the pelvic bone. The pelvis flares out to give the hips width, but it also has depth. Some artists like to think of it as a bowl that houses the internal organs.

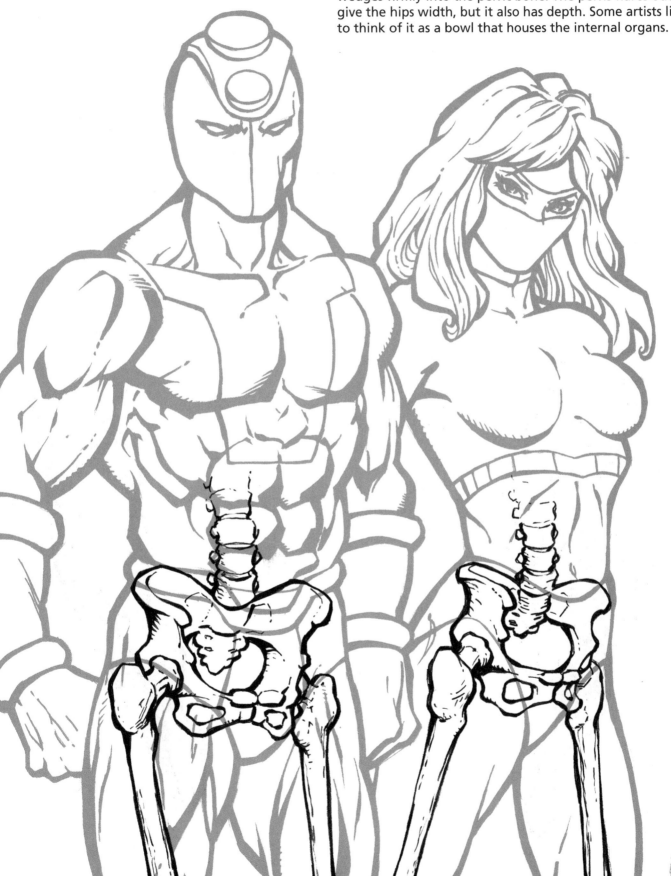

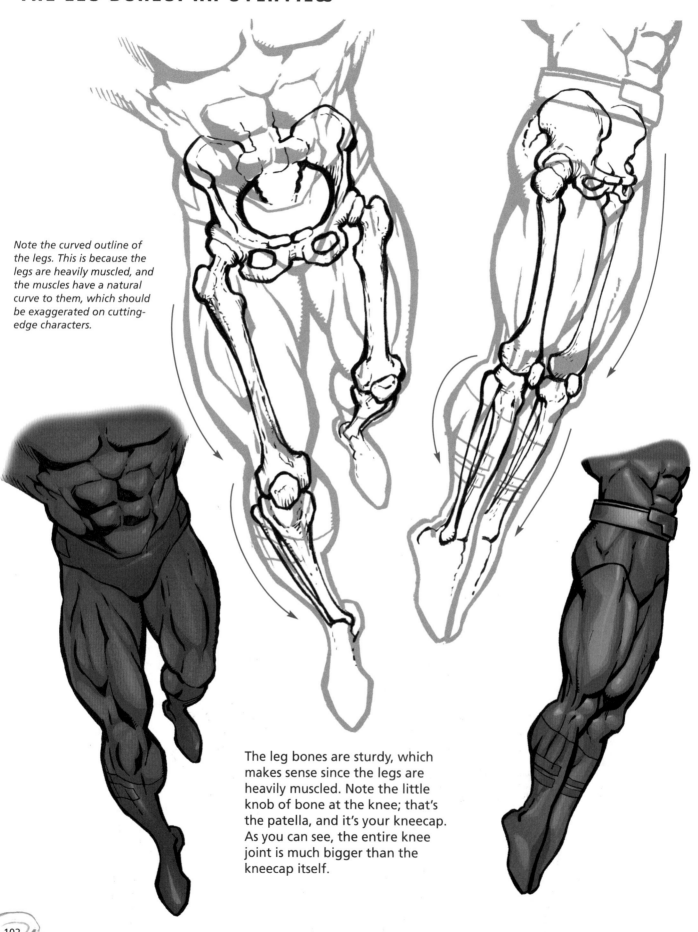

Note the curved outline of the legs. This is because the legs are heavily muscled, and the muscles have a natural curve to them, which should be exaggerated on cutting-edge characters.

The leg bones are sturdy, which makes sense since the legs are heavily muscled. Note the little knob of bone at the knee; that's the patella, and it's your kneecap. As you can see, the entire knee joint is much bigger than the kneecap itself.

Some of these muscle groups may be familiar to you, as you may have noticed them in drawings or even on your own legs. The leg muscles on the average person are usually more defined than any other muscle group. This is because we use our leg muscles every day to carry lots of weight—the upper body—whereas other muscles often don't lift anything heavier than a bagel and cream cheese (and therefore remain underdeveloped).

The anterolateral muscle group in the upper leg is the one that contains the quadriceps, which is the most commonly known and easily recognizable muscle group. The quadriceps group has *four* major muscles: the rectus femoris (the middle muscle), vastus lateralis (the upper outer muscle), vastus medialis (the lower inner muscle), and vastus intermedius (the lower outer muscle). The anterolateral

group also contains the tensor fasciae latae, which you can think of as the hip muscle.

The sartorius is perhaps the most important leg muscle when it comes to creating the contour of the upper leg. It runs diagonally from the outer top of the thigh to the lower inner thigh area. It's what gives the inner thigh it's shape. You can see evidence of this muscle on most poses as it "pulls" the contour of the thigh muscles from the inner knee outward toward the hip. It gives the vastus medialis its teardrop shape. Commit this one to memory!

And finally, next to the sartorius and in the inner thigh are three more muscles: the pectineus, the adductor longus, and everyone's favorite, the adductor magnus. You can draw definition lines along the boundaries of each muscle if your character is extremely defined.

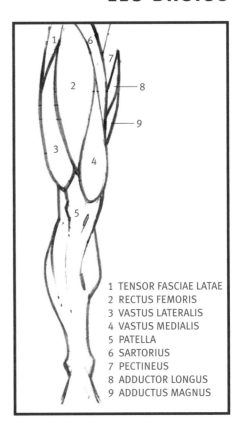

1 TENSOR FASCIAE LATAE
2 RECTUS FEMORIS
3 VASTUS LATERALIS
4 VASTUS MEDIALIS
5 PATELLA
6 SARTORIUS
7 PECTINEUS
8 ADDUCTOR LONGUS
9 ADDUCTUS MAGNUS

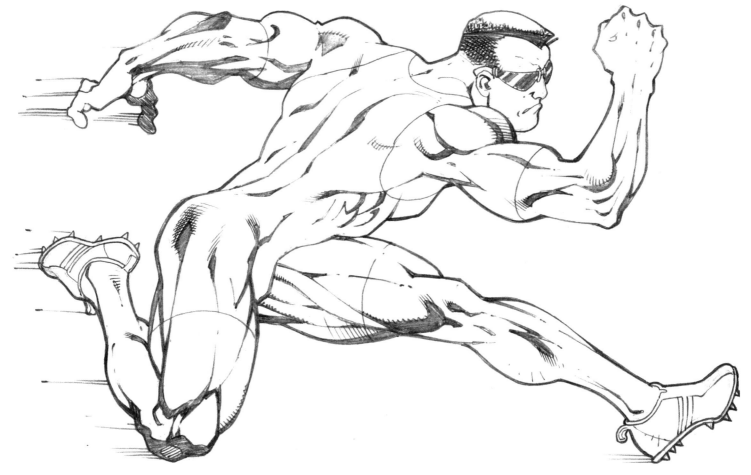

SIDE VIEW

You should flip back and forth from this page to the previous one, and observe the same muscles, by name or number, from different angles.

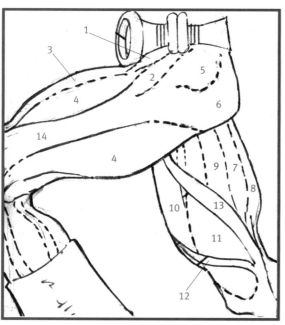

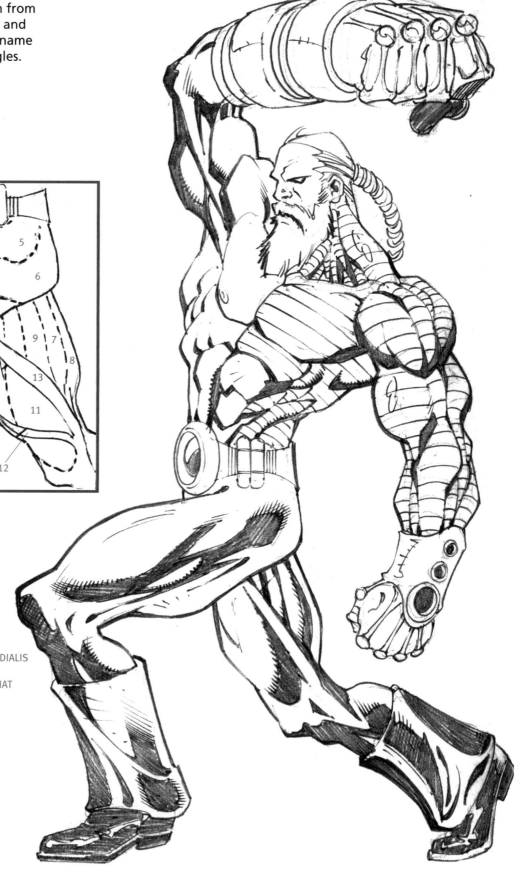

1 SARTORIUS
2 TENSOR FASCIAE LATAE
3 RECTUS FEMORIS
4 VASTUS LATERALIS
5 GLUTEUS MEDIUS
6 GLUTEUS MAXIMUS
7 SEMIMEMBRANOSUS
8 SEMITENDINOSUS
9 ADDUCTOR MAGNUS
10 RECTUS FEMORIS
11 VASTUS MEDIALIS
12 INFERIOR EXTREMITY OF VASTUS MEDIALIS
13 SARTORIUS
14 FASCIA LATA (THIS IS THE TENDON THAT COVERS THE VASTUS LATERALIS)

It's sometimes easier to grasp the concept of the leg muscles on a bulky character simply because the muscles are enlarged. So have a look.

1 RECTUS FEMORIS
2 FASCIA LATA (TENDON)
3 GLUTEUS MEDIUS
4 SEMIMEMBRANOSUS
5 VASTUS LATERALIS
6 BICEPS FEMORIS
7 GLUTEUS MAXIMUS

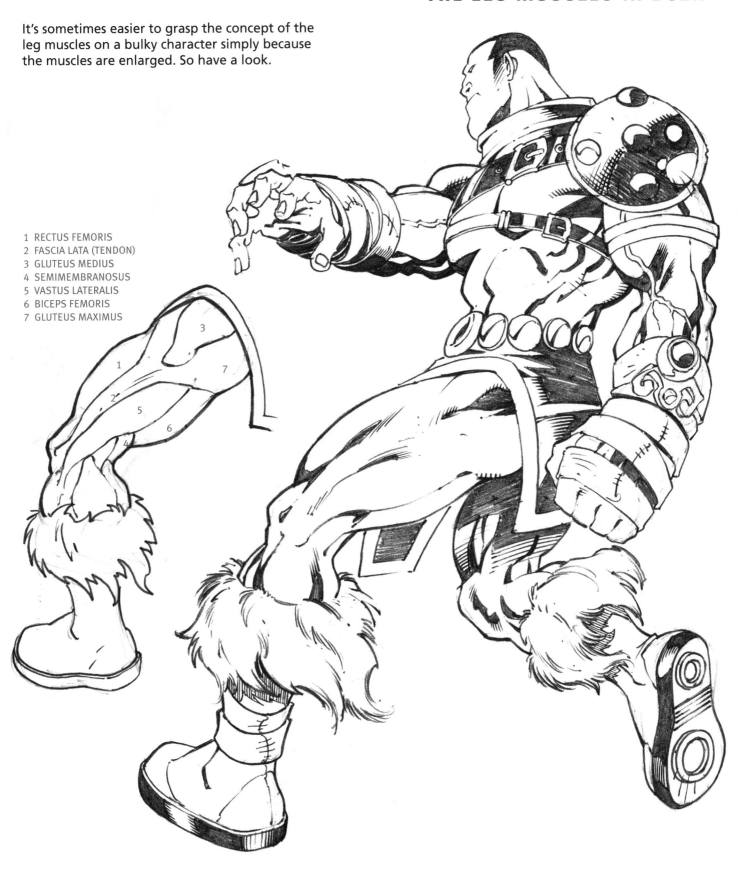

THE FEMALE LEG

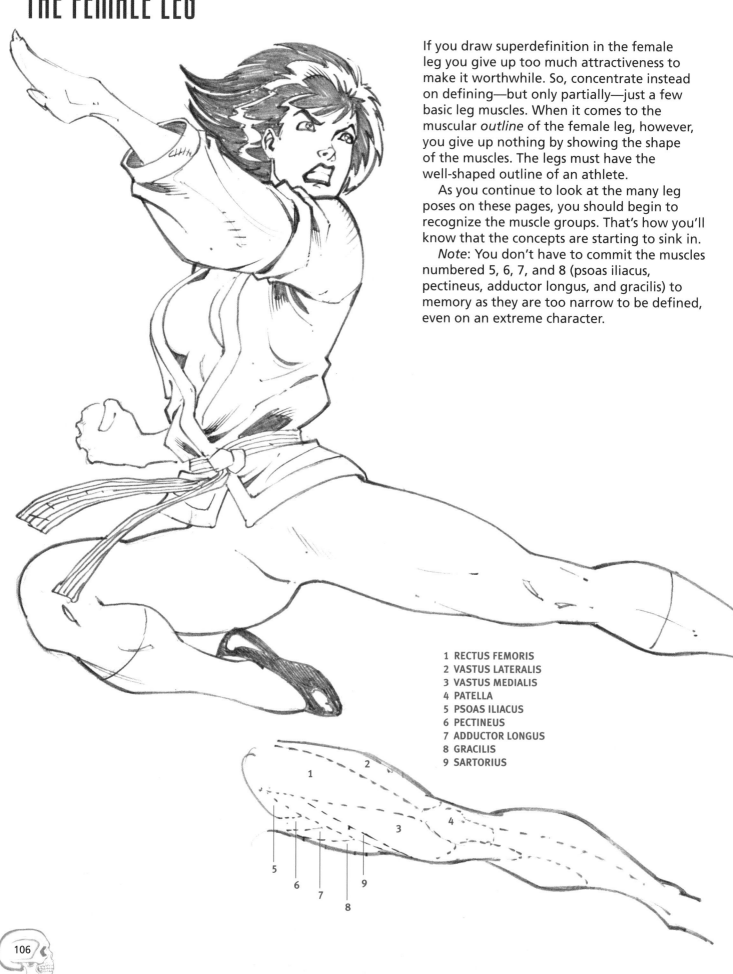

If you draw superdefinition in the female leg you give up too much attractiveness to make it worthwhile. So, concentrate instead on defining—but only partially—just a few basic leg muscles. When it comes to the muscular *outline* of the female leg, however, you give up nothing by showing the shape of the muscles. The legs must have the well-shaped outline of an athlete.

As you continue to look at the many leg poses on these pages, you should begin to recognize the muscle groups. That's how you'll know that the concepts are starting to sink in.

Note: You don't have to commit the muscles numbered 5, 6, 7, and 8 (psoas iliacus, pectineus, adductor longus, and gracilis) to memory as they are too narrow to be defined, even on an extreme character.

1 RECTUS FEMORIS
2 VASTUS LATERALIS
3 VASTUS MEDIALIS
4 PATELLA
5 PSOAS ILIACUS
6 PECTINEUS
7 ADDUCTOR LONGUS
8 GRACILIS
9 SARTORIUS

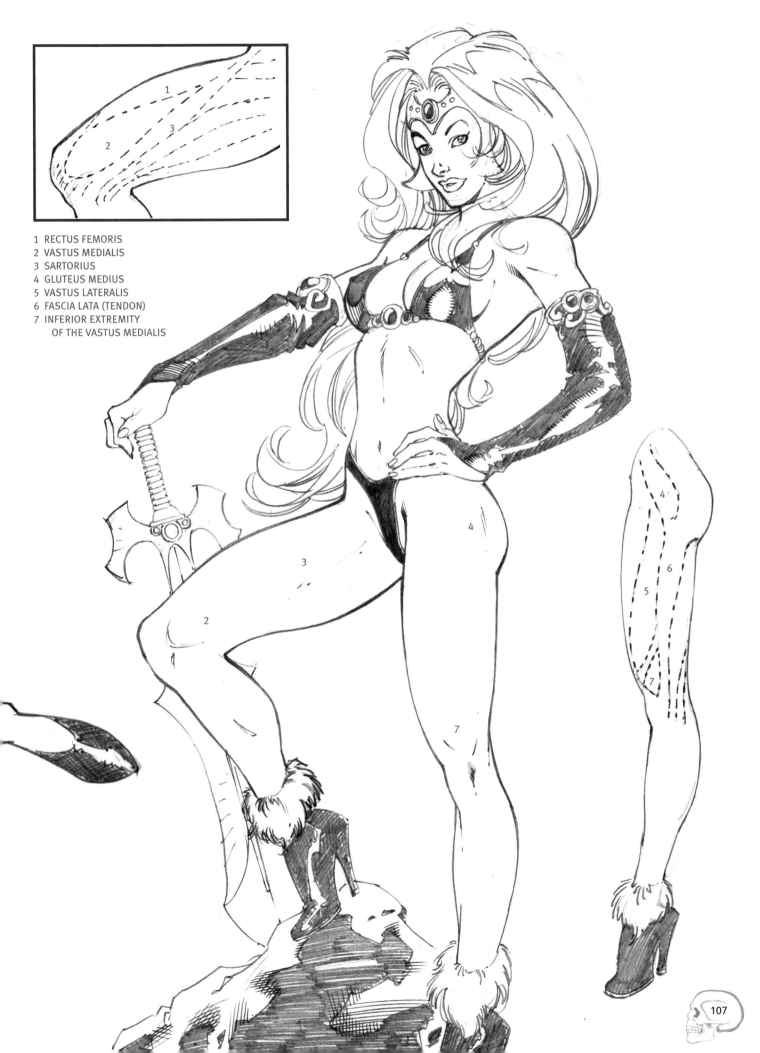

1 RECTUS FEMORIS
2 VASTUS MEDIALIS
3 SARTORIUS
4 GLUTEUS MEDIUS
5 VASTUS LATERALIS
6 FASCIA LATA (TENDON)
7 INFERIOR EXTREMITY
 OF THE VASTUS MEDIALIS

SIDE VIEW OF THE FEMALE LEG

Take a look at the muscles. By comparing them to their locations on the previous pages, you can begin to predict their placement.

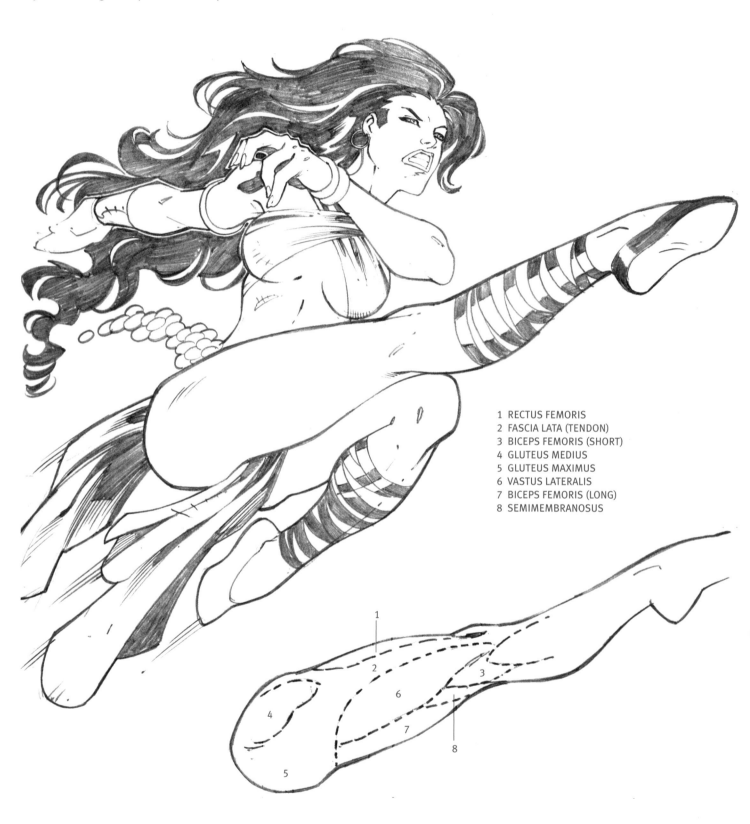

1 RECTUS FEMORIS
2 FASCIA LATA (TENDON)
3 BICEPS FEMORIS (SHORT)
4 GLUTEUS MEDIUS
5 GLUTEUS MAXIMUS
6 VASTUS LATERALIS
7 BICEPS FEMORIS (LONG)
8 SEMIMEMBRANOSUS

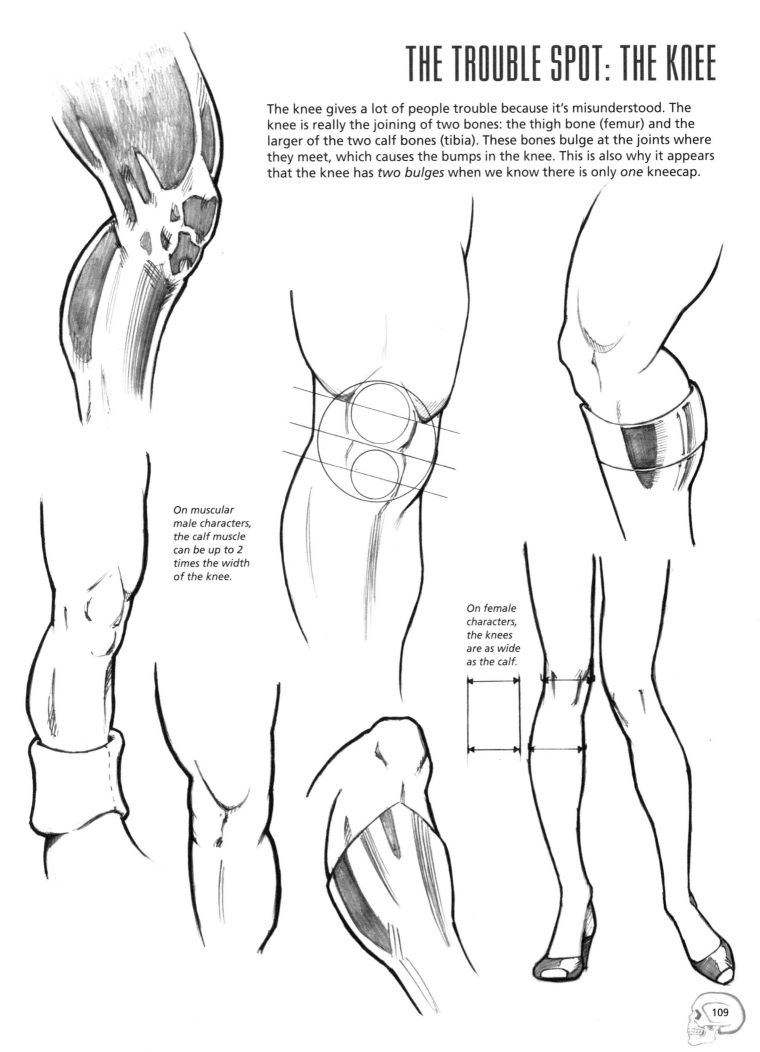

THE TROUBLE SPOT: THE KNEE

The knee gives a lot of people trouble because it's misunderstood. The knee is really the joining of two bones: the thigh bone (femur) and the larger of the two calf bones (tibia). These bones bulge at the joints where they meet, which causes the bumps in the knee. This is also why it appears that the knee has *two bulges* when we know there is only *one* kneecap.

On muscular male characters, the calf muscle can be up to 2 times the width of the knee.

On female characters, the knees are as wide as the calf.

BACK VIEW

You don't see the backs of the legs a whole lot because artists don't draw them that often. First of all, it's hard to recognize a character from the back: The face isn't visible. The hairstyle can't be seen clearly. And, the styling of the costume and any insignias happens more on the front of the figure.

Of course, there are times when it's necessary to show the back of a character. And, even from the rear, you can recognize some muscle groups that are also visible in the side and front views since many of the leg muscles wrap around the legs.

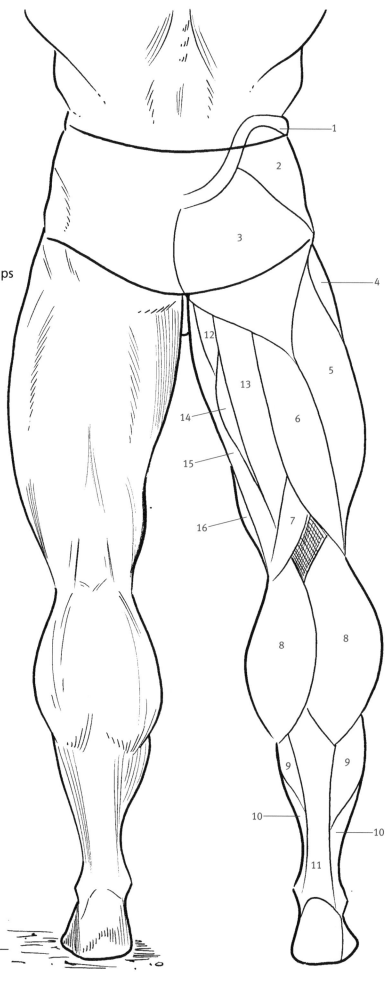

1 PELVIS (HIP BONE)
2 GLUTEUS MEDIUS
3 GLUTEUS MAXIMUS
4 TENSOR FASCIAE LATAE
5 VASTUS LATERALIS
6 BICEPS FEMORIS
7 SEMIMEMBRANOSUS
8 INNER AND OUTER GASTROCNEMIUS
9 SOLEUS
10 PERONEUS BREVIS
11 TENDON
12 ADDUCTOR MAGNUS
13 SEMITENDINOSUS
14 SEMIMEMBRANOSUS
15 GRACILIS
16 SARTORIUS

CALF MUSCLES

The calf muscles on comic book characters are usually pumped. The big calf muscle in the back (the gastrocnemius) is like the biceps of the lower leg—it can ball up when flexed and is a good "show" muscle.

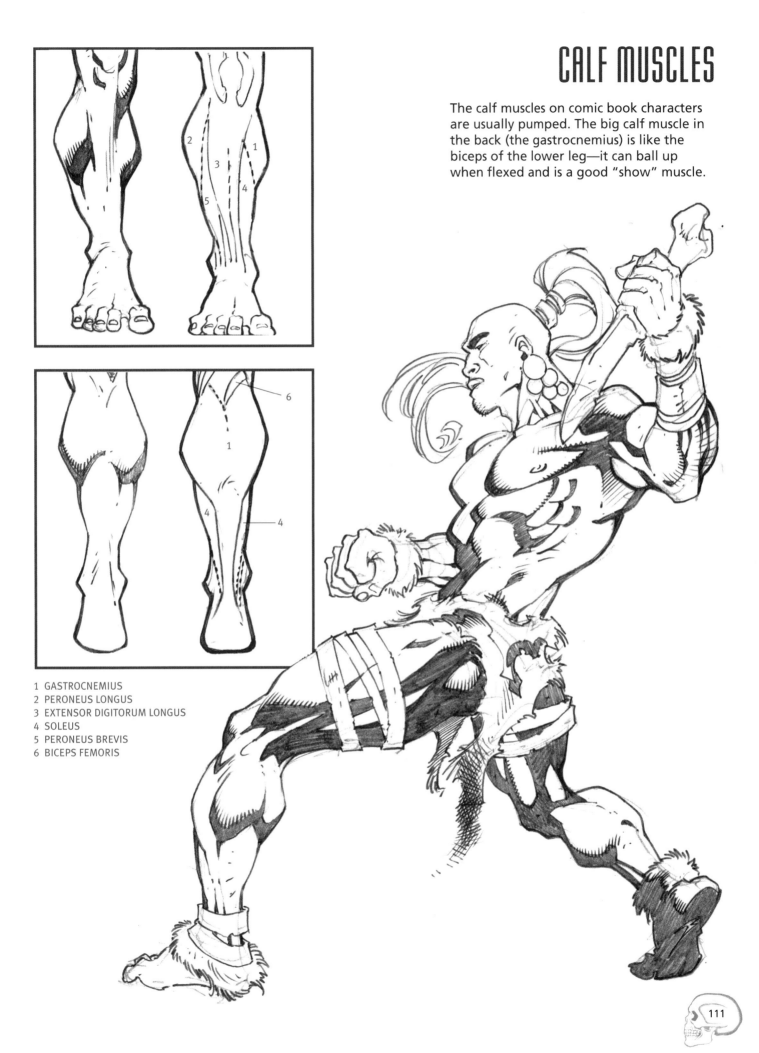

1 GASTROCNEMIUS
2 PERONEUS LONGUS
3 EXTENSOR DIGITORUM LONGUS
4 SOLEUS
5 PERONEUS BREVIS
6 BICEPS FEMORIS

FEMALE CALF MUSCLES

Women's calf muscles often display more definition because high-heeled shoes force the calf into a flexing state. The tibialis anterior muscle (number 3) protrudes slightly beyond the shinbone (but doesn't offer enough padding if you ever get kicked there!).

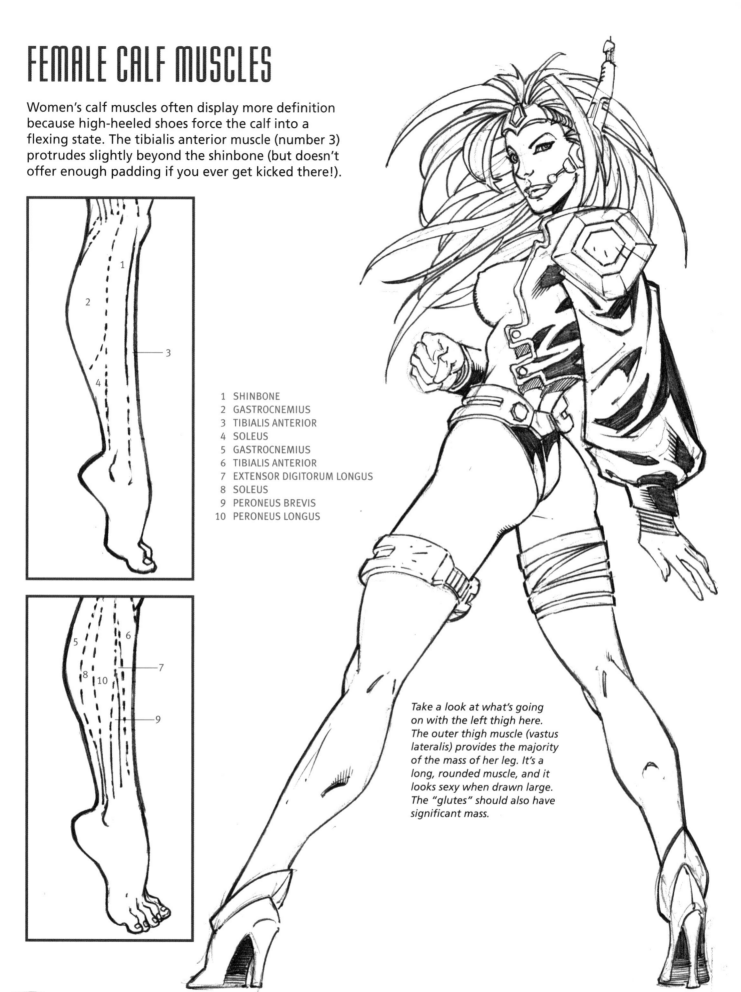

1 SHINBONE
2 GASTROCNEMIUS
3 TIBIALIS ANTERIOR
4 SOLEUS
5 GASTROCNEMIUS
6 TIBIALIS ANTERIOR
7 EXTENSOR DIGITORUM LONGUS
8 SOLEUS
9 PERONEUS BREVIS
10 PERONEUS LONGUS

Take a look at what's going on with the left thigh here. The outer thigh muscle (vastus lateralis) provides the majority of the mass of her leg. It's a long, rounded muscle, and it looks sexy when drawn large. The "glutes" should also have significant mass.

Okay, here's the deal with the feet: The inner anklebone is always higher than the outer anklebone. The balls of the feet are comprised of two areas: inner and outer, with the inner area (the one behind the big toe) being the larger of the two. The toes descend in length from the middle toe down to the pinky toe; on some people, the second toe is at least as long as the big toe, and sometimes longer. The arch occurs on the inner side of the foot between the heel and the ball of the foot, and it's even more pronounced when the foot is in high-heeled shoes or boots. The heel sticks out slightly.

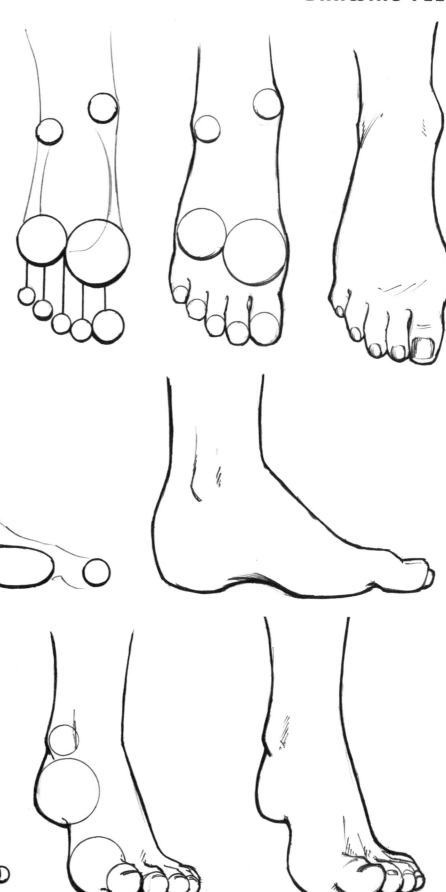

THE BONES OF THE FOOT

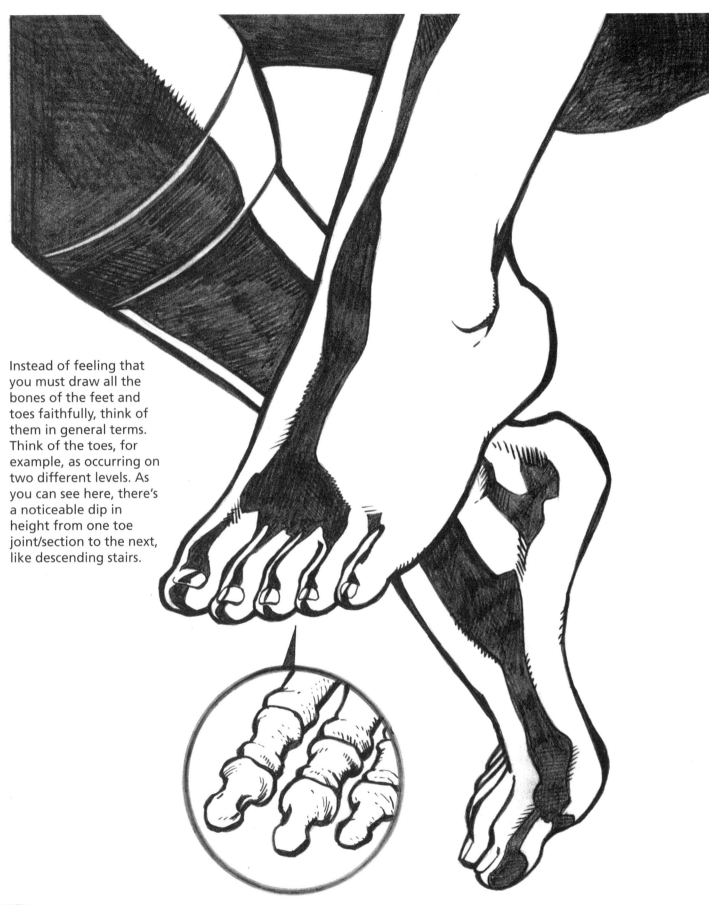

Instead of feeling that you must draw all the bones of the feet and toes faithfully, think of them in general terms. Think of the toes, for example, as occurring on two different levels. As you can see here, there's a noticeable dip in height from one toe joint/section to the next, like descending stairs.

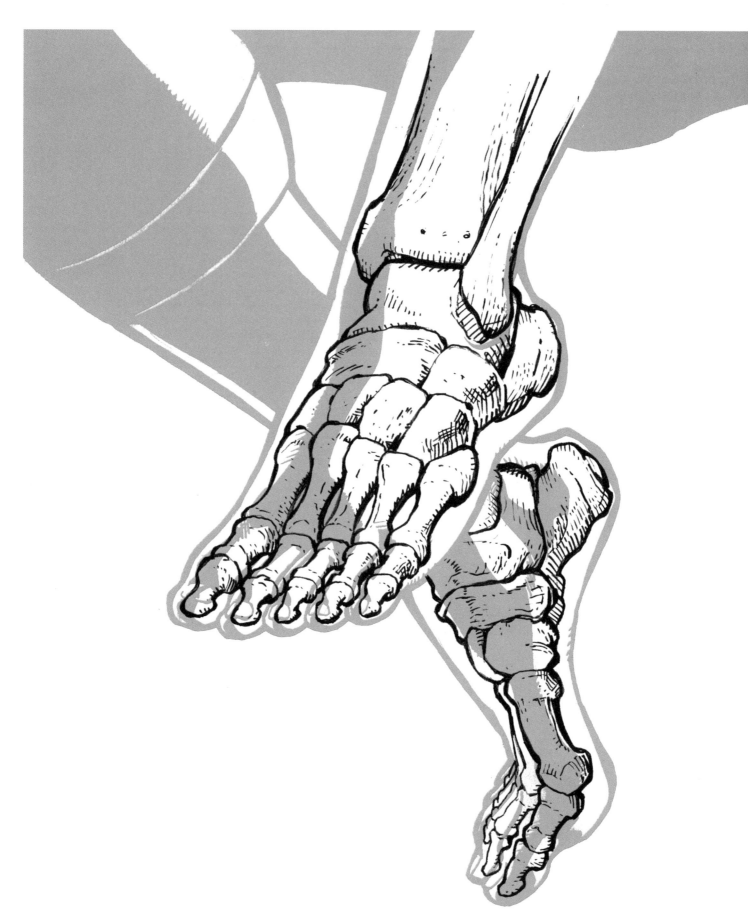

SHOES AND BOOTS

Even the feet can use a little visit to the wardrobe department in order to complete a character's costume.

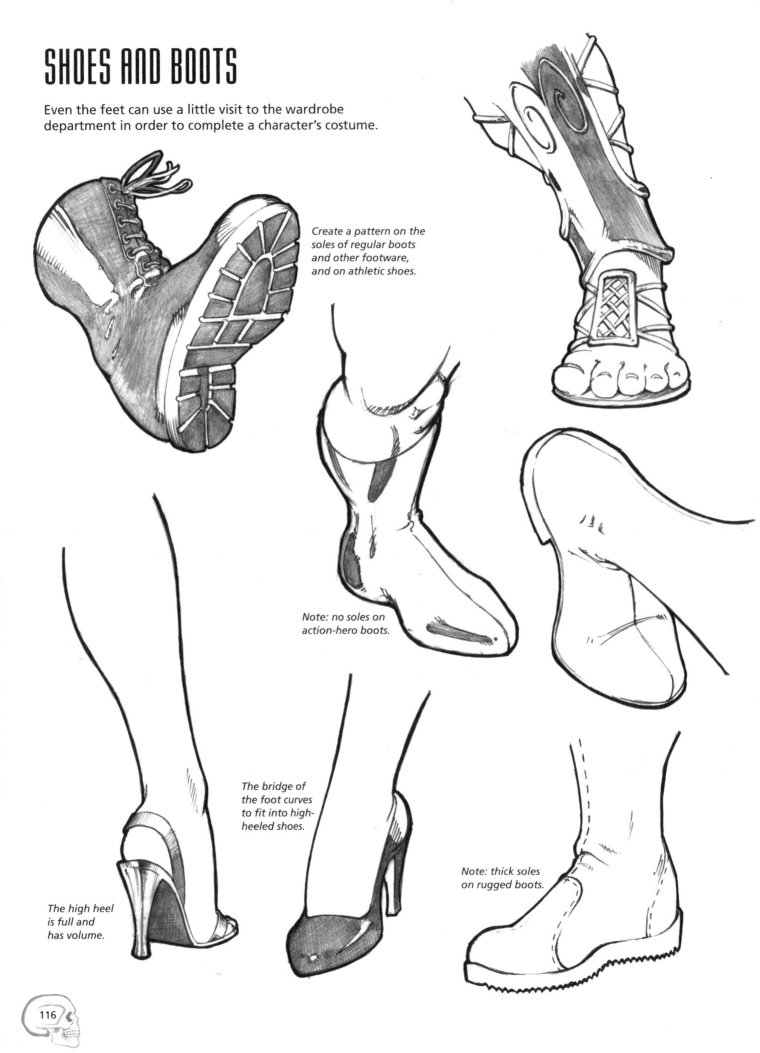

Create a pattern on the soles of regular boots and other footware, and on athletic shoes.

Note: no soles on action-hero boots.

The bridge of the foot curves to fit into high-heeled shoes.

The high heel is full and has volume.

Note: thick soles on rugged boots.

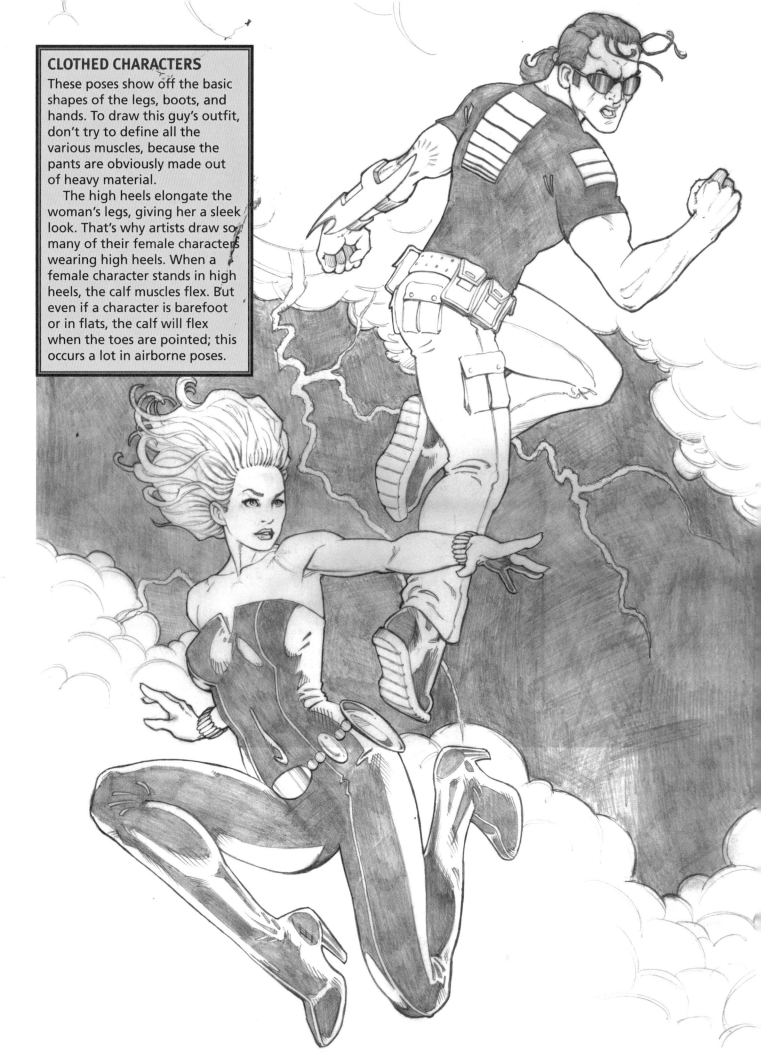

CLOTHED CHARACTERS

These poses show off the basic shapes of the legs, boots, and hands. To draw this guy's outfit, don't try to define all the various muscles, because the pants are obviously made out of heavy material.

The high heels elongate the woman's legs, giving her a sleek look. That's why artists draw so many of their female characters wearing high heels. When a female character stands in high heels, the calf muscles flex. But even if a character is barefoot or in flats, the calf will flex when the toes are pointed; this occurs a lot in airborne poses.

THE COMPLETE LEG

You don't need to show every single muscle in a finished pose—in fact, you shouldn't, as this would make the drawing look overworked. Concentrate on the larger, bulkier muscles and define those. The sartorius muscle is an exception: long and lean, and traveling from the inner knee to the outer hip, it gives the inner quadriceps its teardrop shape. While there are many leg muscles, the four most important ones for drawing are the vastus lateralis, rectus femoris, vastus medialis, and sartorius.

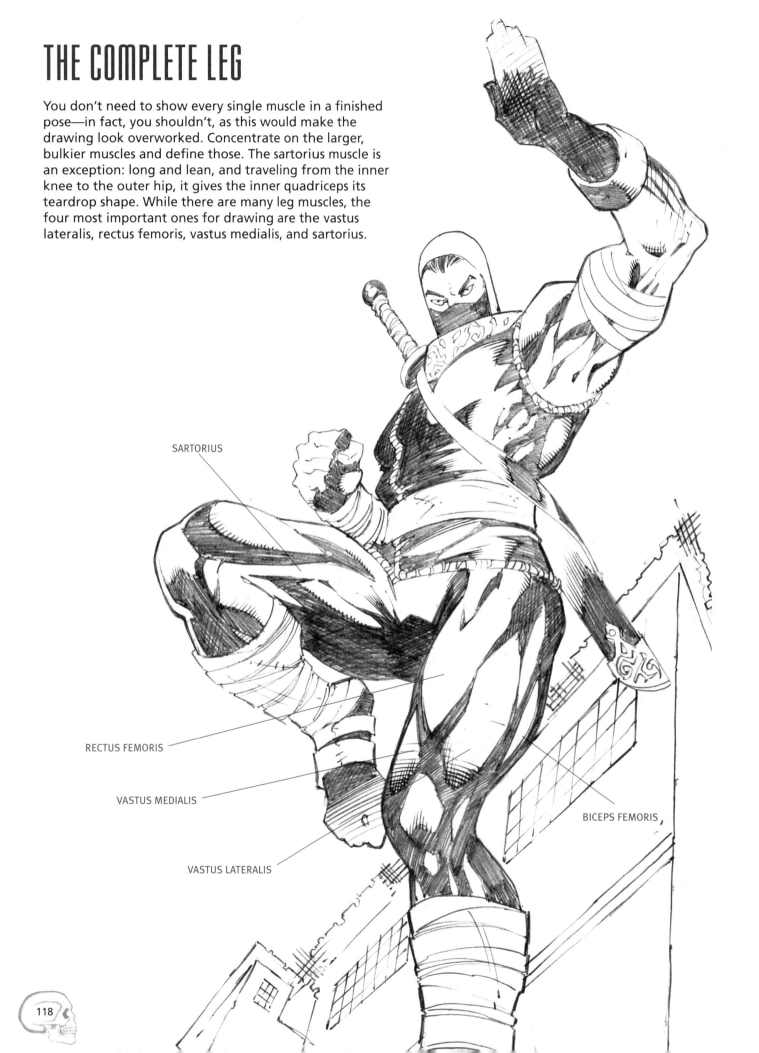

SARTORIUS

RECTUS FEMORIS

VASTUS MEDIALIS

VASTUS LATERALIS

BICEPS FEMORIS

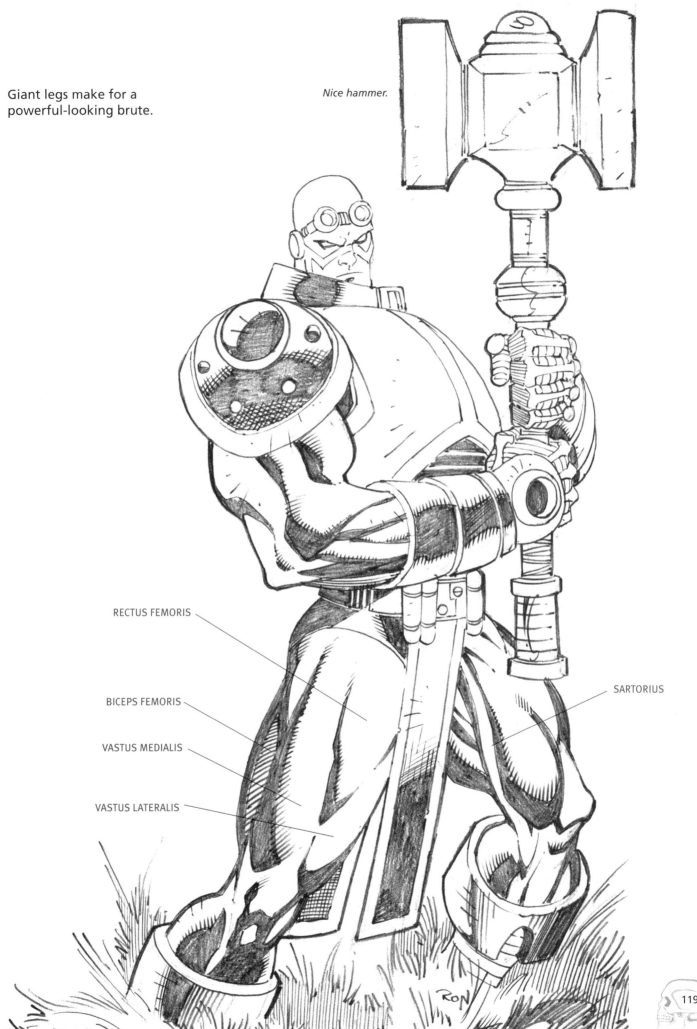

Giant legs make for a
powerful-looking brute.

Nice hammer.

RECTUS FEMORIS

BICEPS FEMORIS

VASTUS MEDIALIS

VASTUS LATERALIS

SARTORIUS

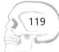

119

THE COMPLETE FEMALE LEG

Attractive women don't need *any* definition to their legs—or if they do, it's only a minimal amount. But, *the outline of the leg must be muscular* and must reflect the placement of the pelvis. The gluteus maximus, thigh, and calf muscles must all have size. Note the width of the skeletal pelvis on the initial rough sketch.

Whereas with men it's important to define the knee, showing where the patella (kneecap) meets the top of the tibia (shinbone), with women it's important to *minimize* the definition. Avoid a bony look to the knee area. Add a sketch line or two, indicating the tibia as it travels from the knee to the foot, but cut the line short. All you want is a slight indication of that bone, to hint at the contour of the leg.

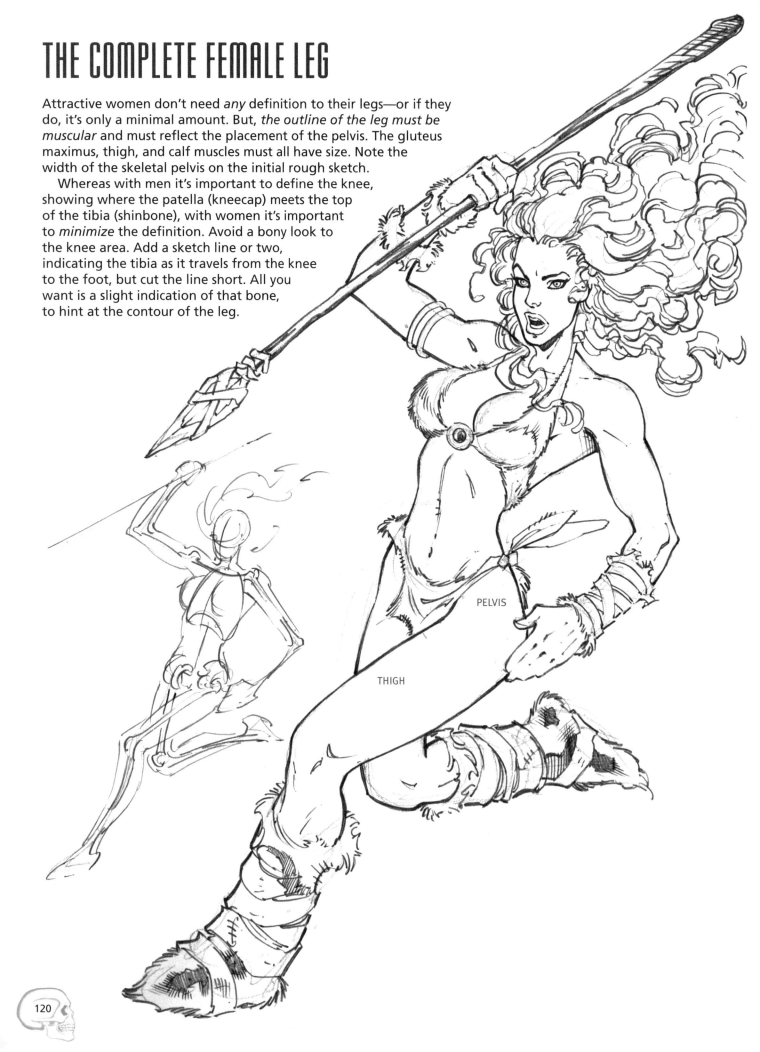

PELVIS

THIGH

GASTROCNEMESIS

VASTUS MEDIALIS

ELEMENTS TO PRACTICE

At this point, you may not have studied every single image, but that's okay because by now you have no doubt begun to understand some muscle groups that used to mystify you. And that's wonderful. This section contains additional helpful details that will help you finesse your drawings.

Keep in mind that you should try to not be a slave to the anatomy of a character. You still have to draw creatively. Anatomy should be a tool that helps you to draw convincing characters—and the characters, costumes, and poses must come from your imagination, not from an anatomy book. Draw a cool pose and *then* correct the anatomy; don't draw every muscle during your initial sketch. Choosing what and how to define the muscles is a creative choice. It's an artistic choice, and it's *your* choice.

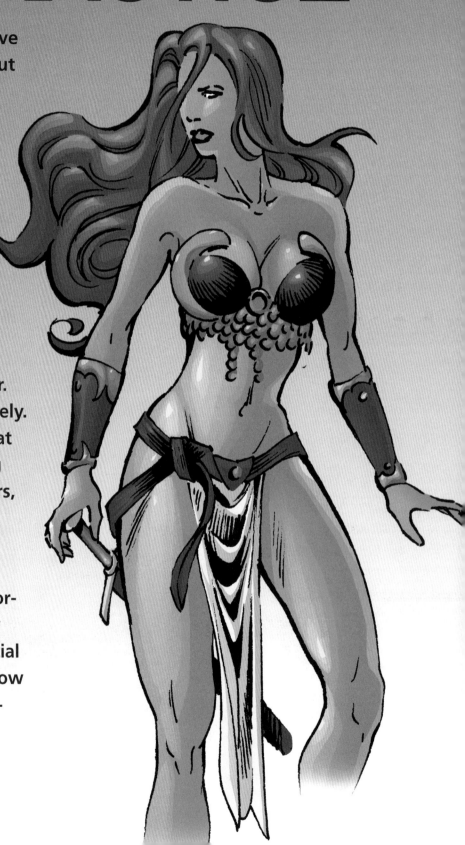

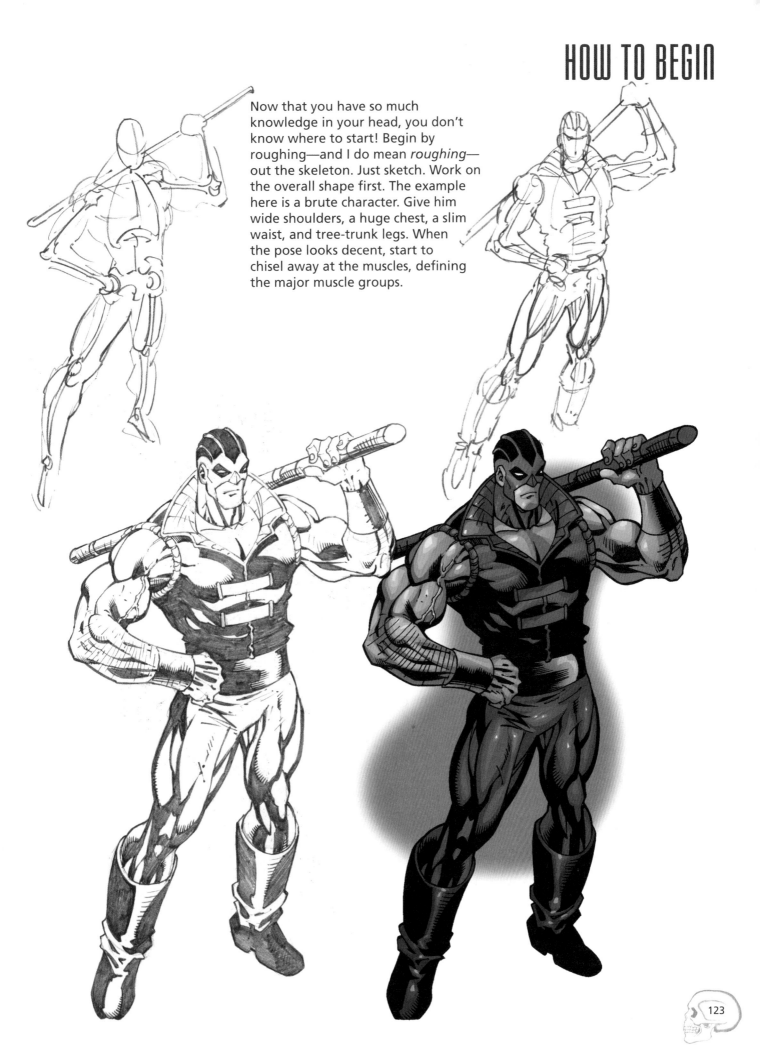

Now that you have so much knowledge in your head, you don't know where to start! Begin by roughing—and I do mean *roughing*—out the skeleton. Just sketch. Work on the overall shape first. The example here is a brute character. Give him wide shoulders, a huge chest, a slim waist, and tree-trunk legs. When the pose looks decent, start to chisel away at the muscles, defining the major muscle groups.

RENDERING THE MUSCLES

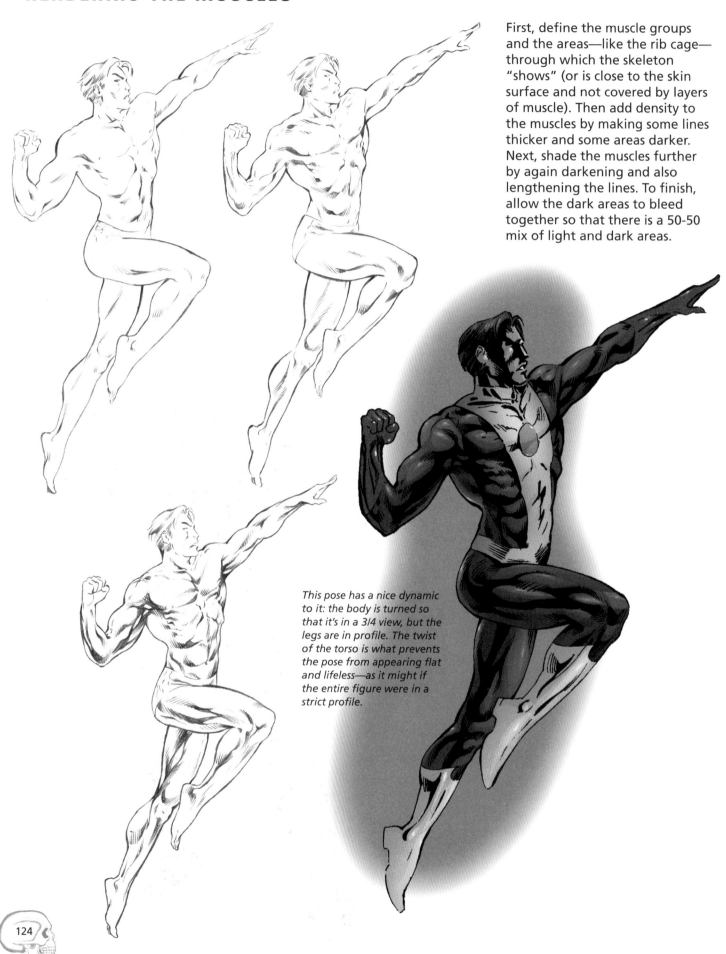

First, define the muscle groups and the areas—like the rib cage—through which the skeleton "shows" (or is close to the skin surface and not covered by layers of muscle). Then add density to the muscles by making some lines thicker and some areas darker. Next, shade the muscles further by again darkening and also lengthening the lines. To finish, allow the dark areas to bleed together so that there is a 50-50 mix of light and dark areas.

This pose has a nice dynamic to it: the body is turned so that it's in a 3/4 view, but the legs are in profile. The twist of the torso is what prevents the pose from appearing flat and lifeless—as it might if the entire figure were in a strict profile.

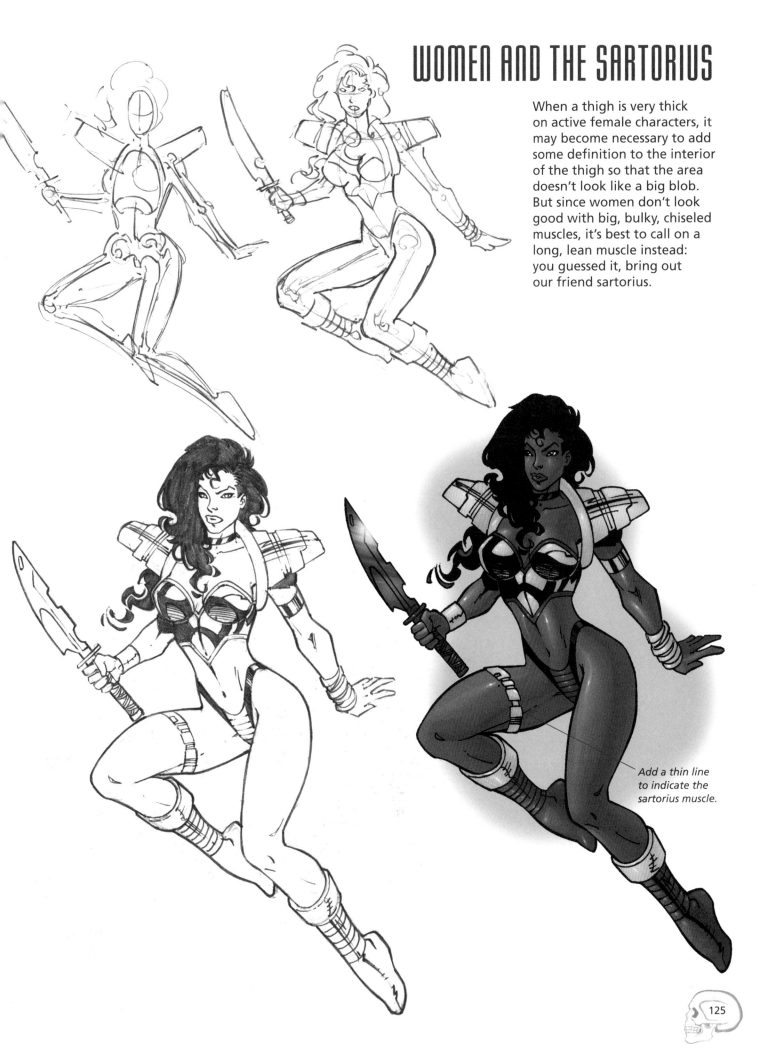

WOMEN AND THE SARTORIUS

When a thigh is very thick on active female characters, it may become necessary to add some definition to the interior of the thigh so that the area doesn't look like a big blob. But since women don't look good with big, bulky, chiseled muscles, it's best to call on a long, lean muscle instead: you guessed it, bring out our friend sartorius.

Add a thin line to indicate the sartorius muscle.

LATS AND A GOOD BACK VIEW

The huge "lats" (latissimus dorsi) on this character give him his impressive stature. In this pose, the back curves toward the reader because the figure holds his arms in front of his body. This curving action causes his shoulder blades to spread out, giving him even more width. Note how far down the back the lats go. The spine should be visible all the way down the back, but is drawn with a broken line so that it doesn't become overemphasized and detract from the back muscles.

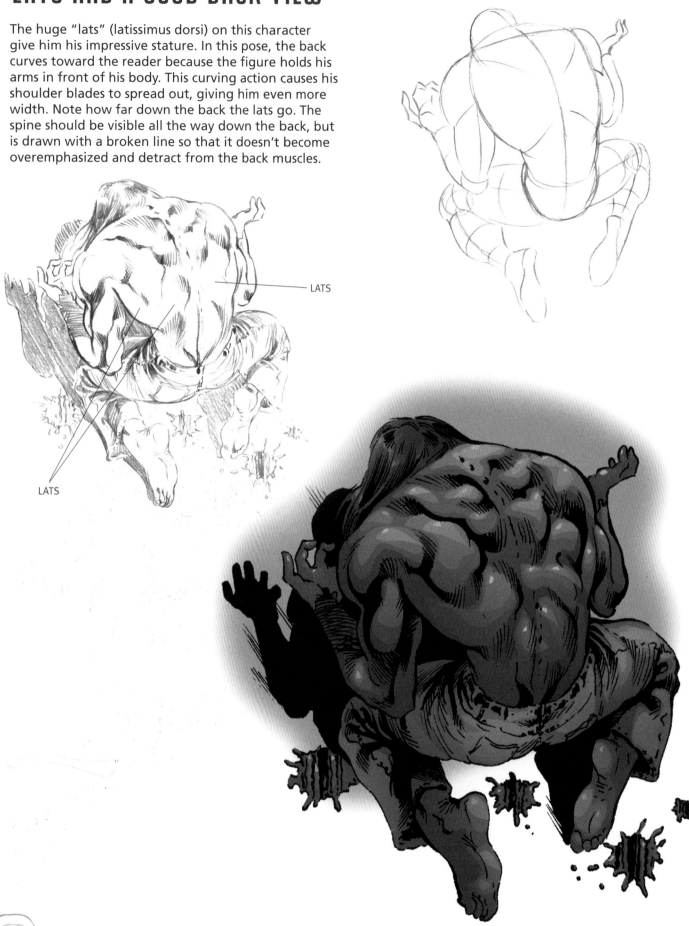

LATS

LATS

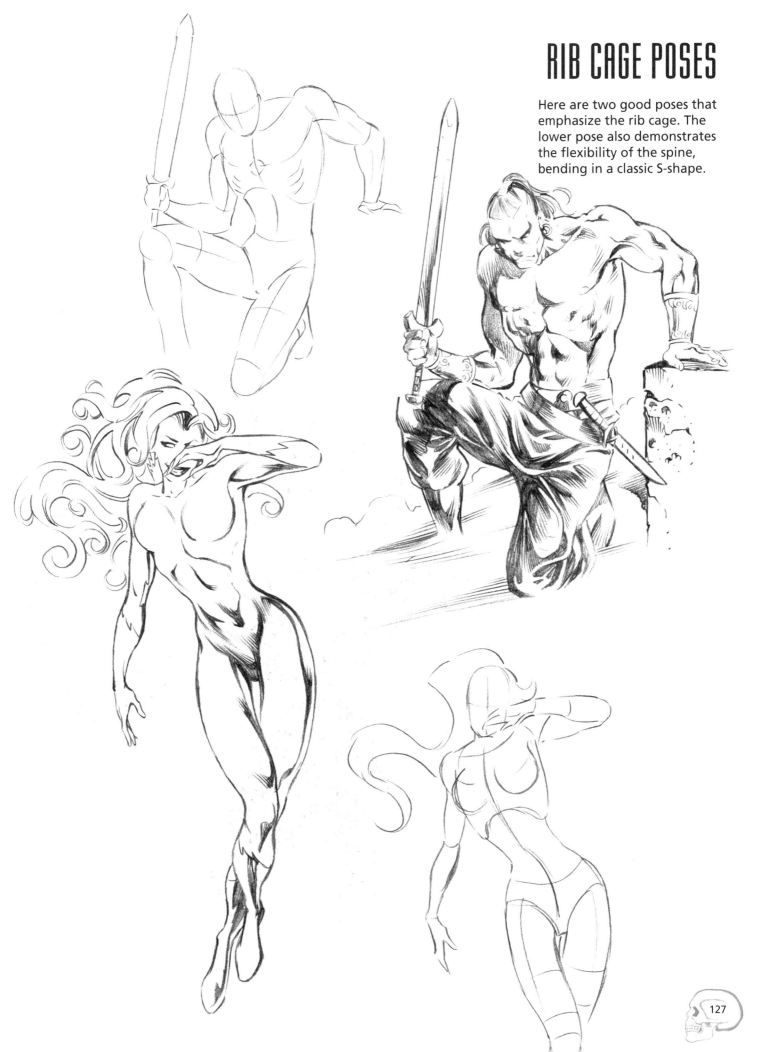

RIB CAGE POSES

Here are two good poses that emphasize the rib cage. The lower pose also demonstrates the flexibility of the spine, bending in a classic S-shape.

KEEPING IT SIMPLE

No matter how complex the muscles may look, the basic pose of each of these characters is straightforward—it has to be. If the pose itself is complex, it will be hard to read, and adding muscles on top of it would only make it more confusing. Good poses are basic poses, as you can see from the initial sketches here.

BE CREATIVE!
Remember that you can adjust these characters to your personal taste. Perhaps you'd like to replace the bow and arrow with a more modern weapon, like a laser rifle. Perhaps she could use a pair of mecha-style wings. Instead of a cape, the guy on the facing page could have the legs and tail of a lizard. These are only starting points; the rest is up to you.

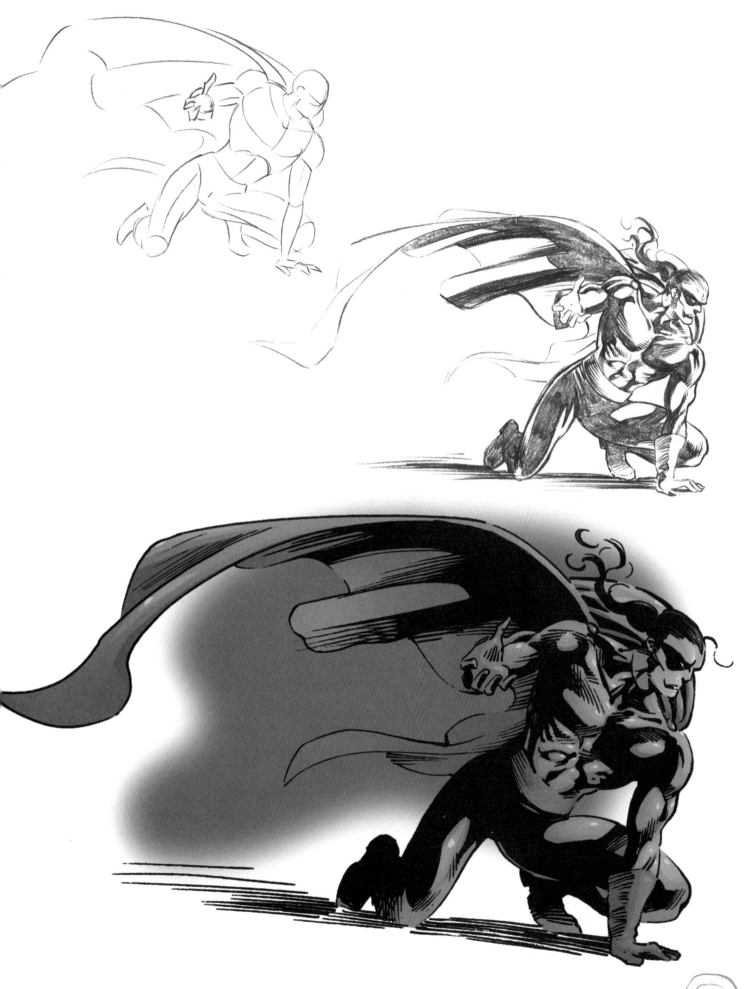

THE BIZ

For artists who want to get published, there's nothing so mysterious as how to get started. It sometimes seems as if you have to invent the road map for success all by yourself. Thankfully, that's not the case. There's a tried and true career path, but many artists waste lots of time because they discover it only by trial and error. This section will save you lots of wasted time and frustration. You'll learn how to get published and what your next steps should be as you climb the ladder in the comic book biz.

STARTING OUT: THE ASHCAN AND OTHER STRATEGIES

How do you get someone to take notice of you, let alone hire you? You could always show editors your portfolio at comic book conventions. That's a great way to do it. But more and more, artists are opting for a method that brings their presentation to a higher level in the hopes of being taken more seriously by an editor. They do something called an *ashcan*, which can be given away at conventions or mailed as part of a submission package. An ashcan is a self-published, short comic book sample. Don't confuse it with a self-published comic book, distributed to comic book retailers. The ashcan is not to be distributed for sale; and it's not printed on comic book stock (paper). It may be eight to twelve pages. It can contain portfolio pieces, but mainly, it's a vehicle to show off an artist's skill at drawing sequential art (the panel-by-panel scene format of comic book art). It should involve well-drawn, original characters, and a number of scenes with mood, energy, and action. It should show how you can handle dialogue with interesting shots—not just "talking heads."

The advantage of the ashcan over the traditional portfolio is that it gives the editor a sense of your ability to deliver material in the form they want. It also shows that you understand the medium and all its elements, such as dialogue balloons, panels, and layout. Ashcans are almost always done in black and white, for expense reasons. And you'll most likely have to do the penciling as well as the inking, lettering, and printing. Most people get their ashcans printed at local print shops on copy paper. Editors understand what an ashcan is and don't expect it to be printed on authentic comic book stock with a glossy cover.

APPRENTICING

Another option for getting started is apprenticing. Busy, successful artists often need help in their offices. This can range from office managing to doing errands, but the contacts you make—and the experiences you gain—are invaluable. Plus, it gives you the opportunity to show your drawings to someone who can do something about it. If you're any good, seasoned artists will likely give you a shot drawing for them when they get too busy.

DOING BACKGROUNDS

You can start off doing backgrounds for an established artist. Basically, you should ask to do anything the artist *doesn't* want to do. To get this work, submit your portfolio or ashcan. Make sure you have a business card, or print your contact information on the ashcan or portfolio (never send original art). You will also have more luck starting out by submitting your stuff to the smaller, independent publishers. The idea is just to get published. An unpublished artist is an unknown quantity. Being published in any form gives you more credibility.

BEING THE FILL-IN ARTIST

Once you've established a relationship with an artist, editor, or publisher, you may inquire about doing fill-ins. Fill-in work is needed when an artist takes a break from a book. Someone has to keep the series going. If the fill-in is well received, it may turn into a regular gig.

DRAWING POSTERS AND PINUPS

Publicity and promotional materials are always being churned out by publishers. Doing these "one-shots" is a good way to establish a working relationship.

GETTING HIRED ON A BOOK!

You've taken every job as an opportunity to improve and show how good your stuff is. And now it's being recognized. The publisher offers you a regular gig on a book. But you're not going it alone anymore. A lot of people are involved with putting the book together. It's a team, without the jerseys. And you'll become acquainted with the other team members' work, even if you don't speak to all of them individually.

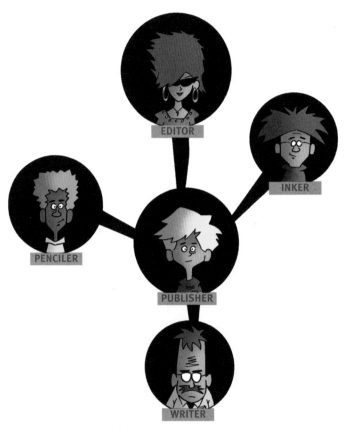

SELLING YOUR ART

If your work on a monthly book has gotten your name in front of the public, collectors may be interested in buying your original artwork. You can set up a Web site, where you can sell your published comic book art online. Some artists also make extra money by doing private commissions for collectors. Ebay is a popular site for artists without Web sites to sell their originals.

MAKING PUBLIC APPEARANCES

When you start getting established, it's *your* turn to appear at the conventions. This is important, as it keeps you in the public eye in front of your target audience. Convention appearances are publicized, which also adds to your prestige. And, people will buy your book just so they can have you sign it. Ahhh, life is good. But wait, it gets even better . . .

SIGNING AN EXCLUSIVE

If a publisher likes your work enough, he or she might ask you to sign an exclusive deal, which prohibits you from taking work with another publisher. This means you're guaranteed regular work—sometimes a lot of work, but you can negotiate for more dough.

BRANCHING OUT

Many comic book artists go into doing storyboards for the movies. Storyboard artists are very well compensated, and it's a nice change of pace. You can also do storyboards for commercials. Some artists go into video game or toy development. It's a good financial strategy to have multiple sources of income. Also, if you've signed an exclusive agreement with a comic book publisher, you're more likely to get permission to do outside work if it doesn't compete with your comic book work and—and this is a big *and*—if it won't slow you down.

LICENSING THE RIGHTS

Your book may get attention from the Hollywood community. Hollywood always looks to comic books for more material, and many, many popular films were first comic books. Try to hold onto as many rights as you can when you sell your idea to a publisher, otherwise, Hollywood will deal directly with your publisher and cut you out entirely from the book you created. Ouch!

CREATING SOMETHING NEW

You can create something new when you've established your credibility to the point where you can pitch a new idea for a comic book to an editor or the publisher. If they buy it—success!—you've launched your own series!

You can also flip and become part of management. Many successful comic book artists become editors or editor-contributors. You commute to the office, drink too much coffee, and tell other artists what to do. But be kind—and remember where you came from.

Being an editor gives you the chance to interact with many top-notch artists and writers. You oversee many books. And besides, it's nice to have someone else pick up the tab for your health care.

BECOMING A PUBLISHER

In this scenario, your book is so successful—spinning off movies and merchandise—that you form your own company as either an imprint of the publisher you've been working for, or your own independent publishing empire. A number of comic book artists have done just that. Sometimes, several of them form a group and start their own company, which gets them immediate attention because of their combined star power and prestige.

YOU ARE HERE

THE INTERVIEWS

Want to know exactly what some of the top comic book publishers are looking for? Want to know how they think and how they view artists? You've come to the right place, and the answers may surprise you. The exclusive interviews in this section are a must-read for anyone who has ever—even for a moment—considered being a published comic book artist.

When you think about comics, you can't help but have tons of great Marvel characters pop into your head. The fantastic character designs, the extreme anatomy, the cool story lines—they've got it all. Marvel is unique in this business: it's the gold standard that remains on the cutting edge. Marvel's marvelous characters are favorites in every medium, from comic books to movies to television to video games to a dizzying array of merchandise. In this segment, Marvel editor Mike Marts has been gracious enough to share his experience and insights into the world of comics, from art techniques and drawing anatomy, to breaking into the business and industry trends. I know you'll get a lot from his wealth of knowledge.

Chris Hart: What's your background, and how did you come to work as an editor at Marvel?

Mike Marts: My career at Marvel began in the early nineties while I was still in college. As a journalism major, I knew I wanted to either write or edit comics . . . and after a dozen or so unsuccessful attempts at submitting stories to Marvel, I enrolled in their editorial college internship program. I spent two semesters as an editorial assistant, which eventually led to an assistant editor position within the Iron Man/Fantastic Four office. I stayed at Marvel for about three years as an assistant, then served a small stint as Wizard's promotions director, then two years as an editor for Acclaim Comics, and then I finally came back home to Marvel as an editor in 1999.

CH: What do you enjoy most about being a comics editor?

MM: It's hard to pinpoint one thing . . . there are so many things about being an editor I enjoy: the freelance talent working on the comics, the constant need to be creative, the pressure of the deadline and making sure a book gets out to the printer on time. But I suppose if I had to mark one thing as my favorite, I'd have to say the continual dance of trying to make a project interesting and fresh. It's to juggle all the things that editors handle in any one given day, but keeping things exciting and new for the readers

always seems to be the most important and, therefore, the most enjoyable.

CH: What are some of your favorite Marvel titles and characters that you've worked on?

MM: The X-Men were my childhood heroes, so I have to say the characters and titles I'm working on now are my favorites: *New X-Men*, *Uncanny X-Men*, *Exiles*. In the past, I've enjoyed my time working on *Deadpool*, *Wolverine*, and *Wolverine: Origin*.

CH: Can you articulate what that "special something" is that makes Marvel characters so appealing?

MM: It really goes back to Stan Lee and Jack Kirby's overall philosophy on Marvel heroes—that they should be [characters] readers could relate to. Sure Spider-Man could be fighting the

Vulture or Kraven on any given night of the week. But Peter Parker had to worry about getting home in time for dinner, too! Spidey had girl problems, the X-Men were outcasts, Daredevil was blind—none of Stan and Jack's creations were without their own personal handicaps that made readers remember them as more human than superhuman.

CH: How important is a solid grasp of anatomy and figure drawing to the comic book artist?
MM: Extremely. There are many different things that go into the making of a great comic book artist—storytelling, page composition, perspective, and contrast to name just a few. But without a solid foundation of the anatomy of the human body, an artist will have a long way to go before he or she can be considered as a professional.

CH: What are some of the common weaknesses you see in anatomy and figure drawing when looking at portfolios of aspiring artists?
MM: A lot of it comes back to just a basic misunderstanding of the human body and how it acts in different scenarios and situations: at rest, in motion, throwing a punch, etc. Faces and hands are always the hardest, so I tend to see either laziness on the part of hands or just extreme misinterpretations of the human face. And that's not to say that these artists aren't trying their hardest—they are. They're just extremely difficult things to master, and I have to hand it to the guys and girls I work with each month who already have it mastered.

CH: What do you want to see in a portfolio?
MM: More than anything, I want to see a good balance of artistic elements. Don't show me a portfolio full of pinups or splash pages—that's going to give me no idea of how well you can sequentially tell a story. Also, think about being specific in showing pieces that relate to your overall goal. If your lifelong dream is to be a penciler, don't show me your still life paintings from the seventh grade. While it will show me that you're well rounded, it's also going to give me the impression that you're unsure of what you want to do and what you want to be. An editor's time is extremely precious, especially at a convention, so be extremely selective

in what pieces you show and what they are. Always put your best pieces—or your more recent—up front. Sometimes an editor won't be impressed with what he or she sees in the first few pages and will wish you good luck, which will really stink if you saved your best pieces for last! Try to put yourself in the mind of the editors, and figure out what they're thinking or what they're looking for. Try to make your best impression as quickly as you can. Be cordial, friendly, and most especially, be receptive to criticism. An editor will never want to give work to the guy who mutters under his breath and walks off in a huff because he was told his anatomy needed work. Most editors have earned their rank and know what they're talking about; they've worked with the best artists in the business and know what type of an artist will sell a book. Take their criticism and take it well. And if they don't give any—ask questions.

CH: Is it important that comic book artists have formal art training, or can

they be self-taught?
MM: It's not always necessary—I have seen some outstanding artwork come from guys and girls who have never had any art training whatsoever—but it always helps. My advice to anyone starting out is to get some form of professional training, whether it's college-level art courses, instructional videos, or how-to books like this one. Get as much instruction and information from professionals as you possibly can. Look into internships at any type of business that's related to artwork. Think about being an apprentice to a local artist. Study the great past masters [of art and illustration]—da Vinci, Picasso, Rockwell—not just the latest issue of *Hulk* or *Captain America*.

CH: What are some of the major trends in the comic book industry, and where do you see things heading in the future?
MM: It's a difficult thing to try and predict where people's tastes will run in comic artwork. If I knew for sure, I'd always have the best artists working on the right comics and everyone would always be happy! But that's never quite the case. It's tough gauging where art trends will take the industry. . . . Conventions and comic book stores are usually the best arenas to figure out what's hot and what's not. Some trends seemed to have died out a bit over the past decade ("bad girl" artwork or the Image-era "in-your-face" type of style spring to mind), while others have remained consistent, or at the very least survived longer than people initially thought. I think most people have been surprised at how long the current animated/manga trend has remained strong. And certain "realistic" styles like Alex Ross's paintings or Neal Adams's and Bryan Hitch's work will probably always remain strong. But in the end, I think it always comes down to how strong the storytelling beneath the current art trend is. Animation art and Japanese manga are grounded in strong storytelling, which is probably why they've both remained strong. Other past trends that have gone the way of the dinosaur, however, were probably based more on dynamics and impact than anything else.

CH: Marvel has so many successful characters that have been turned into movies. When you create new comic

book characters, how important is it that they be adaptable to film roles? And what creates a good movie character?

MM: There are a lot of elements that go into the creation of a new character, and I'm not saying that movie and TV adaptability aren't things creators think about when dreaming up the next Spider-Man, but they aren't the first things. First and foremost, we'll try to create a strong character that people can relate to. Will readers like this character? Will readers relate to what this character does in his everyday life? Will readers be surprised—and pleased—with the decisions these characters make while under pressure? These are all questions we ask ourselves as creators before diving headlong into the character pool. And if the creation comes out strong and relatable and likeable . . . well, then other things like movie and TV adaptability will almost automatically follow.

CH: How important is it for aspiring artists to go to conventions and network, rather than do everything by mail?

MM: It's not essential but it is important. The face-to-face meeting

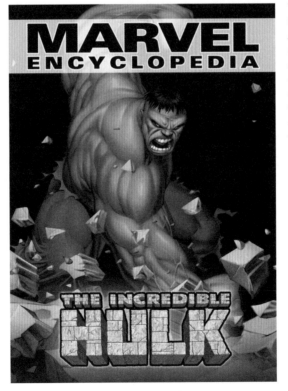

with an editor or fellow artist is worth far more than the submission by mail, no matter how good of an artist you are. Admittedly, my stack of unopened submissions is usually pretty high. And it's not out of lack of interest in finding the next Joe Madureira; it's just that while I'm in the office, my primary

focus usually ends up being making sure the next issue of *Uncanny X-Men* looks good, reads well, and gets out to the printer in time to get into your hands. Conventions, on the other hand, are a whole different story. My primary purpose for being there is to meet and greet and network with all types of talent—new and old. I've made plenty of connections at conventions over the years that have blossomed into longstanding professional relationships, and more than a few of Marvel's elite artists got their big break while showing their artwork to an editor at one of the big cons.

That being said, if you find that as an artist, you can't make the long drive to the next big show, don't despair. Mail and e-mail, especially, are both great ways of showing your artwork. Also think about exhibiting your artwork on your homepage, and send editors your link. This always works great with me. My computer screen gets to look at me more than my girlfriend does, so if an aspiring artist's homepage link pops up in front of my face on my computer, I'd much rather click on it and find out what's inside than start opening that daunting stack of submissions.

AN INTERVIEW WITH CHRIS WARNER
EDITOR AT DARK HORSE COMICS

Dark Horse Comics has grown from a fledgling business to one of the top comic book publishers in the United States. It has continually pushed the envelope to bring the art of comics to a new level, which it sustains in breathtaking comic book after breathtaking comic book. In addition to its groundbreaking original cast of characters, Dark Horse has an amazing stable of comics based on wildly successful television and movie characters. Chris Warner and Scott Allie are both editors at Dark Horse Comics, and they share their experiences with you here.

Chris Hart: What was your route to becoming an editor at Dark Horse?
Chris Warner: For a number of years I'd known Mike Richardson, from whom I used to buy comics at his retail shop, and Randy Stradley, with whom I'd collaborated creatively and lived for a time in New Jersey when we first broke into comics. When Mike and Randy decided to start comics publishing, I was still living in New Jersey and working for Marvel as a penciler (*Moon Knight*, *Alien Legion*, *Doctor Strange*), and they asked me to create the lead feature (*Black Cross*, a character I had been kicking around but had not yet developed into finished stories) for DH's first comic book, *Dark Horse Presents*. After moving back to Portland in the late eighties and doing a lot more freelance work, Dark Horse asked me if I'd be interested in doing some freelance editorial work, since I had a professional background in drawing, writing, and inking comics and had professional editorial and production experience, having worked for a noncomics publisher in the early

eighties. I split time between Dark Horse staff and freelance work for a number of years and eventually became a full-time staff editor.

CH: At what age did you discover comics, and when did you actually think about making a career of it?
CW: Some of my earliest memories are of being read Disney comics by my dad. I had professional ambitions when I was young, tried to break into the business in my early twenties, then sort of lost interest in comics as a profession until my late twenties, when I caught the bug again.

PUBLISHED BY DARK HORSE COMICS, INC.

AND YOU CAN BET I'M GOING TO *ENJOY* HER BEFORE I *KILL* HER.

CH: What are some of the characters and books you have worked on for Dark Horse, and what are you working on now?
CW: As an artist and/or writer, I've worked on *Black Cross*, *The American*, *Predator*, *Aliens*, *The Terminator*, *Barb Wire* (which I created), *Comics' Greatest World*, *X*, *Star Wars*, *Ghost*, etc. As an editor, I've worked on a ton of stuff, especially a lot of great manga, such as *Ghost in the Shell*, *Akira*, and *Astro Boy*. These days, I'm working on *Berserk*, *Astro Boy*, several other Tezuka projects, and a variety of noncomics book projects.

CH: This book focuses on anatomy for comic book artists. How much emphasis does Dark Horse place on an artist's grasp of anatomy? Can an artist fake it with flash and style?
CW: Knowing anatomy is important, but knowing figure drawing is crucial. Anatomy is just knowing what muscle goes where, proper proportion, etc. Figure drawing is knowing how the figure looks in motion, how the muscles look in different positions, how the body balances. If you don't have a natural command of figure drawing, you can't fake it.

CH: When aspiring artists get their first real break in the business, what things would you suggest they do to capitalize on it and impress their editors?
CW: This is the most accurate axiom I know relating to freelancing, and it's 100 percent true. There are three qualities editors are looking for, and if

you have two of them, you'll be able to maintain a career in comics (or probably any creative field): big talent, rock-solid dependability, and great character. If you have fabulous talent and are a good person, but you're shaky on deadlines, an editor will accommodate you if at all possible. If you're extremely talented and never miss a deadline, but you are a complete jerk, you'll still get work. If you're an average talent, but you never miss a deadline and are great to work with, you'll always be working. *But*, you can be the most talented guy on the planet but if you're a flake and a punk, eventually you'll be run out of the business. If you're a deadline machine but can't draw and you're miserable to work with, you're done. And being the nicest guy in the world won't help you if you're an undependable mediocrity. So, choose any two: good, dependable, nice. And if you're all three, you're going to make a lot of people happy and a lot of money.

CH: Suppose that someone has a portfolio of drawings ready to go. How would you advise someone to go about trying to land that first job?
CW: First, show the samples to working professionals, preferably artists, to see if you're ready to take the next step. If you haven't had someone with knowledge give you a solid indication that your work has what it takes, you're probably wasting your time sending work to publishers or showing your work to editors at big shows like Comicon International or Wizard World. An editor is not the first person in the business you want to see your work. Most editors aren't artists, and all they can do is give you thumbs-up or thumbs-down; they don't have the drawing knowledge to really tell you what you need to do in any but the broadest strokes. Almost all local conventions and all regional conventions have guest artists. Show *them* your work, and ask for 100 percent honest opinions. If they tell you you're ready, you're probably ready. In fact, if you are ready, many artists will help you out by putting you in contact with their editors. That's how I got my first break, in fact, and how a number of artist got their break by showing me work at conventions when I was a freelancer.

PUBLISHED BY DARK HORSE COMICS, INC.

CH: Is it important for artists to set up their own Web site as a form of self-promotion?
CW: It's helpful but not essential. Comics is a pretty small business, and it isn't that hard to send your stuff to publishers at regular intervals. For pencilers especially, good-quality, full-size copies in-hand look a thousand times better than scanned, reduced 72dpi jpegs any day. If an artist has aspirations in illustration outside of comics, I think a Web site is an absolute must. Also, if you're doing regular stories on your own, a Web site is great because it shows your dedication to the form, and publishing on the Web is far less expensive than printing physical comics.

If you do have a site, make sure you're updating it regularly, daily if you can (a "Sketch of the Day," for instance). Give editors a reason to come back on their own rather than browbeating them with e-mails (although if you've established a rapport with certain editors, by all means drop them an e-mail when you've updated your site). And make damn sure your site is working before you put it up and start contacting editors. Nothing is more off-putting than having someone send you a link only to have an Under Construction page pop up or an interface where

links don't work or where overly ambitious entry-screen Flash movies just waste an editor's time. The site should look good, but let me get to the art as fast as I can.

CH: Do you find that some talented, young artists fall into the trap of being good at drawing men or women but not both? What do you do, as an editor, if you encounter such a problem?
CW: There are some very talented artists who do well drawing characters of one gender and not the other. Generally, you try to lean to an artist's strengths and not make assignments that rely on a strength a particular artist doesn't have. One of the major challenges for an editor is to find talent whose style is visually appropriate for the material. This doesn't mean that a particular book requires a specific house style, but that whatever style is employed underscores the mood, the themes, the emotional and dramatic content of the work. No matter how talented, not every artist is appropriate for every assignment, and this is one of the biggest pitfalls of many editors, the desire to hire the same people, or "name" people, regardless of whether their work might actually diminish the material.

AN INTERVIEW WITH SCOTT ALLIE
EDITOR AT DARK HORSE COMICS

Chris Hart: How did you become an editor at Dark Horse?

Scott Allie: I was living in Portland, where Dark Horse is based, self-publishing a comic series. This got the crew at Dark Horse to notice me, and I happened to run out of money right when they needed a new assistant. I was lucky enough to inherit *Hellboy* when another editor left, and this set my career rolling.

CH: Have you always been interested in comics?

SA: I only started reading comics in junior high. Before that, I had maybe two comics as a kid. I drew comics, but I never read them until Frank Miller's *Wolverine* series.

CH: Were you one of those kids who always doodled and drew on the margins of his notebook paper?

SA: Yeah.

CH: What are some of the functions of a comic book editor?

SA: It changes from book to book, but sometimes you have to come up with the story yourself, or nurse the writer's ideas along. Sometimes you are just there to make sure the story works on its own merits, or that the art tells the story well, that the artist is giving you his [or her] best work. Sometimes, you're chasing down payments or contracts or lost artwork. Sometimes, you have to fire people, and you're always looking to hire the new guy whose work blows you away.

CH: How much time do you give a comic book artist to complete a typical comic book. And how many actual pages of art are involved?

PUBLISHED BY DARK HORSE COMICS, INC.

GONE FOR GOOD!

SA: The average comic here is twenty-two pages plus cover, but I can't give you much of an average of how long it takes them to do it. I guess the average guy these days might take five weeks, which means you have to be resourceful to keep a monthly book on schedule. But most of what Dark Horse does is miniseries, so we can schedule around an artist's speed, and a lot of guys take six to eight weeks to do a book. A new guy starting out will find himself hard pressed to get work if he's that slow, though.

CH: How often do you speak to an artist during the process?

SA: Also depends, but on average I'd say once a week. There's one guy I only talk to when he turns the finished book

in and I say it's perfect. Other people I talk to every day. Depends on their personal needs and how much I have to stay on them to get the book out of them. I like talking to my artists, so I like a lot of communication, but it's best when I don't feel like I have to call or they're playing Nintendo.

CH: Do the artist and the inker speak directly with each other about the project they are doing, or only to the editor?

SA: At other companies the editors like to keep the talent away from one another, but when I hire a penciler, I generally ask him who he wants to ink him; this means the inker is probably the guy's friend, and they probably talk more than they talk to me. Which is great.

CH: If you're an aspiring artist, and you're at a comic book convention, and you've got only one shot to meet an editor from a major comic book publisher, what should you do to prepare?

SA: Samples that are gonna knock my socks off. Six to ten great pages that really tell the stories they're trying to tell, and show that the artist can draw anything. But if an artist's work is not totally up to professional standards, don't show editors. Show professional artists, who can give much better advice about how to get better. If an artist is not good enough to get work or to at least make a great impression with his [or her] work, then showing an editor is a waste of everyone's time.

CH: Where do you see comics, in general, heading in the future? For example, there is a strong push toward

horrible to have gained this ground and lose it. But I think publishers are being much more shrewd about what they publish, are doing everything they can to put out the best material possible. I think this will translate to a more widely accepted and widely read art form. I think standards were kind of low for a while, but now there is some amazing work coming out—and much less mediocre work.

CH: What are some of the projects you're working on at Dark Horse?

SA: My big thing is *Devil's Footprints*, my creator-owned series with Paul Lee, Brian Horton, and Dave Stewart. It ain't paying the bills, but it keeps the lights on inside my skull. It's part of a horror line I'm overseeing, which includes Mike Mignola's *Hellboy* stuff, Eric Powell's *The Goon*, and various things with Steve Niles, including the Cal McDonald series with Ben Templesmith. Between these books, and Conan and Buffy, which are my two big licenses, I've got my hands full. But it's all stuff I love, so I'm happy.

manga (Japanese comics) and graphic novels.

SA: I think graphic novels are the wave of the future, but the future ain't now. We need a little more evolution to get there. Right now they don't work out financially going straight to so-called graphic novels—that is, skipping the comic books. I think the manga craze, while valid, has got to taper off soon, and hopefully that will make more room for American comics, rather than people just forgetting about comics and manga altogether. It would be

INDEX

abdominal muscles, 55, 56, 58, 62, 63, 64
acromion bone, 81
age, body changes and, 15
Allie, Scott, 142–143
anklebone, 113
apprenticeship, 131, 138
arm muscles
 biceps, 80, 87, 89
 brachialis, 87, 88
 coracobrachialis, 87
 forearm, 86, 90–93
 triceps, 80, 86, 87, 88, 89
arms
 bones, 85
 down position, 54, 58, 71
 poses for, 94–95
 raised position, 54, 60–61, 72, 95, 126
art training, 138
artwork sales, 132
ashcan vs. portfolio, 131

back
 female, 12, 78
 poses for, 76–78
 surface rendering, 74
back muscles, 11, 12, 51
 arms down, 71
 arms raised, 72, 126
 contracting, 75
 lower back, 73
back view, 80, 110, 126
belly button, 56
biceps, 80, 87, 89
body
 age and, 15
 heights, 16–17
 light and shadow on, 34–35
 shapes, 18–19
 simplified figures, 14
 skeleton, 9
 veins and arteries, 28–30
body language, 20–21
boots and shoes, 116–117
brachialis, 87, 88

calf muscles, 11, 111–112, 117
carrying motion, 24
characters
 body language, 20–21
 body shapes, 18–19
 creating, 138–139
chest muscles
 arms down, 58
 arms raised, 54, 60
 in motion, 62
 shoulders and, 55

collarbone (clavicle), 13, 53, 56, 81
comic book conventions, 133, 139, 142
comic book editors, 135, 137, 142
coracobrachialis, 87

Dark Horse Comics, 140–143
deltoids. See shoulder muscles
drawing
 common weaknesses, 138
 figure, 140
 initial sketch, 59, 123
 muscles, 124
 simplified figures, 14
 surface mapping, 31–33

ears, 48
eyes, 39–41, 43

face
 eyes, 39–41, 43
 muscles, 38
 proportions, 42, 44
feet, 113–117
fill-in work, 132
firing weapon motion, 25
forearm, 86, 90–93

graphic novels, 143

hands, 96–99
hauling motion, 26
head
 angle of, 42, 45
 ears, 48
 skull, 37
 tilt of, 46–47
 See also face
heights, 16–17

inkers, 142

kicking motion, 26
knees, 102, 109, 120
knuckles, 97

leaping motion, 23
leg muscles
 back view, 110
 in bulky character, 105
 calf, 11, 111–112, 117
 female, 106–108, 125
 groups, 103
 sartorius, 118
 side view, 104, 108

legs
 bones, 102
 feet, 113–117
 female, 106–108, 120–121, 125
 giant, 119
 knee, 102, 109, 120
licensing rights, 115
lifting motion, 24
light sources, 34–35

manga (Japanese comics), 143
Marvel Comics, 137–139
Marts, Mike, 137–139
muscles
 abdominal, 55, 56, 58, 62, 63, 64
 in action, 23–26
 contours, 31–33
 facial, 38
 men, 10–11
 muscles on muscles concept, 57
 neck, 49–51, 58
 in profile, 13
 on rib cage, 57, 58, 62
 stages of muscularity, 27
 women, 12–13
 See also arm muscles; back muscles; chest muscles; leg muscles; shoulder muscles

neck, 11, 49–51, 58
nipples, 56
nose, 47

pelvis, 64–65, 101, 120
portfolio, 131, 138, 141
poses
 for arms, 94–95
 for hands, 98–99
 for rib cage, 127
 roughing out, 14
 for shoulders, 83
posters, 132
profile, 13, 43, 45
promotional work, 132
pulling motion, 23
punching motion, 26, 93
pushing motion, 24

rib cage
 arms raised, 60
 female, 63, 64–65
 in motion, 62, 64–65
 muscles, 57, 58, 62
 pelvis and, 64–65

poses for, 127
sternum, 53
running motion, 23

sartorius muscle, 118, 125
scaling wall motion, 25
shadows, 34–35
shoes and boots, 116–117
shoulder blade, 79, 81
shoulder muscles
 arms down, 58
 arms raised, 72
 front view, 54, 55, 81
 parts, 13, 79
 poses, 82–83
 rear view, 80
simplified poses, 14
skeleton, 9
sketching, 59, 123
skull, 37
smile, 47
spine of the scapula, 79
starting-out strategies, 131–135, 138, 139, 40–141
storyboard artists, 133
surface mapping, 31–33
suspension from rope motion, 25

thigh, female, 125
three-quarter view, 43, 45, 54
toes, 113, 114
torso
 female, 63–69
 male, 55–62
trapezius muscle, 51, 71, 72, 73
triceps, 80, 86, 88, 89

veins and arteries, 28–30

Warner, Chris, 140–141
Web site, 141
women
 arms, 95
 back, 12, 78
 body shapes, 19
 calf, 112
 eyes, 40
 face, 44–45
 head tilts, 46–47
 heights, 17
 high heels, 117
 legs, 106–108, 125
 muscles, 12–13
 skeleton, 9
 torso, 63–69